British Watercolours
1750–1880

Andrew Wilton
Anne Lyles

Prestel

Munich · London · New York

CONTENTS

9 AMBITION AND AMBIGUITY: WATERCOLOUR IN BRITAIN

31 I THE STRUCTURE OF LANDSCAPE: EIGHTEENTH-CENTURY THEORY

71 II MAN IN THE LANDSCAPE: THE ART OF TOPOGRAPHY

115 III NATURALISM

153 IV PICTURESQUE, ANTIPICTURESQUE: THE COMPOSITION OF ROMANTIC LANDSCAPE

195 V LIGHT AND ATMOSPHERE

229 VI THE EXHIBITION WATERCOLOUR

264 GLOSSARY OF TECHNICAL TERMS

266 CATALOGUE OF WORKS

279 SELECT BIBLIOGRAPHY

282 LENDERS TO THE EXHIBITION

283 PHOTOGRAPHIC ACKNOWLEDGEMENTS

284 INDEX

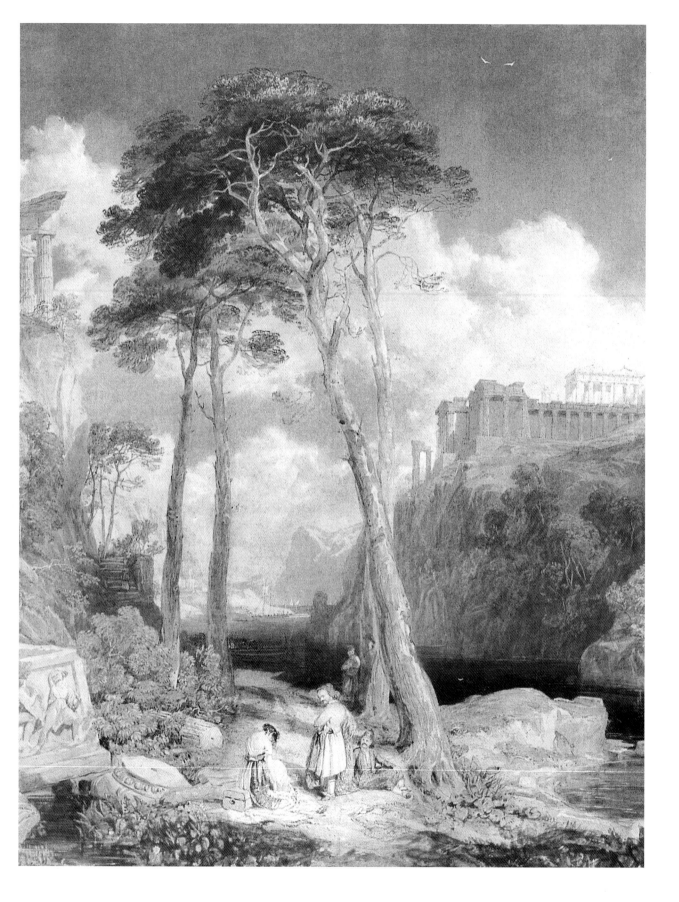

AMBITION AND AMBIGUITY: WATERCOLOUR IN BRITAIN

Watercolour is well named: it embodies in its very nature an uncertainty, a fluidity and ambiguity that seems to symbolise its interest and aesthetic importance. Should we speak of a watercolour drawing, or a watercolour painting? Reporting on the opening of the Old Water-Colour Society's exhibition in 1824, William Henry Pyne recalled: 'Just twenty years ago, almost to the very day, ... we met an old friend on entering the new rooms, one of the founders of the society ... "Well," said we, almost simultaneously, "time was, in discussing the *title* for this society, whether the novel term *Painters* in Water Colours might not be considered by the world of taste to savor of assumption – who now, on looking round, will feel disposed to question the merits of that title?" Thanks to the extraordinary developments of those decades, the terms 'drawing' and 'painting' are both correctly applied to watercolour, but in different contexts.

A drawing in pen or pencil may be amplified with washes, applied with a brush, that can be monochrome – grey, blue, or brown – or coloured. Such a drawing might be made out of doors, and in a short space of time, to record a particular idea, a particular set of observed facts or a response to them. It might be quite elaborate, yet still retain its identity as a drawing, perhaps even as a sketch. Completed, it would be mounted on a sheet of thin card decorated with a few parallel lines as a border, possibly tinted to harmonise with whatever colour is in the design (fig. 1). Rather than being framed, it would then, as like as not, be consigned to an album or portfolio, to be viewed in a collector's study or shown to friends in the course of discussion among antiquaries.

But watercolour can also be used in a quite different way, worked at laboriously in the studio as the medium of a large-scale picture with elaborate conceptual content, dense tones and complex imagery. In other words, a watercolour may be a finished painting in the same sense that a finished work in oils is a painting. Some oil paintings, of course, are themselves sketches or studies. There is a parallel between the two kinds of watercolour and these two uses of oil paint, for preliminary or exploratory studies and for evolved, finished works. There is also a striking historical difference: whereas watercolour evolved from the more tentative to the more complete form, the use of the oil sketch was a development from the process of making a finished oil painting. And while the oil sketch from Nature, which had been in use occasionally since the Renaissance, emerged as a distinct genre in many western European countries at roughly the same moment in the late eighteenth century, the watercolour painting, which developed contemporaneously, was an almost uniquely British phenomenon.

It presented the medium in a new dimension, that of the public statement. From being an essentially private channel of communication, small-scale, intimate and provisional, functioning according to the *ad hoc* requirements of individuals engaged in many aspects of recording the visual world, it became a fully fledged art form, with its own intellectual programmes and purely aesthetic criteria of judgement. At the same time, watercolour retained its other, more practical, purpose, and so the two uses of the medium marched side by side through the nineteenth century, a uniquely flexible and varied means of expression.

In the second half of the eighteenth century, watercolour was developing somewhat similarly on the Continent. Although it had been in use in the Middle Ages for the illumination of manuscripts, its modern application as a medium for recording Nature was pioneered in a watery country, the Netherlands. It was reintroduced into Britain by artists from that part of the Continent in the early seventeenth century. There was no dearth of inventive skill in its use among the Dutch, the French and the Germans, who employed it for more or less elaborate landscape views (fig. 2). By the end of the eighteenth century artists all over Europe were using it as the medium for decorative landscapes, usually of a classicising kind, with subject-matter often drawn from the Grand Tour.

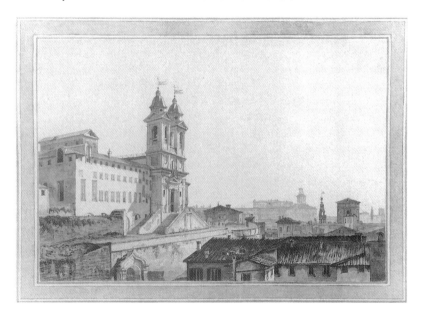

Fig. 1 John 'Warwick' Smith, *Church of SS Trinita dei Monti, Rome*, c. 1776, pencil and watercolour with pen and ink, 34.1 x 54.1. British Museum, London

For the British who made the journey through Europe to see the artistic wonders of ancient and modern Italy, and in due course came to appreciate the natural splendours of the Alps as well, the traditional interests of the antiquary were happily combined with the enthusiasms of the tourist, and watercolour was increasingly called upon to gratify both.[2] The need to record gave way to the need to recall, and recollection was as much a matter of atmosphere as of factual detail. Artists adapted themselves accordingly.

There was close contact between the British artists who travelled in Europe and their Continental *confrères*, and some stylistic interaction: the

German Philipp Hackert (1737–1807), for instance, was much patronised by British travellers, and his drawings were copied by English watercolourists: the connoisseur and collector Richard Payne Knight (1750–1824) took Hackert with him on a journey to Sicily in 1777, although Knight also travelled in the company of an accomplished English amateur draughtsman, Charles Gore (1729–1807), and later, in England, got another of his travelling companions, the professional Thomas Hearne (1744–1817), to make versions of Gore's drawings.[3]

Perhaps the most sophisticated of the Continental practitioners at this period was the Swiss painter Louis Ducros (1748–1810), whose often enormous scenes of Italy and Malta epitomise the technical virtuosity of the time (fig. 3).[4] They embody the dramatic vision of the moment when science and history gave way to the more subjective appreciation of early Romanticism, with its passion for Antique ruins, waterfalls and the scenery of the Roman Campagna. They demand to be treated as paintings, require no mount, and should be viewed in a heavy gilt frame like an oil painting. Ducros employs watercolour in a direct, brilliant way that takes maximum advantage of its inherent luminosity: he revels, for instance, in effects of sun shining through foliage, in which the idea of light transmitted through a membrane of colour is the essence of the image.

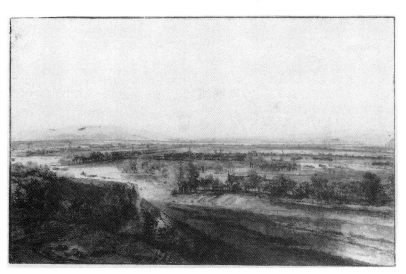

Fig. 2 Philips Koninck, *Landscape with a River and Distant Hills*, c. 1655, watercolour and bodycolour, 13.8 x 21.2. British Museum, London

It is an exact illustration of the principle of watercolour, where the transparent, water-based colour, applied directly to sheets of white paper, reveals the brightness of its ground in varying degrees according to the density of the pigment. The brilliance of sky or falling water is contrasted with the denser masses of rock or woodland, which are often strengthened with applications of gum arabic. Darker areas are often worked on first in a preliminary under-painting with a layer of grey or some other deeper tone. The human figure abounds, and Ducros's foregrounds are alive with the well-drawn and animated crowds that distinguish most good eighteenth-century topographical work. Outlines are lively and have a prominent role in the overall texture, but the linear rhythms of the whole design are generally subordinated to the visual wealth of detail.

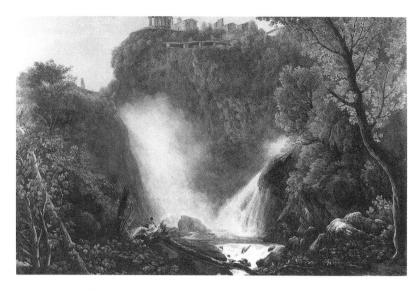

Fig. 3 Louis Ducros, *View at Tivoli*, 1787, watercolour and bodycolour on paper laid down on canvas, 66 x 101.5.
The National Trust, Stourhead

Continental watercolours remained at this stage of development for the next half-century; indeed, on the whole they rarely again approached the complexity of Ducros's work. Hackert and his many followers, such as Franz Kaisermann (1765–1833), applied a decorative and effective formula to produce countless civilised views of an entirely predictable type. If the Continental artists developed technically it was towards a more adaptable sketching style, and hardly at all in the field of the finished watercolour. In Britain, by contrast, the eighteenth-century topographical view, however sophisticated, was soon left behind, and by the early years of the new century the expressive capacity of the medium had been stretched beyond recognition.

This rapid evolution is usually attributed to a special relationship between the British character and the medium of watercolour, to the unique beauty of the British landscape, or to the superabundance of bored young ladies requiring drawing-masters. These considerations all have some bearing on the quantities of topographical sketches produced in the eighteenth and nineteenth centuries, but they cannot adequately account for the profound conceptual seriousness with which watercolour was pursued by professional artists in these years.

The decisive factor in the evolution of the Romantic watercolour in Britain was precisely the same as the motive behind the development of the national school of oil painters. Since the early successes of William Hogarth (1687–1764) in the 1730s, there had been a heightened sense of national purpose in the visual arts, a chauvinism that impelled artists to incorporate themselves as a fully recognised establishment, setting standards at home and winning admiration abroad. The movement coincided with the first great expansion of Britain's imperial interests world-wide, with the Seven Years War and the confident heyday of the East India Company. The instinct for national advancement in the international context was becoming explicit, and when, in 1768, the Royal Academy of Arts was founded in London, supporters of the visual arts could argue for the first time that their activities, too, were taking a rightful place in the expanding scheme of things.[5] The watercolourists were a part of this

patriotic progress, caught up like everyone else in the pushy spirit of the times.

There were two strands to their ambition. On the one hand, they wanted to be part of the Academy; when they found that their work was rendered insignificant in the contest with oil paintings, they determined to make it more impressive; when that did not work, they formed an academy of their own, the Society of Painters in Water-Colours. This new institution was academic in the important sense that it incorporated the professional identity of the watercolourists, and provided them with a centre for exhibitions, their principal means of contact with the public. It did not, however, attempt to teach, as the Royal Academy did. Its 'schools' remained the studios of practitioners who trained their apprentices from the artisan class as engravers, scene-painters or topographers. On the other hand, the watercolourists believed in the intellectual importance of British painting, an idea that had received a substantial boost in the 1760s when William Woollett's engraving *Niobe*, after a historical landscape by the Welsh painter Richard Wilson (1713–82), was marketed all over Europe by Josiah Boydell (fig.4).[6] Similar triumphs abroad were scored with the mezzotints produced by the reproductive printmakers that Joshua Reynolds (1723–92), the Academy's first President, was nurturing to disseminate his portraits.[7] There was no reason why watercolours should not reflect and embody this new international importance as much as oil.

This last assumption was, on the face of it, an illogical leap from the premisses. Until the 1780s there was little indication that watercolour might be a medium for the expression of the higher aspirations of art.

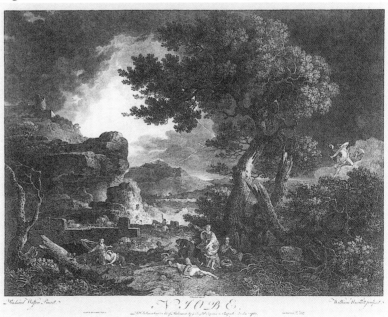

Fig. 4 William Woollett after Richard Wilson, *Niobe*, 1761, etching and engraving, 47.5 x 60. British Museum, London

Indeed, it was by definition a lowly and inferior branch, devoted chiefly to landscape (itself inferior to historical painting and portraiture), and a lesser type of landscape at that – topographical view-making. Because the art establishment was locked into this system of hierarchies, there was plenty of scope for rivalry.

The very relegation of watercolour as a lesser art-form stimulated its practitioners to assert its potential. Those practitioners were a considerable body, with a well-established and much sought-after function in society. For the best part of a century they had supplied views of towns, of country seats, of antiquities to the nobility and gentry; they had accompanied the Grand Tourists on their journeys to Italy, and the archaeologists to Greece and Asia Minor and Sicily, with colours always ready on the spot to take an exact and scientific likeness of whatever objects of interest might appear. They had demonstrated the power of watercolour in worked-up views that might be hung like paintings on the wall. Ducros was by no means alone in doing so: Paul Sandby (1731–1809) had for much of his career specialised in large watercolours of just this type (pl. 24, 51), and had experimented with variations on the pure watercolour medium that gave his work a greater richness and intensity. While some artists, such as Ducros, preferred gum for this purpose, Sandby frequently adopted the thoroughly Continental medium of bodycolour – *gouache* as the French call it, from the Italian *aguazzo*, meaning mud. (In the early nineteenth century the word was sometimes expressively mistranscribed as 'gwash'). Instead of being mixed, as watercolour pigments are, with a transparent binding medium such as gum, and applied in thin washes that permit the tone of the support to contribute to their effect on the eye, the powdered pigments in bodycolour are combined with opaque matter, usually a fine clay or lead white, and applied thickly, so that the colour of the support cannot influence what the eye sees. When using pure watercolour the painter leaves the paper untouched (or 'reserved') as a way of introducing highlights, but bodycolour functions like oil paint: with it, the artist mixes increasing amounts of white into the pigment to achieve the lighter tones, with pure white for the highest lights.

Bodycolour pigments tend to be dense and saturated, more brilliant than watercolour. The medium had been used in Italy and France for two hundred years for painting fans and little fancy scenes, many of which were copied on a small scale from oil paintings. It had been put to serious purposes in the Renaissance when Albrecht Durer (1471–1528) executed a series of exquisitely observed landscapes and Nature studies in bodycolour, but by the eighteenth century it was a largely decorative medium, associated particularly with the French. Its use in England was typified by the *capriccios* of the Italian viewmaker Marco Ricci (1676–1729; fig. 5) and the meticulous, brightly coloured copies after Old Masters of the Flemish draughtsman Bernard Lens III (1681–1740). Two Huguenots, Louis (1700–1747) and Joseph Goupy (c. 1680–c. 1768), used it in similar ways; Louis practised as a fan-painter and it was he who taught the young James 'Athenian' Stuart (1713–88), later famous as one of the earliest Greek Revival architects and co-author of *The Antiquities of Athens*. Stuart's bodycolour views in Greece (pl. 59, 60), drawn according to the most strict topographical principles, 'preferring', as he said, 'Truth to every other consideration',[8] are therefore executed in what was by tradition an essentially frivolous medium, and one which was, and remained for many decades, rather un-British.

If Stuart had direct influence on any of the topographers it was on William Pars (1742–82), who learnt much from his work but did not imitate his use of bodycolour (pl. 58). Paul Sandby, on the other hand, employed it frequently The numerous *capriccios* that he painted in bodycolour, although often Italianate in general style, effectively Anglicise the conven-

tion passed down by Ricci; and the decorative quality of body-colour perfectly suits his topography, imbuing his sunny mornings with a light-hearted, Haydnesque cheerfulness that has come to epitomise a certain aspect of eighteenth-century life. Sandby's fresh insouciance often disguises the richness of these works, but despite appearances, there is in the topographical discipline considerable complexity both aesthetic and intellectual, complexity of structure and, correspondingly, of the economic and social perceptions conveyed. When the watercolourists asked for academic recognition, they were protesting against a serious undervaluing of their art.

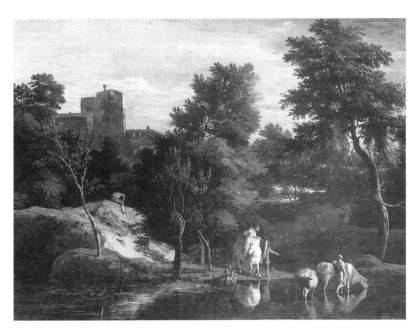

Fig. 5 Marco Ricci, *Capriccio Landscape*, c. 1710, bodycolour on leather, 29.5 x 44.6. Private Collection

The late arrival of an academy in Britain was symptomatic of a typi-cally British attitude to oil painting: a pragmatic readiness to experiment and evolve techniques according to need. No formal painting courses were instituted in the Academy's Schools; students were expected to work out their own technical salvation. The expressive vitality and variety of British Romantic painting, in which every artist devised his own means of expres-sion, is due to this approach, although the frequent technical disasters of the school must also, no doubt, be ascribed to it. A precisely similar psy-chology governed the evolution of watercolour. Once the patriotic motiva-tion and the professional competition had been established by the suc-cessful inauguration of the Royal Academy, innate inventiveness took over. Between 1770 and 1800 a gamut of technical innovations had been tried, and the whole appearance of watercolours had been changed unrecognisably. This experimental drive had no parallel on the Continent, where watercolour was to change little until the 1820s or later.

Since the revolution in watercolour of the 1790s was so closely linked to contemporary oil practice, the connections between the two media need to be examined in more detail. The progenitor of the move-ment, if a single figure can be named, was John Robert Cozens (1752–97),

who in the 1770s systematised a method of applying watercolour pigment, without the admixture of bodycolour or any other substance, that for the first time comprehensively answered the requirement of landscape painting that it should represent vast expanses of land and sky. If earlier artists had failed to achieve this, it was because public sensibility had not required it: the appreciation of landscape scenery as a moving experience in its own right was only beginning at that time to make headway against the conventional perception of it as the setting for objects and actions of essentially extrinsic interest. The achievement of Richard Wilson was to reinterpret the seventeenth-century Ideal landscape of Claude Lorrain (1600–82), with its beautifully disposed and balanced elements and subtly diffused light, in terms appropriate to the eighteenth century (fig. 6). In consequence, a poetic value had at last come to be placed on open space, distance and aerial perspective for their own sakes. Cozens found the visual equivalent of that value in the physical language of the watercolourist.

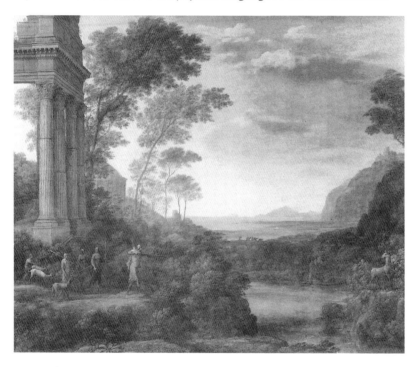

Fig. 6 Claude Lorrain, *Landscape with Ascanius Shooting the Stag of Silvia*, 1682, oil on canvas, 120 x 150. Ashmolean Museum, Oxford

The main characteristic of John Robert's mature style largely derives from his training with his father, Alexander Cozens (c. 1717–86), which explains almost everything about him – his attitudes to composition, to texture and to colour are all present in some form in his father's work. It may be that his watercolour technique came to him by the same path, but that is less obvious, and there is something of mystery about the appearance of so masterly, powerful and poignant a means of expression at this moment in the history of landscape appreciation.

For John Robert was profoundly original. In his mature watercolours he propounded a view of Nature that was yet to be fully articulated in literature. The main direction of eighteenth-century writing on the natural world had been established as early as 1730 by James Thomson in his great

sequence of poems, *The Seasons*, where for the first time a detailed, almost scientific description of natural phenomena was married to a dramatic exposition of the place of humanity in the scheme of things. But the intimate personal engagement of the Romantic poets was not to be articulated clearly until the 1790s, when William Wordsworth invoked

> this majestic imagery, the clouds,
> The ocean, and the firmament of heaven

as representative of the grandeur of creation, echoing the main themes of John Robert's work. But Wordsworth went on to draw broader moral conclusions:

> All things shall live in us, and we shall live
> In all things that surround us. This I deem
> Our tendency, and thus shall every day
> Enlarge our sphere of pleasure and of pain.
> For thus the senses and the intellect
> Shall each to each supply a mutual aid.. .[9]

A passionate involvement in Nature as the embodiment, symbol and determinant of human experience was to form the kernel of Wordsworth's attitude to life and art alike. Many other Romantics voiced similar ideas. In 1798 Samuel Taylor Coleridge wrote to his brother: 'I love fields & woods & mountains with almost a visionary fondness'; like Wordsworth he saw this passion as central to his moral identity: 'because I have found benevolence & quietness growing within me as that fondness increased, therefore I should wish to be the means of implanting it in others – & to destroy the bad passions not by combating them, but by keeping them in inaction'.[10]

The close interconnection between the natural world and the moral well-being of the individual was a notion that had received its impetus from several sources. The Swiss philosopher Jean-Jacques Rousseau had identified the truly healthy human being as one free from the corruption of evolved modern civilisations, and set up as an ideal the 'natural' and 'innocent' state of primitive societies. In Britain, writers concerned with a range of different aspects of life and thought had defined increasingly precisely the conditions that determine aesthetic experience. In particular, they had related our perceptions of the external world to mental and emotional states: our appreciation of beauty can be traced to our reproductive urge, and hence 'beauty' is determined by those qualities that make a woman physically attractive to a man: softness, smoothness, gentleness, grace, delicacy, and so on. Our instinct for self-preservation, on the other hand, produces a *frisson* both disturbing and aesthetically exciting when we are confronted by danger. To contemplate the unknowably vast, the infinite, the empty, is to receive such a *frisson*, as is the experience of high waterfalls and cliffs, mountains, oceans and storms. These all threaten, or seem to threaten, our safety and can be classified as 'Sublime', either in themselves or in the effect they produce on our minds. Memory, likewise, gives a dimension to experience that renders particular places powerfully stimulating for their historical, literary or personal associations. In Germany, the most profound of the Romantic philosophers, Immanuel Kant, argued that in grasping such ideas as those presented by the Sublime, the human mind is capable of a transcendent effort 'which gives us courage to measure ourselves against the apparent almightiness of nature'.[11]

This sense of transcendental striving, of man in a vast and challenging universe, was fundamental to the thinking of the new age – the age that the French Revolution, beginning in 1789 and continuing into the wars of the 1790s and the conflict with Napoleon, was forcing into a new mould. The long ruminations of the Enlightenment were suddenly focused by that lens and burst into violent flame. Thomson's calm acceptance of a divine and immutable order was transmuted into a fierce sense of the value of the individual, however insignificant: landscape is the context of human life; its splendours are our splendours, our moral exemplars and encouragers. By the same token, it is the dwelling-place of humanity, and conditions our existence in all its aspects.

It so happened that the topographers had already given eloquent demonstration of at least some facets of this latter truth, although without any awareness of its Romantic implications. For them, Thomson's account of the place of man in his environment sufficed as a framework within which to describe the towns and countryside of Britain, a broad sunny realm in which everyone had his appointed place. Wordsworth restated that vision as a more thoughtful perception of 'The still, sad music of humanity',[12] – but, as Byron was to show in the succession of colourful and impassioned descriptions of Europe in his *Childe Harold's Pilgrimage* (1812–18), the survey of countries in terms of their civilizations and populations could still be a powerful vehicle of polemic and poetry alike.[13] Topography remained relevant, and its enduring strength as a basis for serious thought is one important reason why watercolour, the topographical medium *par excellence*, retained its value into the nineteenth century. As Samuel Palmer (1805–81) put it in 1856: 'Landscape is of little value, but as it hints or expresses the haunts and doings of man. However gorgeous, it can be but Paradise without an Adam'.[14]

Against this rapidly changing intellectual background, landscape began to undergo a succession of substantial investigations at the hands of a sequence of major artists. As its spiritual and emotional value was reappraised, so it was reformulated aesthetically, and in the process theories of aesthetics, too, were modified. By the 1830s, a potent new visual language had been created, ranging in its scope from the spontaneous atmospherics of David Cox (1783–1859) to the lean linearism of Edward Lear (1812–88) and the almost art-nouveau distortions of Samuel Palmer at Shoreham.

Revolutionary though these artists were, all of them belonged quite consciously to the watercolour tradition that stretched back to John Robert Cozens. It was a tradition as much cultivated and promoted as that of the 'national school' of oil painters at the Academy. If the Academy held Hogarth and Reynolds to be its founding fathers, so the watercolour societies revered, on the one hand, the topography of Paul Sandby and, on the other, the Sublime of John Robert and his great successor, Thomas Girtin (1775–1802). Girtin's early experience included copying the outlines of Cozens's sketches at the evening sessions of Dr Thomas Monro's famous 'academy' at the Doctor's home in Adelphi Terrace, by the Thames. It was Girtin's colleague J.M.W. Turner (1775–1851) who, according to Joseph Farington (1747–1821), 'washed in the effects',[15] but no doubt Girtin became well enough acquainted with Cozens's watercolour technique. His work evinces a thorough understanding of it. But temperamentally Girtin was not a fey, melancholic poet like Cozens. He was a modern, idealistic classicist, strongly sympathetic to the French Revolution and with a formalist streak

that suggests that if he had ever found himself leading a revolutionary party he would have been the first to institute rigorous proceedings against faint-hearts and equivocators. There is no parallel to be drawn between a political and an aesthetic personality, of course; but Girtin's style of drawing and painting is a decidedly authoritarian neoclassicism. It abolishes the tender, feathery touches of Cozens's style and proceeds by firm, vigorous definitions, bold generalisations and a ruthless suppression of detail. His natural sympathies were surely with the academic establishment. There is something Reynoldsian about his masterly abstraction from the particular to the general. He modelled his style quite specifically on that most Reynoldsian of landscape painters, Richard Wilson, although Wilson never used watercolour. Girtin's clear intention was to reproduce in watercolour the full, solid tonality of Wilson's paintings, and at the same time to attain something of Wilson's high seriousness in the depiction of natural scenery (fig. 7).[16]

Yet the wish to emulate oil painting in its appearance and content did not extend to compromise with the medium itself: there was no question of Girtin's enlisting bodycolour to strengthen the effect of his watercolour. The rule applied to everyone. This was partly a consequence of the chauvinistic pride of the watercolourists. To be sure, Sandby, their doyen, had used bodycolour – indeed he continued to do so until his long career ended in 1809; but he generally distinguished carefully between works in that medium and works in watercolour: the two were not to be mixed. And then, again, Sandby was not a Romantic poet, but a more earthy and practical artist, seeking effects that were not incompatible with the lighter mood of bodycolour.

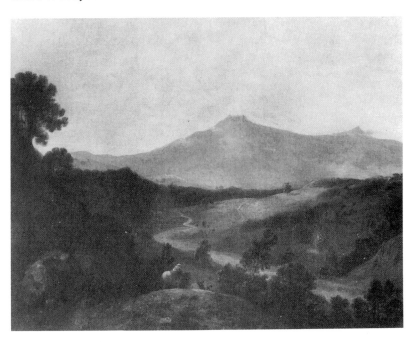

Fig. 7 Richard Wilson, *The Valley of the Mawddach, with Cader Idris Beyond*, early 1770s, oil on canvas, 92 x no. Walker Art Gallery, Liverpool

J.M.W. Turner, a Beethoven to Sandby's Haydn, was equally convinced of the rigid distinction to be made between watercolour and bodycolour, though unlike Girtin he used both throughout his life. He too imitated

Wilson, and did so in both media: his finished watercolours of the late 1790s are highly Wilsonian, and so not far removed from Girtin's in mood and purpose. By that date he was also working regularly in oils, with a similar debt to the Welsh master. At this stage, however, he confined his use of bodycolour to experimental sketches.[17]

William Blake (1757–1827), whose concerns lay in very different fields from those of Girtin and Turner, illustrates the ferment of the time in quite another way. His subjects were rarely landscape, though like Coleridge he approached all experience with an intensity that found its natural expression in terms of the 'visionary'. More literally than Coleridge, he claimed to depend on visions for the imagery of the intricate mythological dramas that he recorded in both his paintings and his poetry. Equally visionary were the means he adopted to transcribe them. His dead brother Robert revealed to him in a dream the system of stereotype printing by which Blake produced his Prophetic Books; and some of his most ambitious works, the great colour-printed drawings that he was making about the same moment as Girtin and Turner were experimenting so fruitfully, use a related technique of printing and hand colouring that creates a richness of effect and density of tone precisely parallel to the performances of the landscapists (fig. 8).[18]

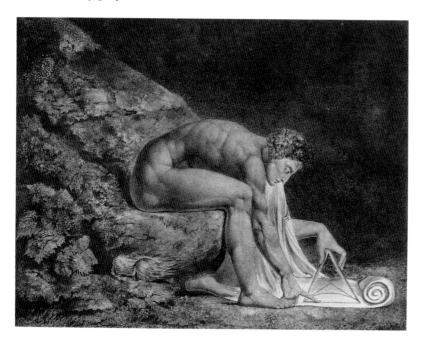

Fig. 8 William Blake, Newton, c. 1805 (first impression 1795), colour print finished in pen and watercolour, 46 x 60. Tate Gallery, London

Although his subject-matter was of the profoundest, and sometimes made use of fantastic and dreamlike landscapes, the bulk of Blake's later work, outside the Prophetic Books, is in pure watercolour – indeed, though entirely suited to his own needs, his methods were reactionary by 1810. Some other artists maintained the traditional techniques because their preoccupations did not require them to change. Thomas Rowlandson (1756–1827), who would never have claimed the highest intellectual status for his popular comic drawings, found the old washes, supported by ener-

getic pen outlines, congenial to his purposes throughout his life (pl. 69).[19]

Girtin retained one thing in common with the old guard: his methods were essentially simple, in conformity with the view of watercolour as a 'pure' medium, best tackled directly and rapidly. He applied his washes boldly, sometimes over a simple underpainting of gamboge or earth colour, the intention of which was not so much to differentiate tones as to unify the whole design – a significant change of function – and used little or no scratching and scraping away of the pigment layers. What Girtin achieved he achieved by the dexterous laying on of the wash, and by the grandeur of his initial conception. The finer points of description he left to calligraphic touches of brown colour applied with a fine brush, which he used to define details. His system was an eminently reproducible one, and was widely copied, adapted and reduced to simple formulas by the writers of watercolour manuals, which became the handbooks of a thousand amateurs. Turner, by contrast, evolved a technique unfathomable in its variety and complexity and subtle shades of expression; having been taught watercolour during the first decade of his career, he abandoned any attempt to do so, and moved further and further from the common practice, assuming more and more the role of miracle-worker, an inspiration rather than an example.[20]

Fig. 9 Martino Rota (fl. 1558–86) after Titian, *The Death of St Peter Martyr*, engraving, 29.4 x 37.5. Titian's original altarpiece of 1528–30 for SS Giovanni e Paolo, Venice, was destroyed by fire in 1867

Turner was not the only artist of the period to whom virtuoso powers were attributed. Indeed, sheer brilliance of execution became a characteristic of much Romantic art – the idea is summed up in the

'demonic' reputation of Paganini as a violinist. The greatness of Richard Parkes Bonington (1802–28) can be seen as resting primarily on his consummate manipulation of his materials – a pure technical control that leads on to Aestheticism. Even more notable is the magical draughtsmanship of John Sell Cotman (1782–1842), whose abstract invention in pure line, supported by infinitely subtle arrangements of colour, sets him apart from all his contemporaries in his approach to the very nature of picture-making. Beside him, Turner's attitudes to composition were, quite deliberately, conventional. On the other hand, Turner in the end combined the virtuosities of all the virtuosos of his time in a single astonishing achievement.

If Turner was moved to imitate Wilson in his early years, he quickly found other models. As a painter in oils as well as watercolours, he was avidly concerned to bring into his stylistic net a range of masters whose work was worthy of emulation, even of straight imitation. Titian and Claude were among the earliest and most enduring of these influences, and when, after Girtin's untimely death in 1802, Turner became the prime inspiration of the Society of Painters in Water-Colours (OWCS) that was founded two years later, both Titian and Claude featured largely as stimuli to its members.[21] Claude's position as the inventor of Ideal landscape painting was well enough understood; the status accorded to Titian reveals more tellingly the role that the water-colourists had cast themselves in. He was, pre-eminently, the master who had demonstrated the symbiotic relationship of the genres of landscape and history – he had painted landscape which 'tho natural is heroick' as Turner put it, analysing Titian's *Death of St Peter Martyr* in Venice (fig. 9).[22] Turner spoke – or wrote – as an oil painter on this occasion; but his interest comprehended watercolour, and the early members of the OWCS devoted much energy to establishing the principle that a heroic landscape, that is, one containing large-scale and significant figures, might be expressed in their medium. Joshua Cristall (1768–1847) often made single figures or groups the whole subject of his pictures, and as often incorporated them in landscapes that are either arcadian or idyllic recastings of the contemporary countryside. A primary inspiration was Nicolas Poussin (1593/4–1655; fig. 10), but it has been pointed out that in painting his idealising subjects Cristall was responding to an entirely modern fashion. His stalwart peasants resemble the figures in contemporary neo-Greek illustrations by artists such as Samuel Buck and Thomas Hope (pl. 289); and the arrival in London in 1808 of the Elgin Marbles, which so inspired painters like Benjamin Robert Haydon (1786–1846) and David Wilkie (1785–1841), must have had a profound influence on Cristall as well.[23] Thomas Heaphy (1775–1835), on the other hand, saw himself as continuing the Northern tradition, painting large-scale figures in cottage interiors that have nothing of the idyllic about them, but concentrate on vividly realistic still-life detail, and a dramatic, sometimes comic presentation of the psychology of his characters that depends heavily on the work in oils of Wilkie (fig. 11). Wilkie's reinterpretation of the Dutch genre tradition, from his first appearance, in 1805, at an Academy exhibition, put realistic rustic genre on a new footing (fig. 12), and began a movement that was to lead directly to the triumph of realist genre at the mid-century. So the Continental tradition of painting in oils became a crucial source for the new watercolour school, sometimes (as it was for Turner himself) through the medium of contemporary oil practice.

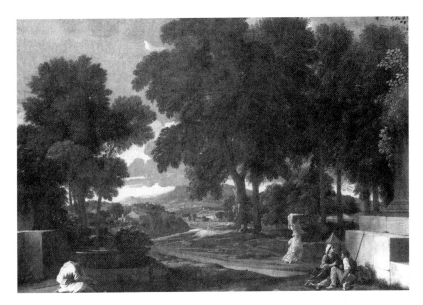

Fig. 10 Nicolas Poussin, *Landscape with a Man Washing his Feet at a Fountain*, c. 1648, oil on canvas, 74.5 x 100. National Gallery, London

The development distinguished the new generation of water-colourists sharply from those of the recent past who had been content to paint landscape views but to adventure no further. Now, watercolour had to be seen to be infinitely versatile, susceptible of no limitation either technical or conceptual. To Girtin's bold washes was added Turner's arsenal of effects, assiduously gleaned or guessed at by careful analysis of his exhibited works, since he divulged few clues even to his closest associates, and had a habit, even when he did vouchsafe a hint, of letting it out in a sort of code that was deliberately intended to be difficult for any but the genuinely gifted to understand.[24]

Fig. 11 Thomas Heaphy, *Fisherman's Cottage*, 1810, pencil and watercolour, 47 x 62.2. Laing Art Gallery, Newcastle upon Tyne

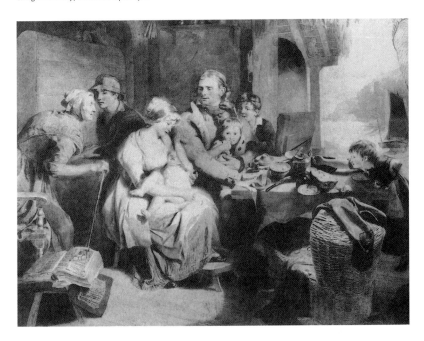

Turner may have begun by subscribing to the generalised Sublime style perfected by Girtin, but his broad and inquisitive interest in everything natural and human rapidly forced him to diversify his methods and to invent ever more ingenious techniques. He took the manipulation of washes on wet paper to the point at which they became an incomprehensible jumble of marks, and used sponging, stopping-out, scratching-out and blotting-out with exquisite refinement and deftness. The hatching that he had adopted from John Robert Cozens, and which was a technique quite alien to Girtin's system, became a staple that enabled him to transfer the grandest ideas onto the smallest sheets of paper, a miniature technique that treated the details of Nature as if they were the details of an individual face, characterful, subtle, never to be fixed in permanence (pl. 89).

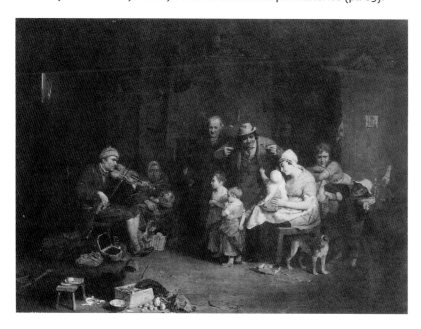

Fig. 12 David Wilkie, *The Blind Fiddler*, 1806, oil on canvas, 57.8 x 79.4. Tate Gallery, London

There was, then, a healthy opposition of approach and method between Turner and Girtin. Although so frequently thought of as 'twins' of the watercolour revolution, and although both were evangelists of the Sublime in landscape watercolour, they exemplified different principles, and exerted contrasting, and somewhat unexpected, influences. Through two of his most brilliantly inventive followers, David Cox and Peter De Wint (1784–1849), Girtin was the initiator of a development that led to a fullblown British impressionism in the 1840s and 1850s (pl. 234, 236). By contrast Turner, whose work as a watercolourist was known almost exclusively from his elaborate finished views – which contain important elements of the topographical tradition and, in particular, a strong emphasis on the role of the figure – became the progenitor (with John Ruskin as midwife) of High Victorian realist and Pre-Raphaelite landscape.

In practice, it is impossible to speak of either strand separately from the other. Much of what is thought of as a tight, hard Victorian realism is in fact often dedicated to the examination and reproduction of evanescent effects of atmosphere – of dappled sunlight, mist, cloud or spray. One of the most technically and visually adventurous of these 'Pre-Raphaelite'

artists, Alfred William Hunt (1830–96), took Turner as his supreme model and could quite easily devote a whole drawing to the study of a nebulous mist or a twilit shadow. An even younger artist, Albert Goodwin (1845–1932), often focused on the smooth surface of a stretch of weedy river or a band of morning haze along the sea-shore (pl. 320). What would for Turner have been only a part of a larger design can become for Hunt or Goodwin the self-sufficient subject of an elaborately finished work, heavy with moral overtones. Goodwin, in his self-dramatising diaries, wrote of 'a morbid liking for clouds' which are 'of the nature of *stain* on the clear heavens', with the rider, 'How impossible to see good without its shadow – evil'.[25] The Victorian landscape was a parable in which the patterns of Nature expressed the forces of human life. It could even take the form of a reflection of the artist's moral being.

Conversely, the breezy effects of light and air that foreshadow a much more apparently 'modern' approach to landscape in the work of Cox or Constable spring directly from the long-established impulse to observe and record precisely what nature presents to the eye. In the context of the ever-expanding scope of watercolour in the period, the two apparently contradictory streams, Pre-Raphaelitism and Impressionism, so clearly separate in the history of oil painting, can be seen as facets of the same development, a manifestation of the inherent ambiguity of the medium.

British watercolour, then, has stimulated a network of interacting experiments, trials and explorations that were made possible by the very nature and status of the medium. Empiricism was an integral part of the British temperament, and watercolour was the ideal vehicle for recording its progressing experience. In spite of its proud independence from oil painting, watercolour was from first to last a close sibling, appearing to follow but often leading in matters of expressive range and innovatory technique. The watercolourists' wish for an established position in the London art world was in no way at odds with their real independence of thought and originality of spirit. Their sheer virtuosity in expanding the technical capacity of the medium is alone a fact of primary significance. On this level, the innovatory brilliance of John Robert Cozens, Cotman or Cox must be seen in an international perspective if it is to be fully understood. But what gives that virtuosity its true importance is its close alliance with a wide-ranging content that draws its strength both from the intellect and from the emotions.

Much of the aesthetic evolution that worked itself out in Europe in the eighteenth and nineteenth centuries is adumbrated in the work of the watercolourists. The heightened value attached to form and colour in twentieth-century aesthetics can be traced to their innovations. Few artists in Europe were as sophisticated as Cotman in the handling of pure form, or as expressive as the young Palmer in its manipulation for emotional purposes. Constable and Cox explored the physical qualities of air and sky with unprecedented insight. Turner married the poetic grandeur he had imbibed in the eighteenth century from J. R. Cozens with the minutest observation of a range of natural phenomena never before discussed in art. The Victorians developed all these ideas in a perception of landscape that was a yet further development, a blend of poetry and pragmatism, of pure aesthetics and careful science. It arose out of, and responded to, the first period in history when technology threatened the natural world with extinction. Nature was injected with a new poignancy, and emerged as a fresh and urgent metaphor for the lot of humanity.

The institutionalisation of watercolour in nineteenth-century London was a measure of its status and of its estimated contribution to the national culture. If its biossom was splendid, its roots ran deep. Most of the members of the watercolour societies were teachers, and for every artist who exhibited professionally with the societies, there were dozens who pursued humble careers as drawing-masters to the gentry. The amateurs that this great force instructed, either directly or through the medium of published manuals, were legion. They were by no means confined to young ladies and maiden aunts; the activity was a highly respectable one for everybody, and was growing in popularity for much of the early nineteenth century, as the complaint of Thomas Uwins (1782–1857) from Rome in 1830 makes clear: 'What a shoal of amateur artists we have got here! I am old enough to remember when Mr Swinburne and Sir George Beaumont were the only gentlemen who conde-scended to take a brush in hand, but now gentlemen painters rise up at every step and go nigh to push us from our stools.'[26]

The amateur provides, as Vaughan Williams has said in another context, the loam from which great art can grow,[27] and this was never more true than in the case of watercolour. The machinery by which talent emerged from this social and economic structure can be seen in the opera-tion of the regional schools of watercolour. In Exeter, for instance, a group of artists received their training and their inspiration from the teaching of Francis Towne (1740–1816), whose style they all imitated. One of them, John White Abbott (1763–1851), became a considerable figure on his own account while never shaking off the characteristic mannerisms of Towne (pl. 133). In Norwich, first John Crome (1768–1821) and then Cotman, with contrasting approaches and methods, disseminated a technical and aesthetic sense that has had an enduring influence on the way we perceive the landscape of East Anglia. Two great ports, Bristol and Newcastle upon Tyne (pl. 71, 282), stimulated significant local schools, and from both cen-tres emerged major as well as highly talented secondary figures. These observations can be made despite the fact that, inevitably, London, with its academies and its wider market attracted many of the more accom-plished artists.

If watercolour in Britain has been immeasurably enriched by the armies of amateurs who have practised it, it has been bedevilled as an art-historical subject by so amorphous and intractable a context. The tradi-tional practice of oil painters throughout Europe, working professionally on technically complex projects with studio assistants who were them-selves professionals either actually or potentially, has had the effect of limiting the field of research to a relatively compact and definable, albeit often large, body of practitioners. Watercolour, taught throughout Britain by itinerant or local masters as the accomplishment of almost every member of the upper social classes above the age of fifteen, comprehends a vast mass of work that ranges from the abysmal to the inspired. The penumbra of each professional may consist of drawings by others virtually indistinguishable from his own, of drawings executed partly by him and partly by a pupil, and of independent work more or less recognisable as having been derived from his. The pressure on artists even of high calibre to produce run-of-the-mill examples, for copying purposes, or to augment an exiguous wage, was often great. The very nature of watercolour practice encouraged repetition. Turner, as is well known, operated a kind of produc-tion line, having many sheets going simultaneously, washed with

preliminary colour grounds and hung up on lines to dry or part-dry, like laundry.[28] The steady application of layers of colour to a sheet of paper brought to the requisite degree of moistness or dryness meant that the process required delays, and it was more efficient to work on a group of sheets together than to finish each one individually. The effects of this method are quite evident in Turner's output, although he was able to maintain an astonishing degree of freshness and originality from one composition to the next. Other, lesser artists inevitably concealed the artifice with less skill, and even the best of them can be accused of over-production. The proliferation of minor examples, the application *ad nauseam* of compositional formulas, which were disseminated by means of potboiling manuals and eagerly adopted by the amateurs – all these factors have made it difficult for any but *aficionados* and specialist connoisseurs to find their way through the vast mass of material, to identify the significant threads and follow them through to some meaningful art-historical judgement. All this has only confirmed the view, assiduously propagated by the British themselves, that watercolour is of local and national interest only, hardly deserving of consideration in the wider international context. It may be added that the intrinsic charm of most watercolour, its cheerful palette and congenial subject-matter, while recommending it to collectors, has obscured the importance of its intellectual content and its aesthetic significance in the history of European art.

Perhaps the greatest obstacle to the understanding of watercolour is the problem of condition. Any painting is subject to change, to chemical alteration, to damage and to inappropriate cleaning or restoration. Watercolour is vulnerable to all these things, but most of all to the effects of light on its pigments, which far more than oil paints are liable to complete chemical modification under the influence of ultra-violet rays. The indigo blue that is so vital a component of many landscapes has been particularly fugitive, and its loss has reduced most greens, as well as blues, to a dull brown or pink. Where other pigments have survived unchanged, their relationship to the tonal and chromatic scheme of the work as a whole has been hopelessly distorted. Crisply defined forms have become vague; subtleties of lighting are annihilated, sunshine and shadow alike turned to a feverish, or pallid, twilight. The great developments in watercolour manufacture that accompanied the expansion of the art in the early nineteenth century only contributed to the problem, for many of the new, experimental pigments were even more unstable than the traditional ones.

The difficulty was unimportant as long as watercolour drawings were kept in portfolios or albums, as many were in the eighteenth century; but it was in the very nature of the reformed watercolour painting of the early nineteenth century that it should be given more prominence: that was, after all, what the watercolourists themselves wanted. Watercolour paintings were to be framed and hung in a good light. Many collectors at that time were perfectly well aware of the dangers. Smaller works were often equipped with fine gilt frames fitted with green silk blinds, which were religiously drawn down when the watercolour was not being examined. But the larger pictures rarely had this benefit and few artists seem to have taken precautions to ensure that their owners were properly advised. Throughout the second half of the nineteenth century John Ruskin, among others, was warning watercolour owners of the risks of exposure to light, and as late as the 1880s was having to argue his case against a determined opposition – there have always been those who refuse to believe, or to

care, that watercolours can be destroyed by this form of neglect.[29] Yet it is almost impossible now to see the more important finished work of some leading figures of the school: for instance, the larger watercolours of John Glover (1767–1849), a prolific early member of the OWCS (pl. 211), hardly survive to be studied.

In Europe, British watercolour, like British painting in general, is known only by isolated examples, and those not necessarily of high quality or in good condition. In keeping with its popular character as an essentially intimate medium, watercolour still thrives in private collections, and that is a highly desirable state of affairs, though the proviso must be added that private collections are the least susceptible of the kinds of control needed to ensure the conservation of works in the best condition. The more important the work, the more vulnerable it is: it is required for display and decoration, and needs a 'good light'; it is attractive to dealers and collectors alike. Watercolour, unlike oil painting, cannot be 'retouched' successfully. Like fading, overcleaning is permanent and disastrous.

These problems should not discourage collectors: it is possible to distinguish the fresh from the faded, and, with some practice, the pristine from the overcleaned. Watercolours can be kept in low light and still enjoyed. The old-fashioned system of blinds or easily removable covers is an excellent one; indeed it is ideal, for it combines the possibility of unlimited light on the work while it is being viewed, and total darkness at other times. But a due awareness of the dangers may help those who appreciate the watercolour as an art form to understand that, like all forms of art, it requires knowledgeable handling. It is as delicate, in its way, as porcelain; but its content is as robust as the greatest of Western painting. In this, as in so much else, it is characteristically ambiguous.

A.W.

1 W.H. Pyne [Ephraim Hardcastle], ed., *Somerset House Gazette, and Literary Museum*, 2 vols, London 1824, II, p. 45.

2 A valuable study of the impact of the Grand Tour on British landscape artists in the later eighteenth century is *Travels in Italy, 1776–1783: Based on the 'Memoirs' of Thomas Jones,* exh. cat. by F. W. Hawcroft; Manchester, Whitworth Art Gallery, 1988. The evolution of artists' vision of the Alps is surveyed in D. Helsted, ed., *Maegtige Schweiz: Inspirationer fra Schweiz, 1750–1850,* Copenhagen 1973.

3 See *The Arrogant Connoisseur: Richard Payne Knight, 1751–1824,* exh. cat. by M. Clarke & N. Penny; Manchester, Whitworth Art Gallery, 1982, pp. 20–31.

4 A recent study of Ducros is *Images of the Grand Tour: Louis Ducros, 1748–1810,* exh. cat. by P. Chessex *et al.,* London, The Iveagh Bequest, Kenwood; Manchester, Whitworth Art Gallery; Lausanne, Musee Cantonal des Beaux-Arts; 1985–6. See also D. Cutajar, ed., *Louis Ducros in Malta,* Valletta 1989.

5 A general survey of the fine arts in eighteenth-century Britain is W. T. Whitley, *Artists and their Friends in England, 1700–1799,* 2 vols, London 1928. The foundation of the Royal Academy is discussed in detail in S. C. Hutchison, *The History of the Royal Academy, 1768–1968,* London 1968, especially ch. IV.

6 See *Painters and Engraving: The Reproductive Print from Hogarth to Wilkie,* exh. cat. by D. Alexander & R.T Godfrey; New Haven, Yale Center for British Art, 1980, especially pp. 24–5.

7 See A. Griffiths, 'Prints after Reynolds and Gainsborough', *Gainsborough and Reynolds in the British Museum,* exh. cat. by T. Clifford, A. Griffiths & M. Royalton-Kisch; London, British Museum, 1978; and *Painters and Engraving,* pp. 35–6.

8 James Stuart, *The Antiquities of Athens,* I, London 1762, p. viii.

9 From lines written in 1798 as a possible conclusion to *The Ruined Cottage;* quoted in S. Gill, *William Wordsworth: A Life,* Oxford 1989, p. 496.

10 *The Collected Letters of Samuel Taylor Coleridge,* ed. E. L. Griggs, Oxford 1956–71, I, pp. 397–8.

11 Immanuel Kant, *Kritik der Urteilskraft,* Berlin 1790, trans. J. H. Bernard as the *Critique of Judgement,* 1931, p. 125.

12 'Lines Composed a Few Miles above Tintern Abbey' *(Lyrical Ballads,* 1798), *The Poems,* ed. J. O. Haydon, Harmondsworth 1977, I, p. 360, l. 91.

13 An assessment of the significance of Byron's *Childe Harold* for landscape painters, and especially Turner, has been made in *Turner and Byron,* exh. cat. by D. B. Brown; London, Tate Gallery, 1992.

14 *The Letters of Samuel Palmer,* ed. R. Lister, Oxford 1974, I, p.516.

15 J. Farington, *The Diary,* ed. K. Garlick, A. Macintyre & K. Cave, London 1978–84, III, p. 1090. The relevant part of the entry for 12 November 1798 reads: 'Turner & Girtin told us they had been employed by Dr Monro 3 years to draw at his house in the evenings. Girtin drew in outlines and Turner washed in the effects. They were chiefly employed in copying the outlines or unfinished drawings of Cozens &c &c of which copies they made finished drawings. Dr Monro allowed Turner 35. 6d. each night. – Girtin did not say what he had.' The complicated literature is summarised in A. Wilton, 'The "Monro School" Question: Some Answers', *Turner Studies,* IV/2, 1984, pp. 8–23.

16 The most thorough attempt to define Girtin's achievement, stressing his 'high seriousness', is T. Girtin & D. Loshak, *The Art of Thomas Girtin,* London 1954.

17 Examples of Turner's early use of bodycolour are to be found in his *Wilson* sketchbook of *c.* 1797, TB XXXVI. See *J. M. W. Turner: The 'Wilson' Sketchbook,* with an Introduction by A. Wilton, 1988. A later insight into Turner's attitude to the 'permanent white' pigment that became an increasingly prominent feature of nineteenth-century watercolour is given in J. C. Horsley, *Recollections of a Royal Academician,* 1903, p. 241, where the landscape painter is recorded as saying to J. D. Harding and David Roberts: 'If you fellows continue to use that beastly stuff you will destroy the art of water-colour painting in our country'.

18 Blake's intentions were characteristically complex. They cannot easily be explained by generalisations that apply to his contemporaries. The background to his technical experiments in the 1790s is discussed in D. Bindman, *Blake as an Artist,* Oxford 1977, pp. 28–48.

19 A recent survey is J. Hayes, *Rowlandson: Watercolours and Drawings,* Oxford 1972.

20 The watercolour techniques adopted by Turner in different contexts were discussed and described by Ruskin on various occasions, primarily as guidance for other artists. His intention in making such careful descriptions was no doubt at least partly to dispel, but partly to enhance, the 'miraculous' aspect of Turner's art.

21 The foundation of the OWCS is recounted at length in J. L. Roget, *A History of the 'Old Water-ColourSociety'* now the Royal Society of Painters in Water-Colours, London 1891, 1, p. 125 ff. A more recent account is M. Spender, *The Glory of Watercolour,* London 1987.

22 In the *Studies in the Louvre* sketchbook, TB LXXII, p. 28a. See A. J. Finberg, *A Complete Inventory of the Drawings of the Turner Bequest,* London 1909, 1, p. 184.

23 See *Joshua Cristall (1768–1847),* exh. cat. by B. Taylor; London, Victoria & Albert Museum, 1975, pp. 26–7. The *Magazine of the Fine Arts for* 1821 said of Cristall's *Jupiter Nursed in the Isle of Crete by the Nymphs and Corybantes:* 'It is impossible not to compare it with some of the works of Poussin; but there is in the production of these two artists a difference in favour of Cristall... [;] Poussin... in too many instances painted *Sculpture.* Cristall learnt to see nature in the same point of view in which the ancients contemplated her...' *(Joshua Cristall,* p. 34).

24 'In teaching generally, he [Turner] would neither waste his time, nor spare it; he would look over a student's drawing, at the Academy, – point to a defective part, make a scratch on the paper at the side, saying nothing; if the student saw what was wanted, and did it, Turner was delighted, and would go on with him giving hint after hint; but if the student could not follow, Turner left him... Explanations are wasted time. A man who can see, understands a touch; a man who cannot, misunderstands an oration.' (John Ruskin, *The Works,* ed. E. T. Cook & A. Wedderburn, London 1903–12, VII, p. 441).

25 Albert Goodwin, *Diary* (12 October 1909), privately printed 1934.

26 *A Memoir of T. Uwins, R. A., by Mrs Uwins,* London 1858, II, p. 251.

27 Ralph Vaughan Williams, *Some Thoughts on Beethoven's Choral Symphony, with writings on other musical subjects,* Oxford 1953, p. 170.

28 *The Athenaeum,* 1894, p. 327.

29 A curious and detailed discussion of the problem (concluding that light does not usually damage watercolours) is to be found in B. Webber, *James Orrock: Painter, Connoisseur, Collector,* 1903, II, ch. XVIII–XX.

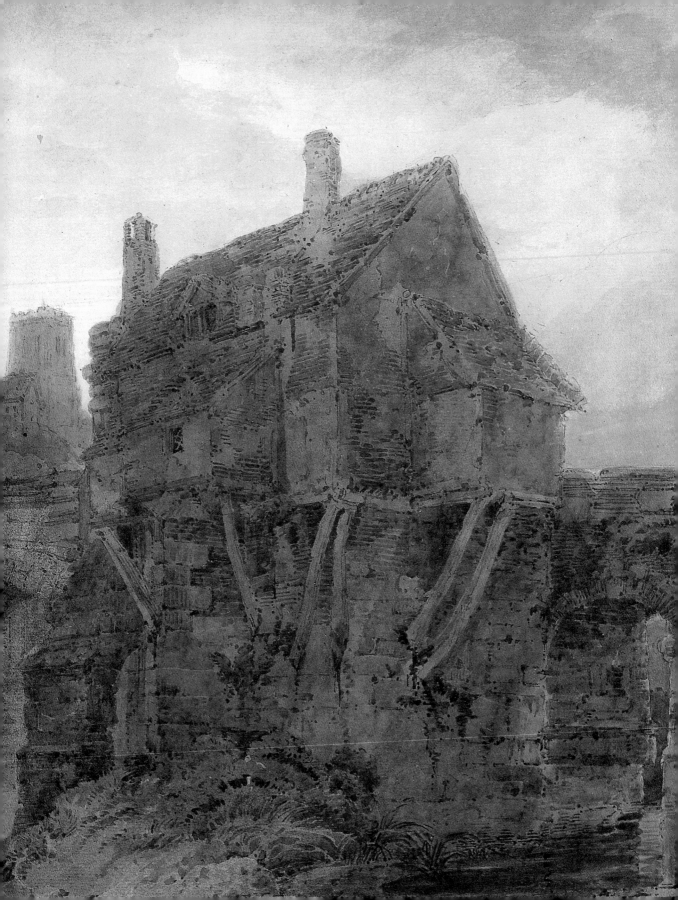

I

THE STRUCTURE OF LANDSCAPE: EIGHTEENTH-CENTURY THEORY

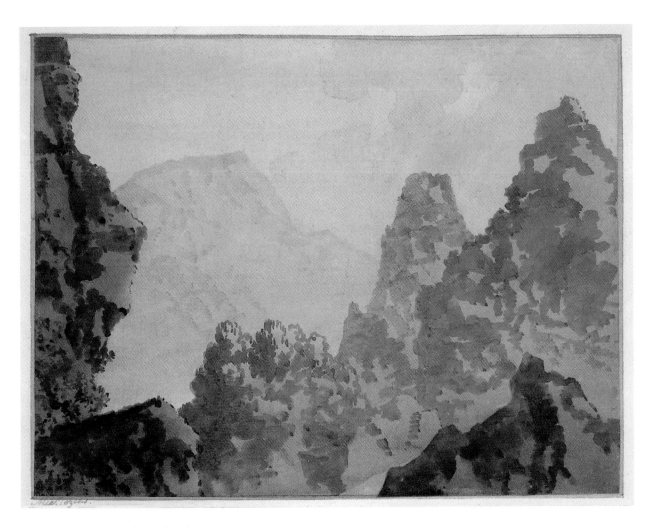

1 Alexander Cozens, *Mountain Peaks*, c. 1785 (cat. 82)

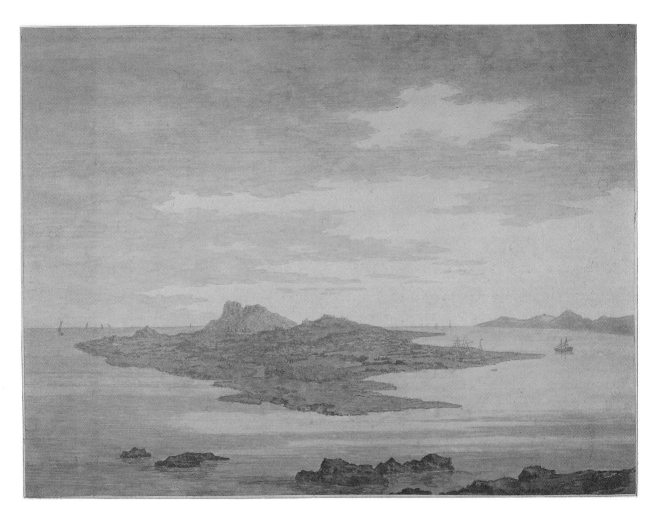

2 Alexander Cozens, *A Rocky Island*, c. 1785 (cat. 83)

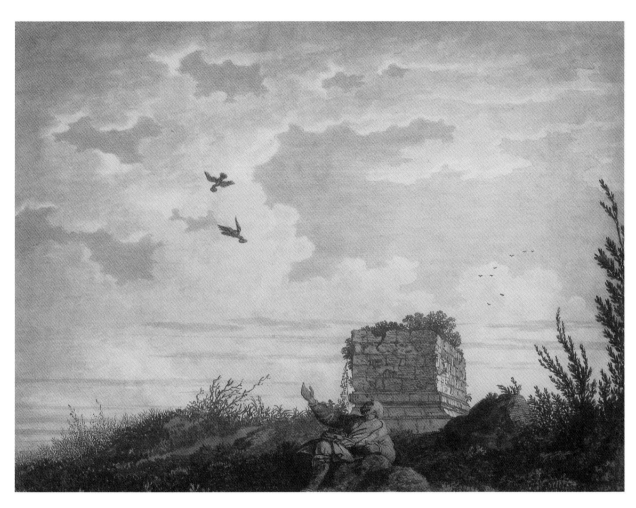

3 Alexander Cozens, *The Prophet Elijah Fed by Ravens*, c. 1765 (cat. 80)

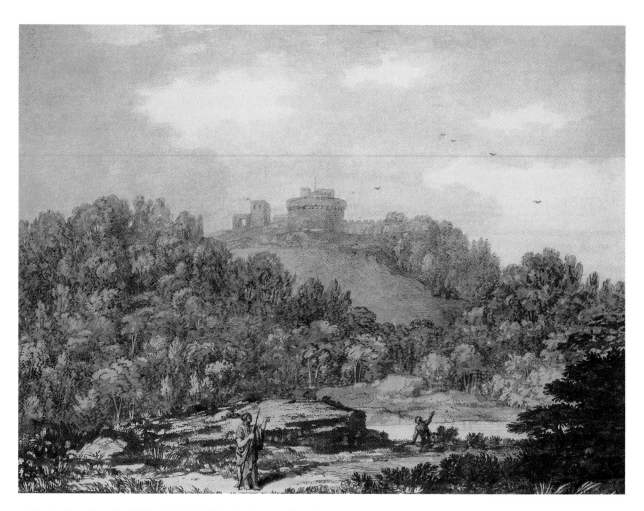

4　Alexander Cozens, *Figures by a Pool below a Fortress in an Italianate Landscape*, c. 1765 (cat. 79)

5 Alexander Cozens, *Mountain Landscape with a Hollow*, c. 1785, (cat. 84)

6 William Gilpin, *A View into a Winding Valley*, c. 1790 (cat. 137)

7 Alexander Cozens, *A Villa by a Lake*, (?) c. 1770 (cat. 81)

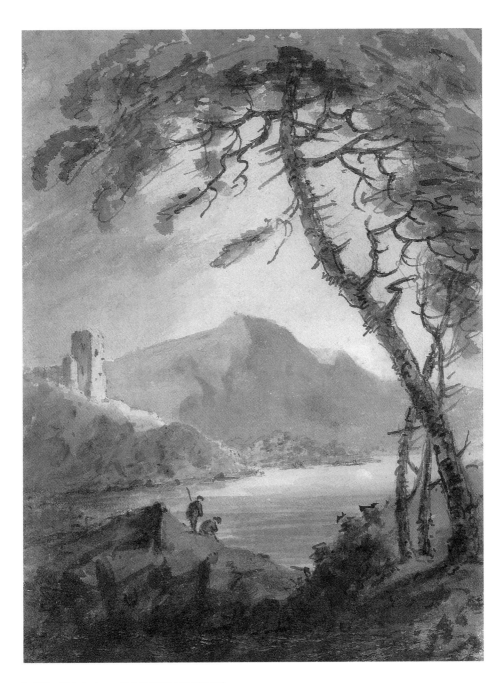

8 William Gilpin, *Landscape with Ruined Castle*, c. 1790 (cat. 136)

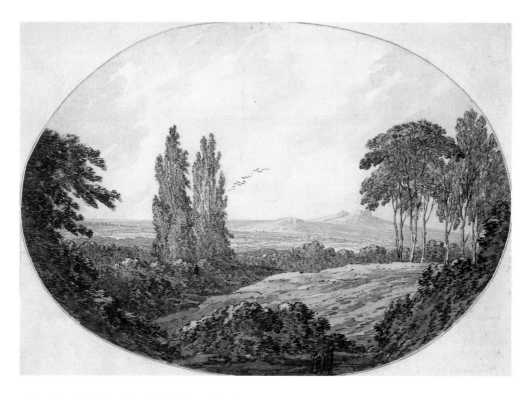

9 Richard Cooper Jnr, *Landscape: Trees and Rocky Hills*, c. 1780 (cat. 36)

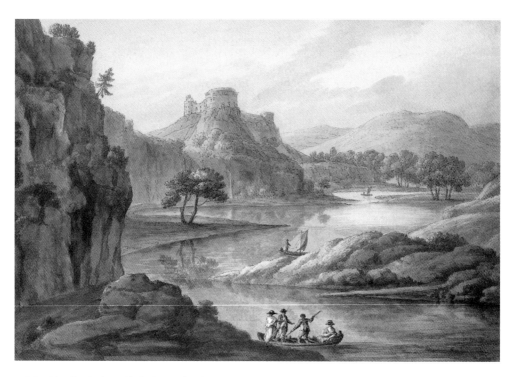

10 Robert Adam, *River Landscape with a Castle*, c. 1780 (cat. 2)

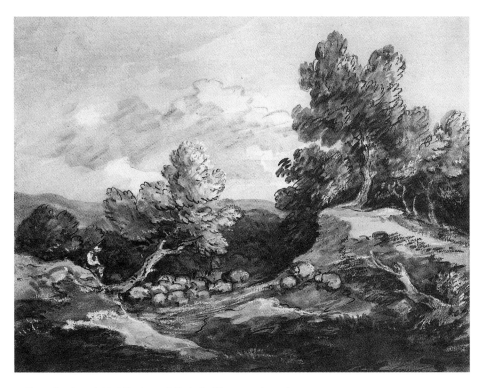

11 Thomas Gainsborough, *Wooded Landscape with Shepherd and Sheep*, c. 1780 (cat. 133)

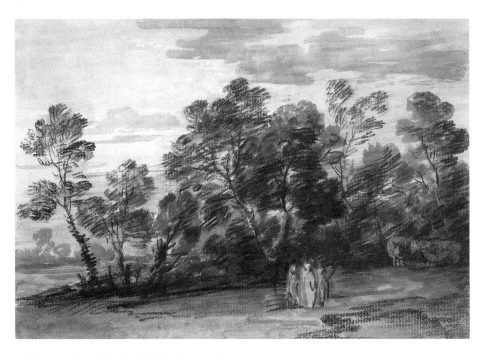

12 Thomas Gainsborough, *Figures in a Wooded Landscape*, c. 1785 (cat. 134)

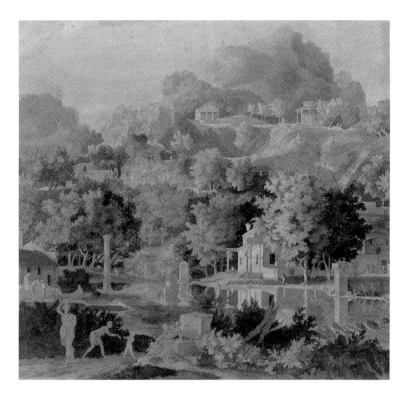

13 James Deacon, *Landscape Fantasy*, 1740–3 (cat. 107)

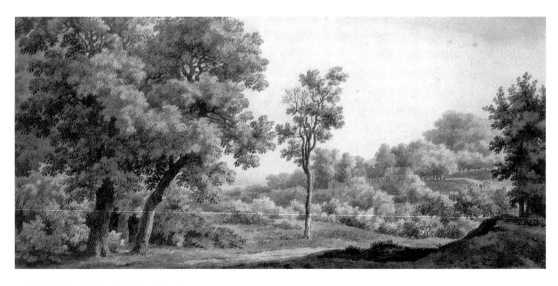

14 Jonathan Skelton, *In Greenwich Park*, 1757 (cat. 263)

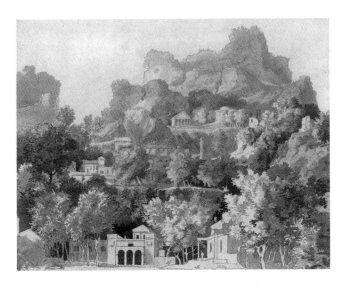

15 James Deacon, *Rocky Landscape with Classical Buildings*, 1745–50 (cat. 108)

16 Michael 'Angelo' Rooker, *Entrance to a Park*, (?) c. 1790 (cat. 240)

17 Francis Towne, *Naples: A Group of Buildings Seen from an Adjacent Hillside*, 1781 (cat. 270)

18 Francis Towne, *Head of Lake Geneva from Vevay*, 1781 (cat. 273)

19 Francis Towne, *Pantenbruck*, 1781 (cat. 274)

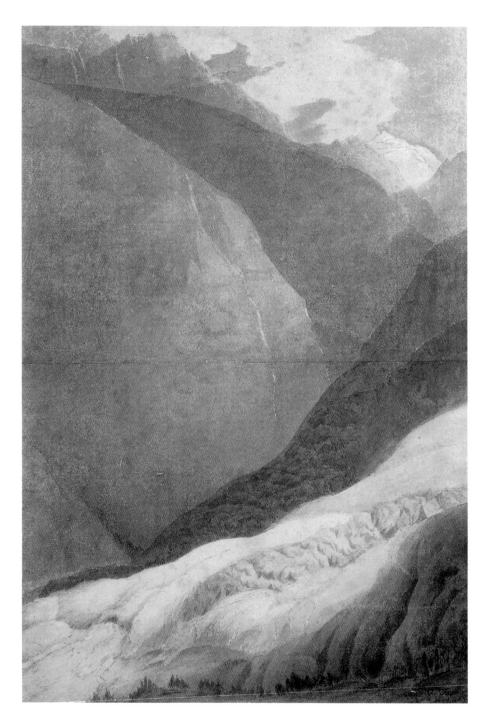

20 Francis Towne, *The Source of the Arveiron*, 1781 (cat. 272)

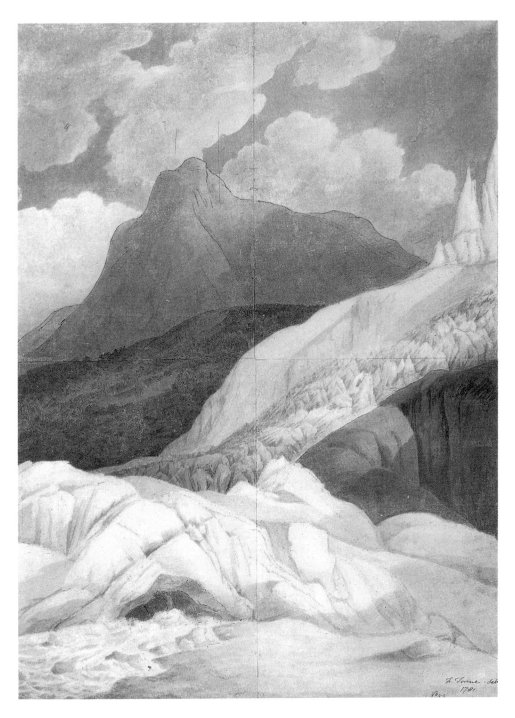

21 Francis Towne, *The Source of the Arveiron: Mont Blanc in the Background*, 1781 (cat. 271)

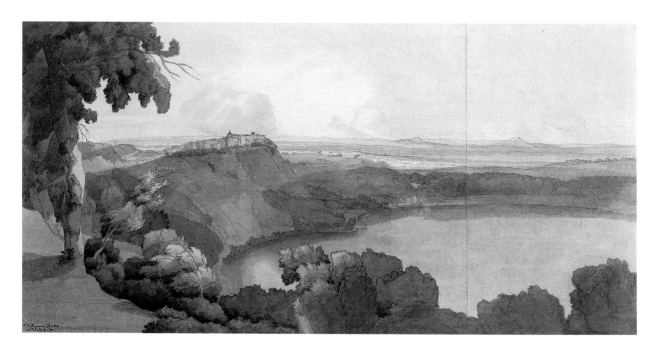

22 Francis Towne, *Lake Albano with Castel Gandolfo*, 1781 (cat. 269)

23 Francis Towne, *A View at the Head of Lake Windermere*, 1786 (cat. 275)

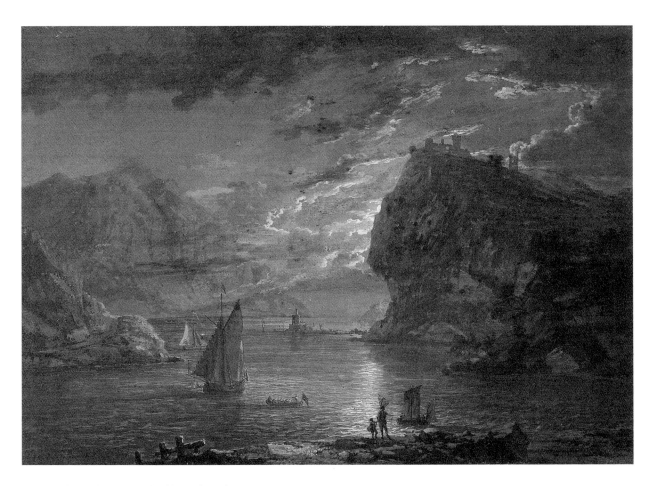

24 Paul Sandby, *A Rocky Coast by Moonlight*, (?) c. 1790 (cat. 255)

25 John Robert Cozens, *The Reichenbach between Grindelwald and Oberhaslital, c.* 1776 (cat. 85)

26 John Robert Cozens, *Interior of the Colosseum,* 1778 (cat. 87)

27 John Robert Cozens, *Cetara, on the Gulf of Salerno*, 1790 (cat. 94)

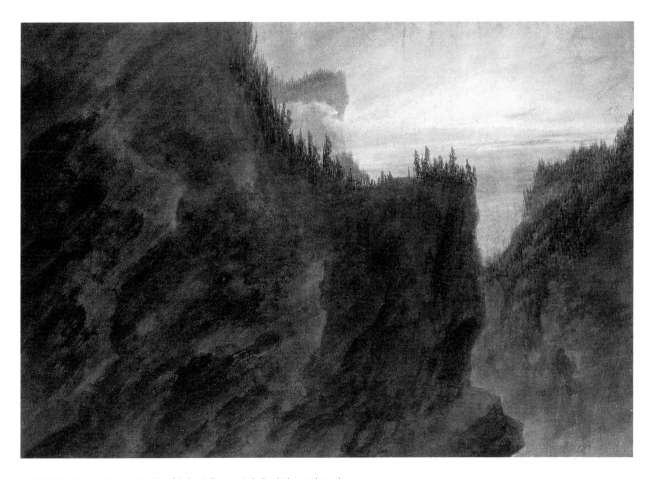

28　John Robert Cozens, *Entrance to the Valley of the Grande Chartreuse in the Dauphiné*, c. 1783 (cat. 90)

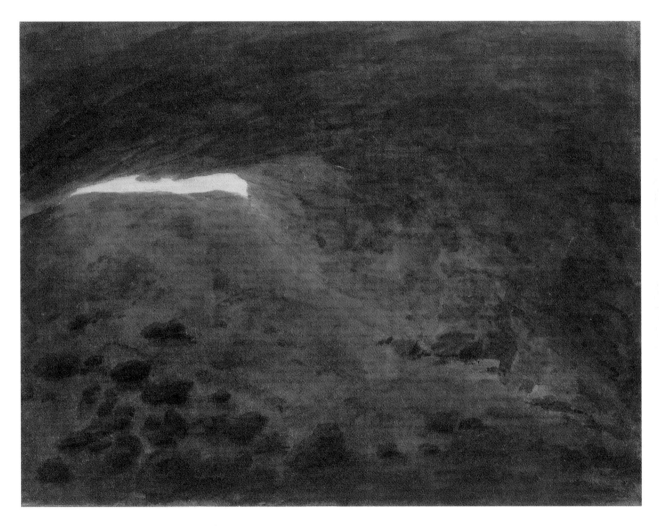

29 John Robert Cozens, *Cavern in the Campagna*, 1778 (cat. 86)

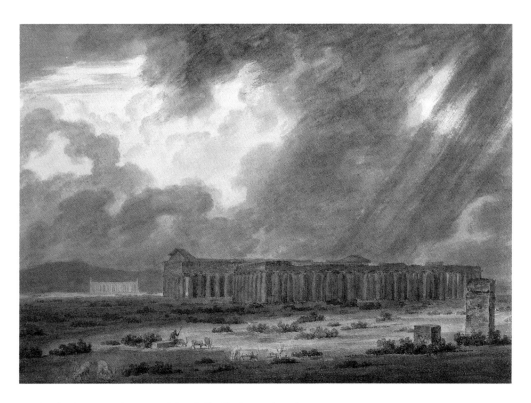

30　John Robert Cozens, *Ruins of Paestum, near Salerno: The Three Temples*, c. 1782 (cat. 88)

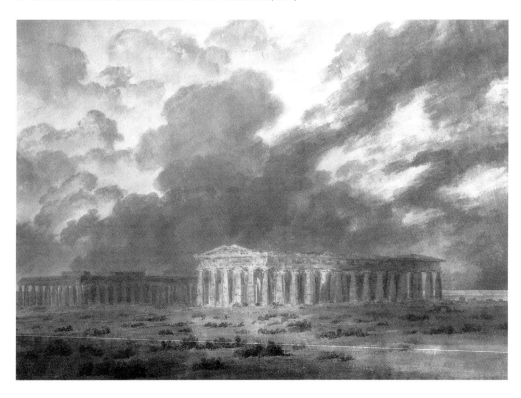

31　John Robert Cozens, *The Two Great Temples at Paestum*, c. 1782 (cat. 89)

32 John Robert Cozens, *Florence from a Wood near the Cascine*, c. 1785 (cat. 91)

33 John Robert Cozens, *Lake Albano and Castel Gandolfo*, c. 1790 (cat. 92)

34 John Robert Cozens, *Lake Albano and Castel Gandolfo – Sunset*, c. 1790 (cat. 93)

35 Joseph Mallord William Turner, *View across Llanberis Lake towards Snowdon*, c. 1799 (cat. 280)

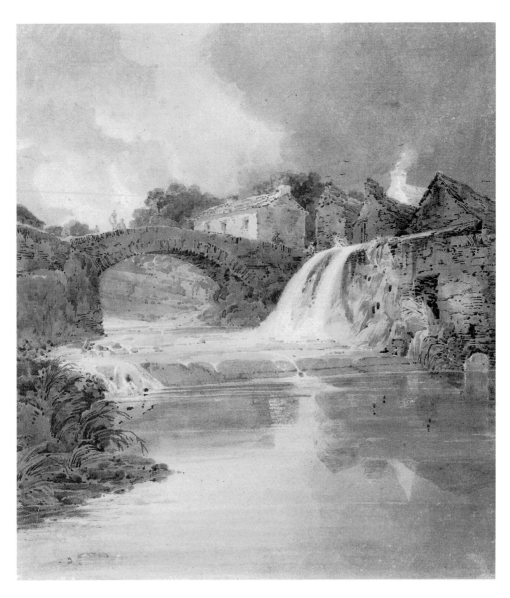

36 Thomas Girtin, *Hawes, Yorkshire*, 1800 (cat. 141)

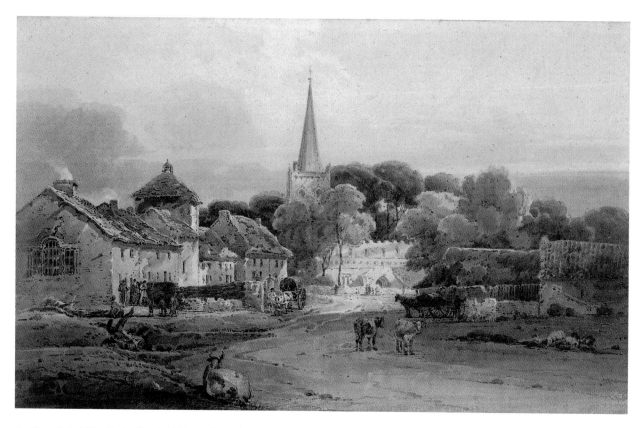

37 Thomas Girtin, *A Village Street and Church with Spire*, 1800 (cat. 144)

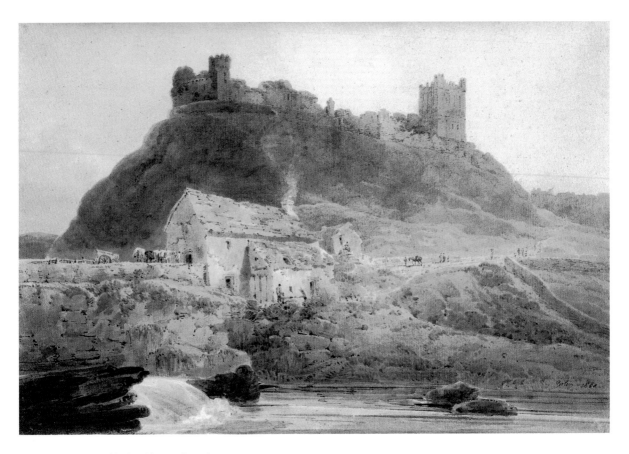

38 Thomas Girtin, *Richmond Castle, Yorkshire*, 1800 (cat. 145)

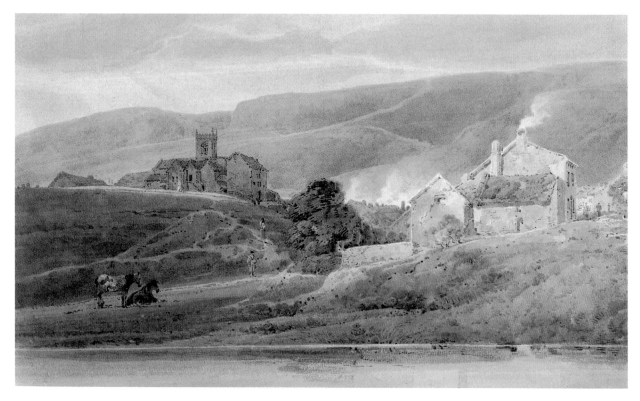

39 Thomas Girtin, *Ilkley, Yorkshire, from the River Wharfe*, c. 1801 (cat. 150)

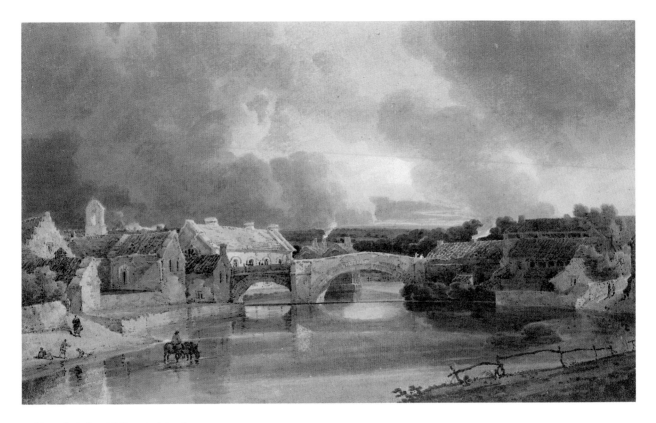

40 Thomas Girtin, *Morpeth Bridge*, c. 1802 (cat. 154)

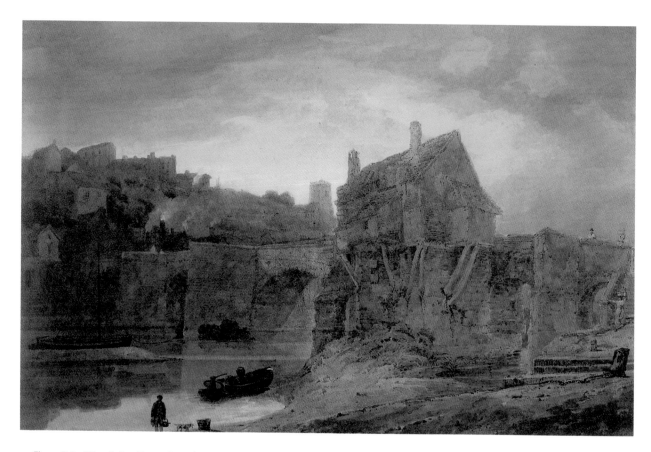

41 Thomas Girtin, *Bridgnorth, Shropshire*, 1802 (cat. 152)

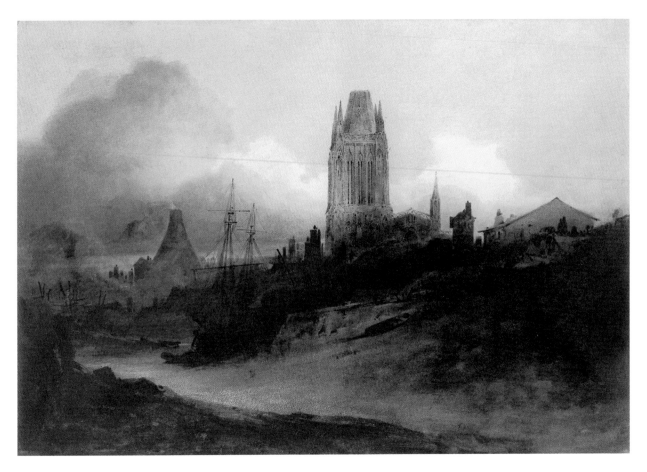

42 John Sell Cotman, *St Mary Redcliffe, Bristol: Dawn*, c. 1802 (cat. 38)

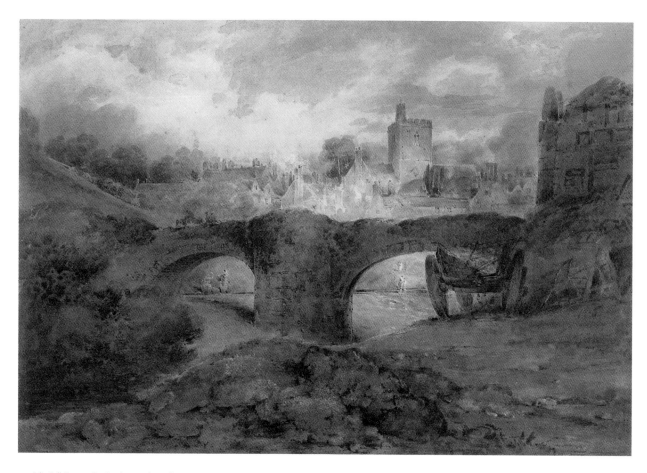

43 John Sell Cotman, *Brecknock*, c. 1801 (cat. 37)

44 John Sell Cotman, *Bedlam Furnace, near Ironbridge, Shropshire*, 1802–3 (cat. 39)

45 John Sell Cotman, *Croyland Abbey, Lincolnshire*, c. 1804 (cat. 40)

46 John Sell Cotman, York: The Water Tower, 1804 (cat. 41)

47 John Constable, *View in Langdale*, 1806 (cat. 26)

II

MAN IN THE LANDSCAPE: THE ART OF TOPOGRAPHY

48 Paul Sandby, *Horsefair on Bruntsfield Links, Edinburgh in the Background*, 1750 (cat. 249)

49 Thomas Sandby, *The Camp on Cox Heath*, (?) 1754 (cat. 260)

50 Thomas Sandby, *Windsor, from the Lodge Grounds in the Great Park*, early 1750s (cat. 259)

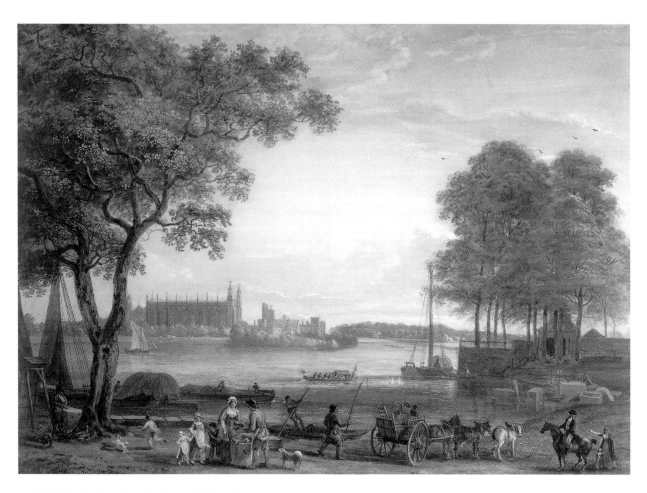

51 Paul Sandby, *View of Eton College from the River*, c. 1790 (cat. 256)

52 Paul Sandby, *Windsor: The Curfew Tower from the Horseshoe Cloister, Windsor Castle*, c. 1765 (cat. 252)

53 Paul Sandby, *Windsor: View of the Ascent to the Round Tower, Windsor Castle*, c. 1770 (cat. 253)

54 Paul Sandby, *Windsor: The Lodge Kitchen at Sandpit Gate*, c. 1751 (cat. 251)

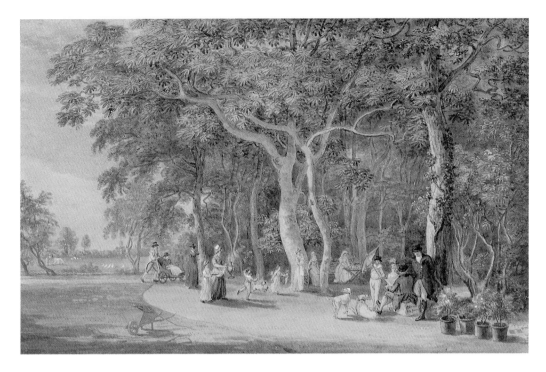

55 Paul Sandby, *Tea at Englefield Green, near Windsor,* c. 1800 (cat. 258)

56 William Pars, *A Picnic Party in Ireland,* 1771 (cat. 232)

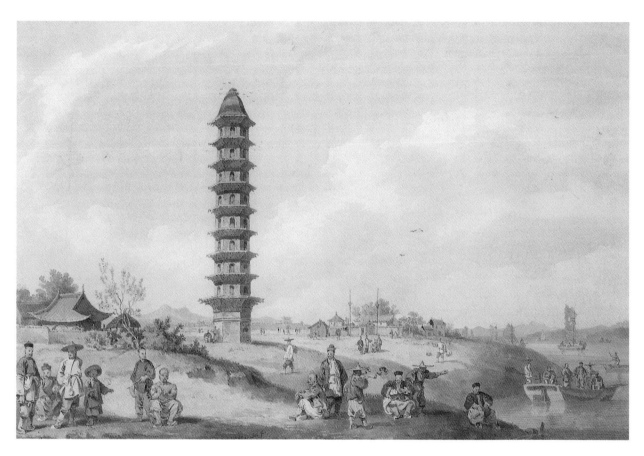

57 William Alexander, *The Pagoda of Lin-ching-shih, on the Grand Canal, Peking*, c. 1795 (cat. 3)

58　William Pars, *A Ruin near the Port of Aegina*, c. 1766 (cat. 231)

59 James 'Athenian' Stuart, *Athens: The Monument of Philopappos*, c. 1755 (cat. 266)

60 James 'Athenian' Stuart, *Salonica: The Incantada or Propylaea of the Hippodrome*, c. 1755 (cat. 267)

61 Allan Ramsay, *Study of Part of the Ruins of the Colosseum*, 1755 (cat. 235)

62 John 'Warwick' Smith, *Study of Part of the Interior of the Colosseum*, 1776 (cat. 265)

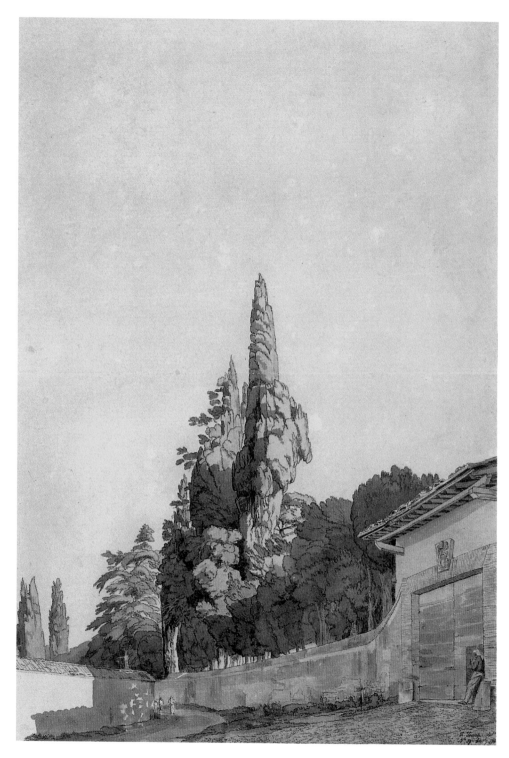

63 Francis Towne, *Rome: A Gateway of the Villa Ludovisi*, 1780 (cat. 268)

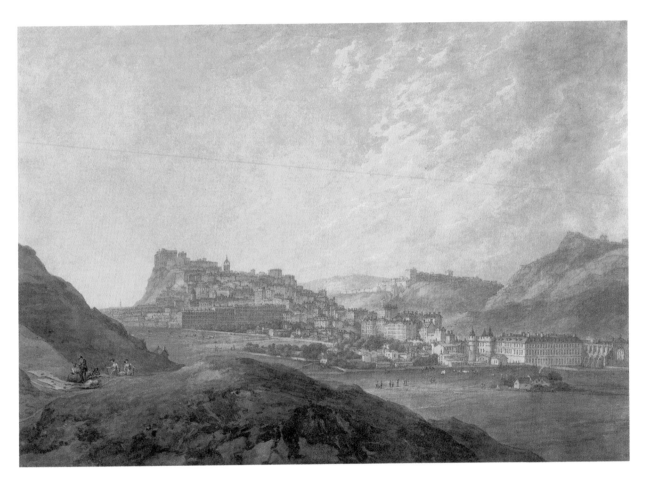

64 Thomas Hearne, *Edinburgh Castle from Arthur's Seat*, c. 1778 (cat. 163)

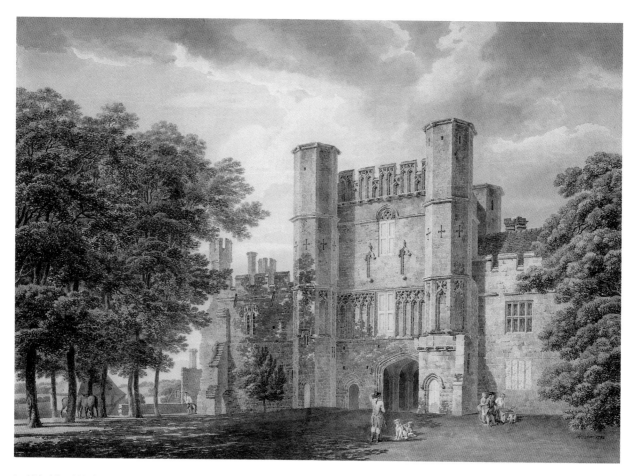

65 Michael 'Angelo' Rooker, *The Gatehouse at Battle Abbey, Sussex*, 1792 (cat. 241)

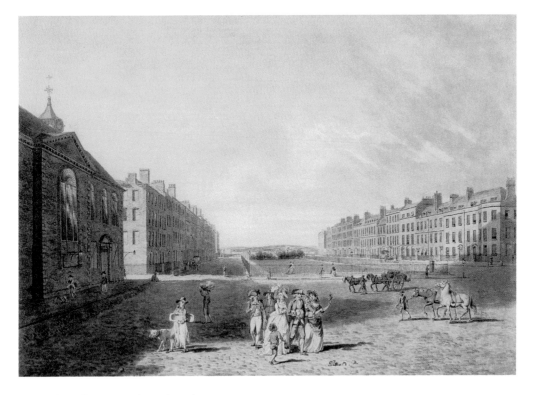

66 Edward Dayes, *Queen Square, London*, 1786 (cat. 106)

67 Thomas Malton Jnr, *St Paul's Church, Covent Garden, London, from the Piazza*, c. 1787 (cat. 209)

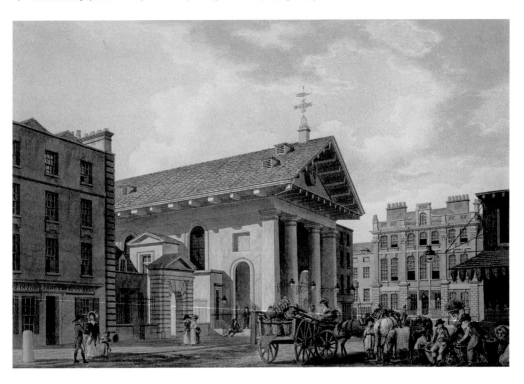

68 Joseph Mallord William Turner, *The Pantheon, Oxford Street, London*, 1792 (cat. 277)

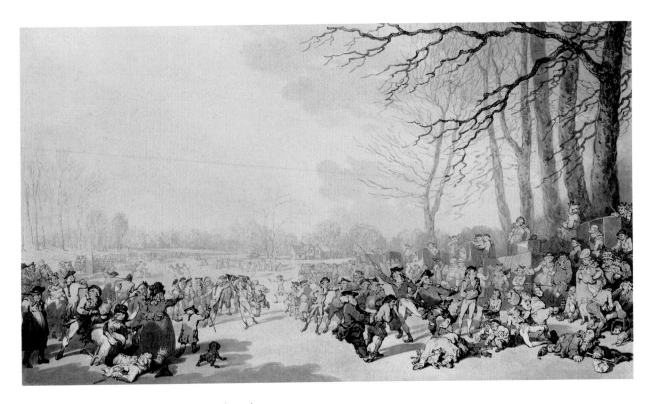

69 Thomas Rowlandson, *London: Skaters on the Serpentine*, 1784 (cat. 243)

70 Joseph Mallord William Turner, *Wolverhampton, Staffordshire*, 1796 (cat. 278)

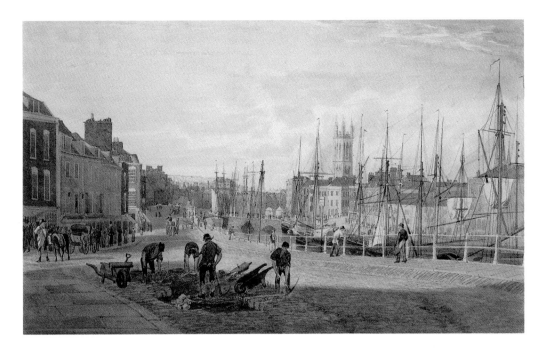

71 Samuel Jackson, *Bristol: St Augustine's Parade*, c. 1825, (cat. 188)

72 John Varley, *Market Place at Leominster, Hereford*, 1801 (cat. 316)

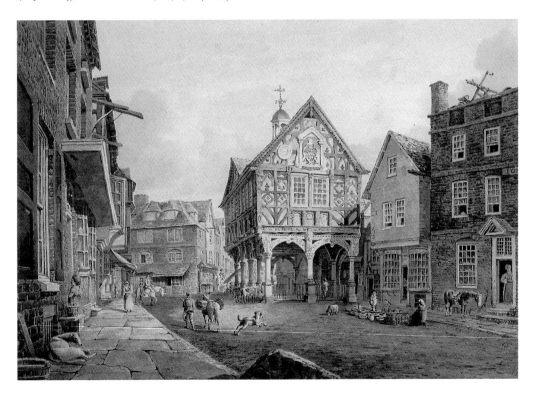

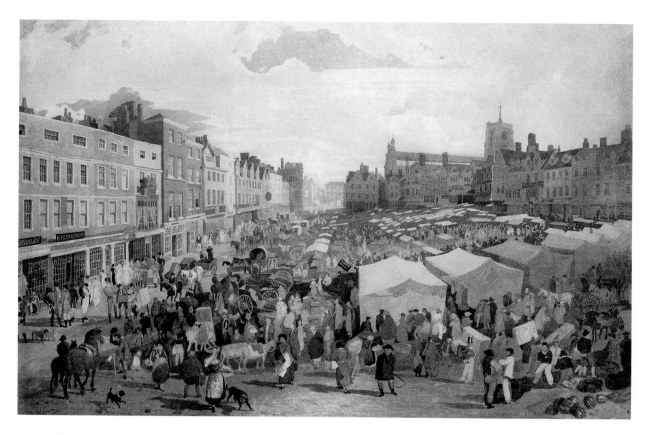

73　John Sell Cotman, *Norwich Market Place*, c. 1809 (cat. 52)

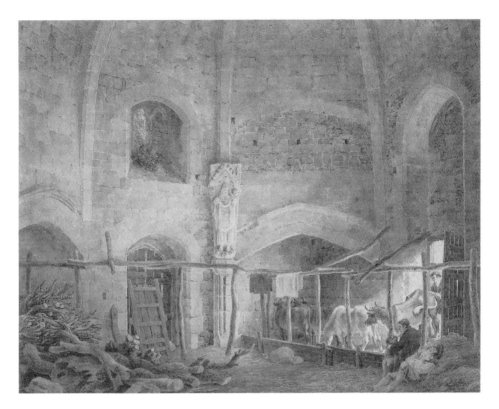

74　Michael 'Angelo' Rooke, *Interior of the Abbot's Kitchen, Glastonbury, c.* 1795 (cat. 242)

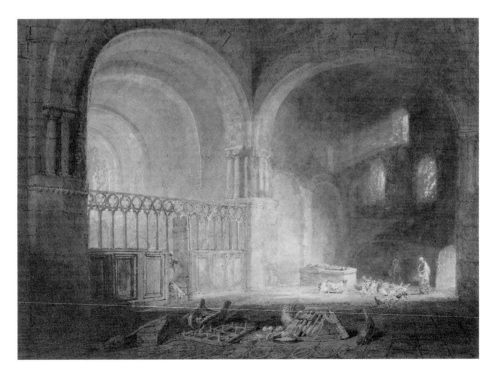

75　Joseph Mallord William Turner, *Transept of Ewenny Priory, Glamorganshire,* 1797 (cat. 279)

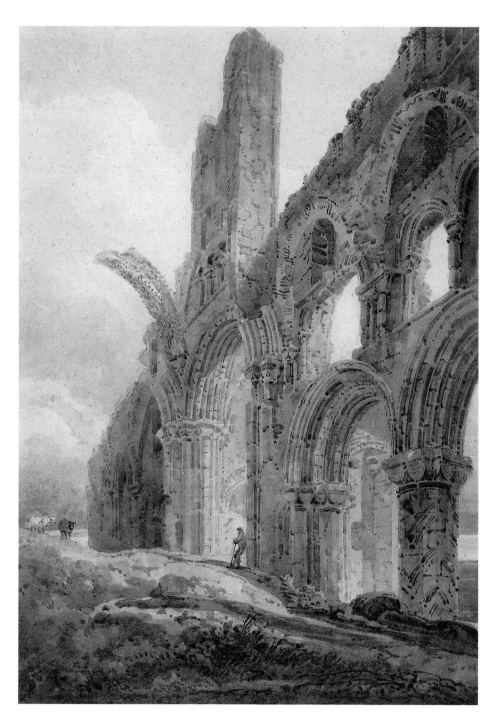

76 Thomas Girtin, *Lindisfarne*, c. 1798 (cat. 139)

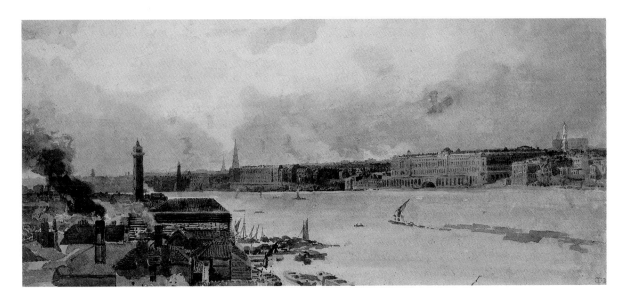

77 Thomas Girtin, *London: The Thames from Westminster to Somerset House*, c. 1801 (cat. 149)

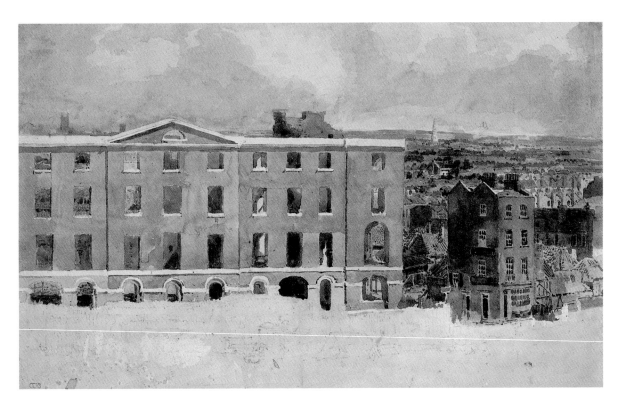

78 Thomas Girtin, *London: The Albion Mills*, c. 1801 (cat. 148)

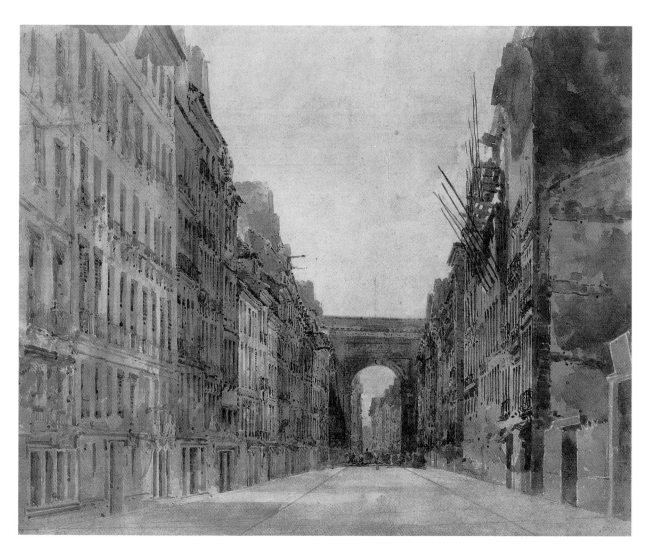

79 Thomas Girtin, *Paris: Rue St Denis*, 1801–2 (cat. 151)

80 Henry Edridge, *Old Houses, with a Castellated Wall*, c. 1810 (cat. 126)

81 William Henry Hunt, *Old Bell Yard, Bushey*, c. 1815 (cat. 178)

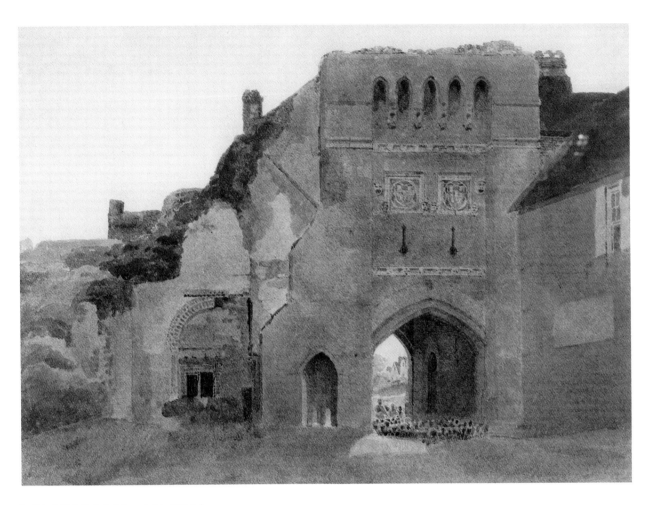

82 Peter de Wint, *Winchester Gateway*, c. 1810–15 (cat. 110)

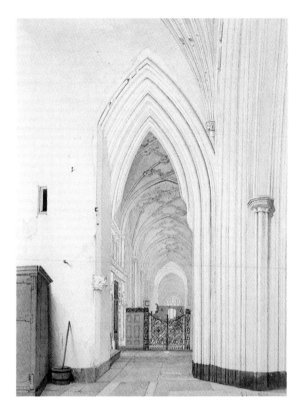

83 James Johnson, *Bristol: Interior of St Mary Redcliffe; the North Aisle looking East,* 1828 (cat. 191)

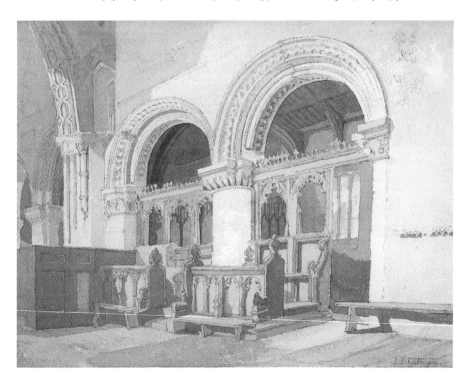

84 John Sell Cotman, *Interior of Walsoken Church, Norfolk: The Chancel, North Arcade, c.* 1811 (cat. 54)

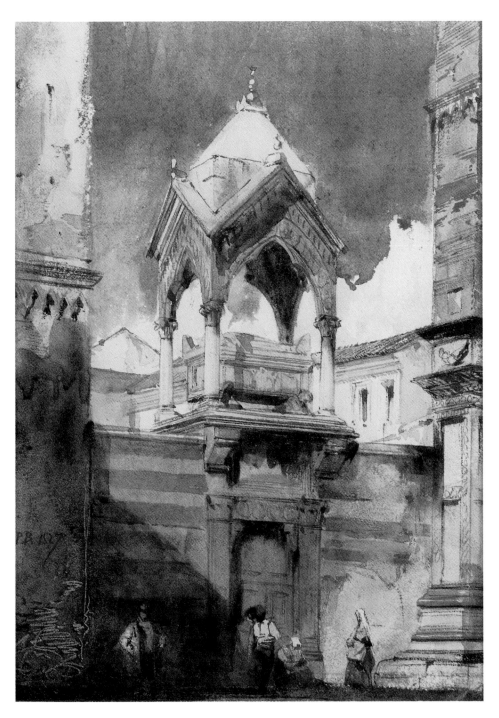

85 Richard Parkes Bonington, *Verona: The Castelbarco Tomb*, 1827 (cat. 16)

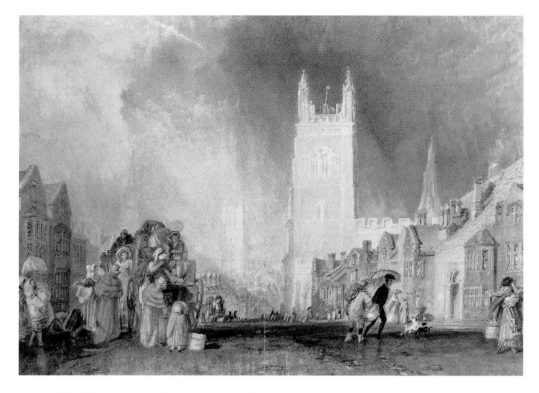

86 Joseph Mallord William Turner, *Stamford, Lincolnshire*, c. 1828 (cat. 293)

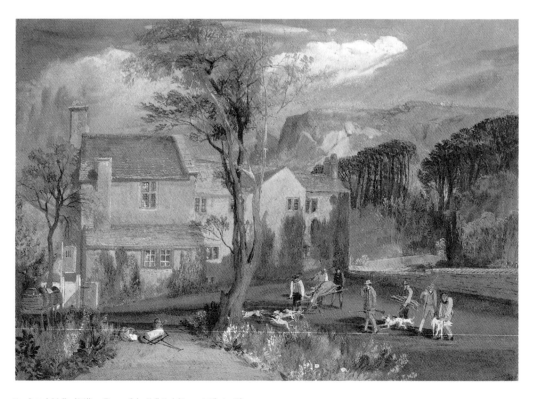

87 Joseph Mallord William Turner, *Caley Hall, Yorkshire*, c. 1818 (cat. 288)

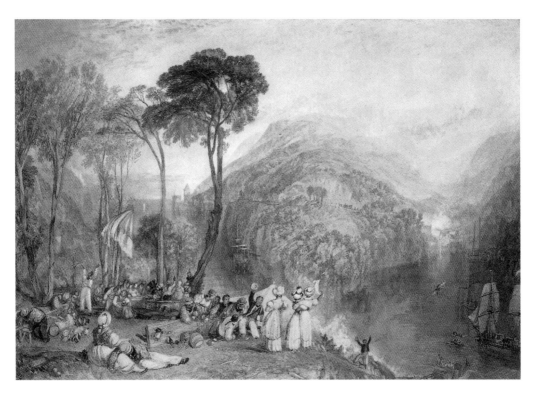

88 Joseph Mallord William Turner, *Dartmouth Cove*, c. 1826 (cat. 292)

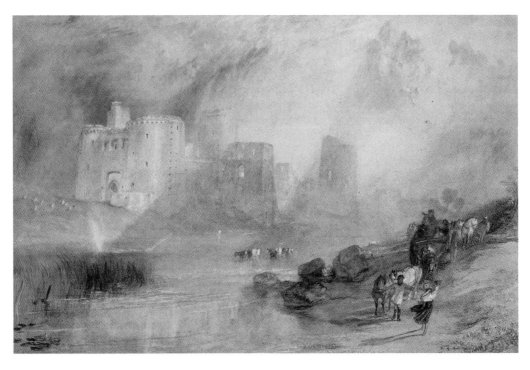

89 Joseph Mallord William Turner, *Kidwelly Castle, Carmarthenshire*, 1832–3 (cat. 295)

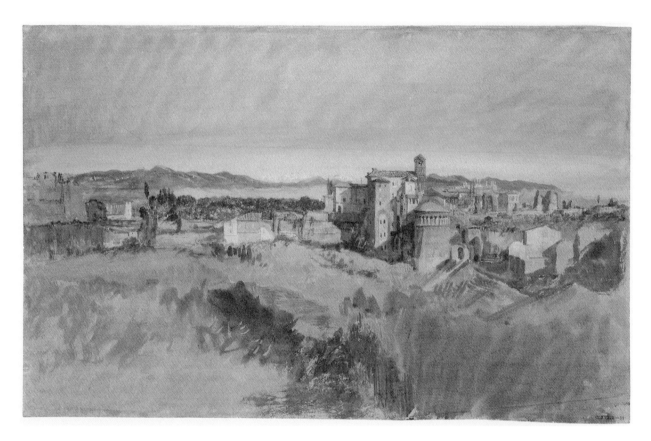

90 Joseph Mallord William Turner, *Rome: The Church of SS Giovanni e Paolo*, 1819 (cat. 289)

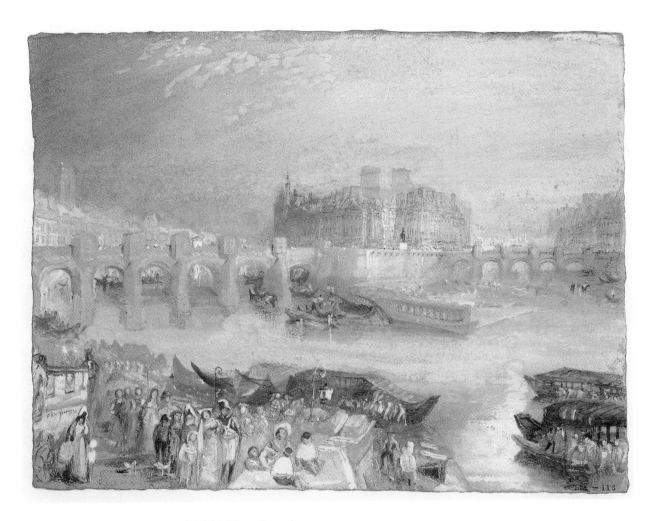

91 Joseph Mallord William Turner, *Paris: Pont Neuf and Ile de la Cité*, c. 1832 (cat. 294)

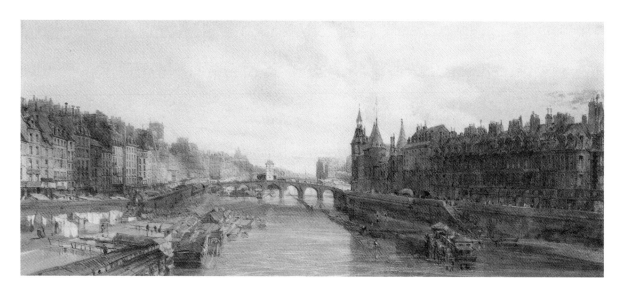

92 William Callow, *Paris: Quai de l'Horloge, c.* 1835 (cat. 21)

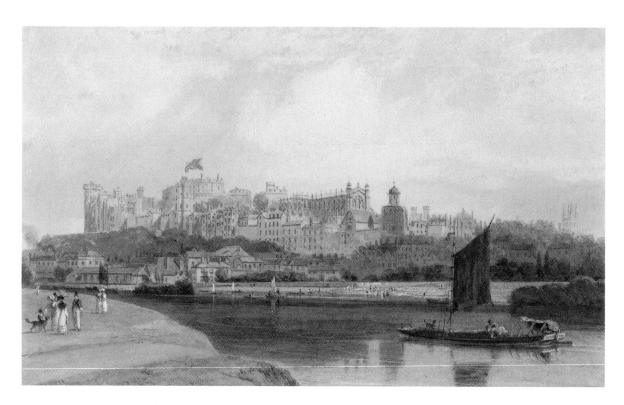

93 William Daniell, *Windsor,* 1827 (cat. 105)

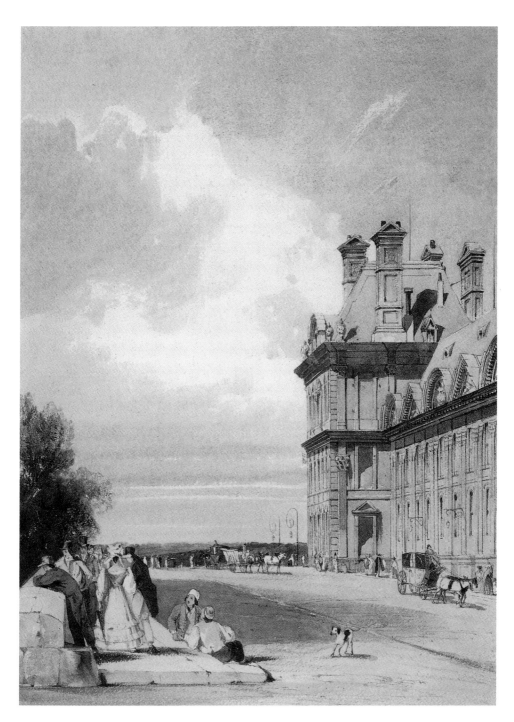

94 Thomas Shotter Boys, *Paris: Le Pavillon de Flore, Tuileries, c. 1830* (cat. 20)

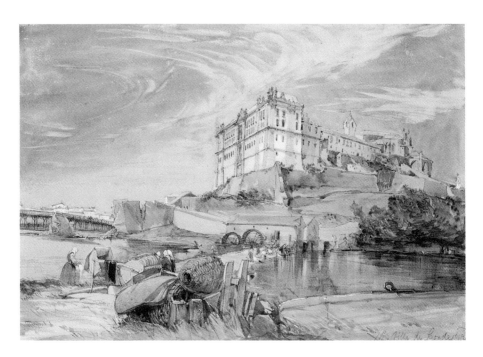

95 James Holland, *Villa do Conde, near Oporto, Portugal*, 1837 (cat. 171)

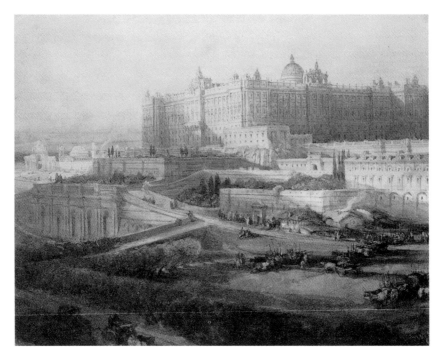

96 David Roberts, *Madrid: Palacio Real*, 1833–5 (cat. 237)

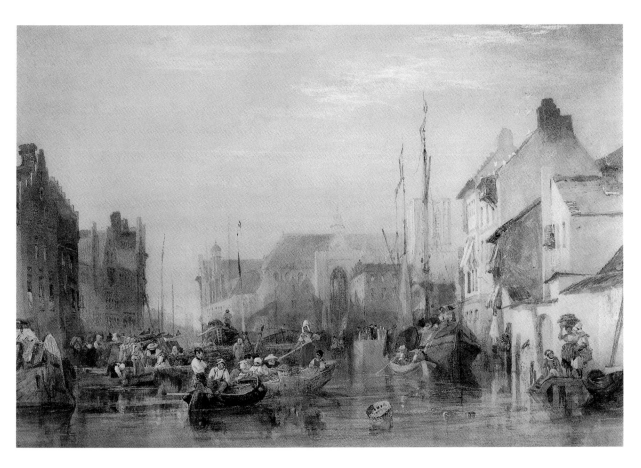

97 Samuel Austin, *Dort, Holland*, c. 1830 (cat. 4)

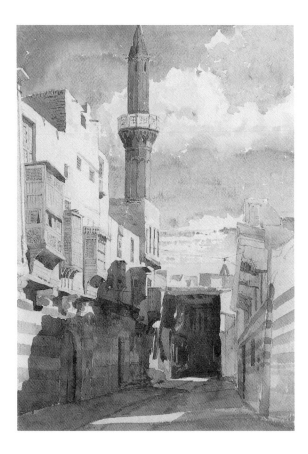

98 William James Müller, *Cairo: A Street with a Minaret*,
c. 1838 (cat. 216)

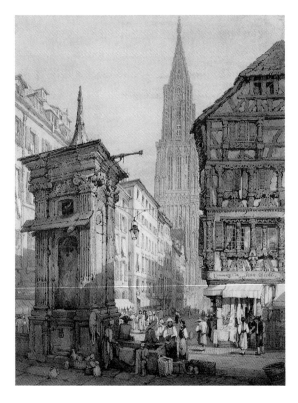

99 Samuel Prout, *A View in Strasbourg*, (?) 1822 (cat. 233)

100 David Cox, *Paris: (?) A Street in the Marais, c.* 1829 (cat. 68)

101 David Cox, *Rouen: Tour d'Horloge,* 1829 (cat. 69)

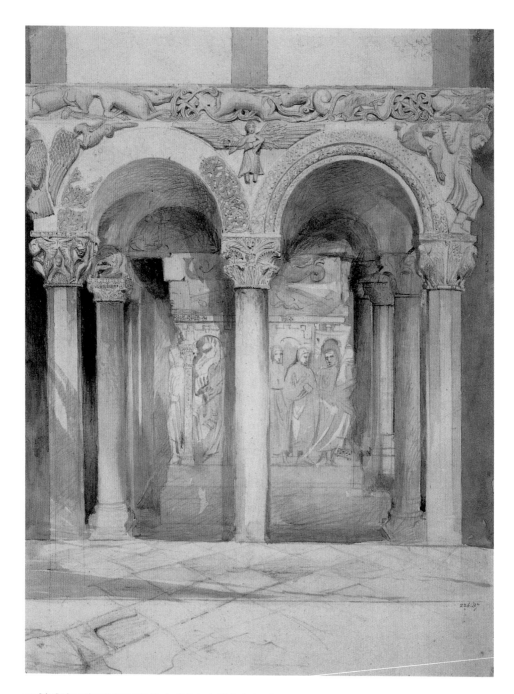

102 John Ruskin, *Milan: The Pulpit in the Church of S. Ambrogio*, (?) 1845 (cat. 244)

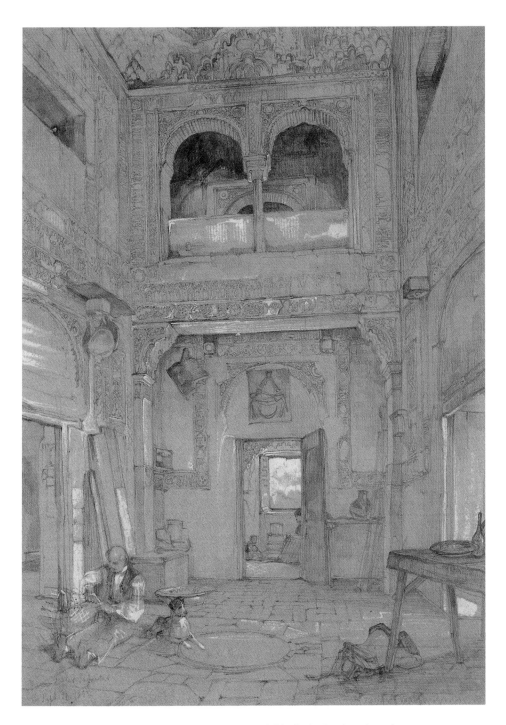

103 John Frederick Lewis, *Torre de las Infantas: One of the Towers in the Grounds of the Alhambra, Granada*, 1833 (cat. 197)

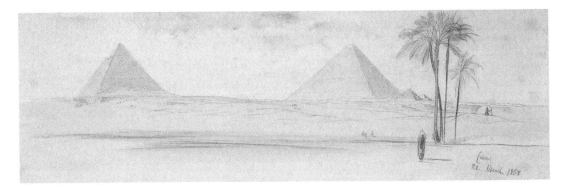

104 Edward Lear, *The Pyramids with Sphinx and Palms*, 1858 (cat. 193)

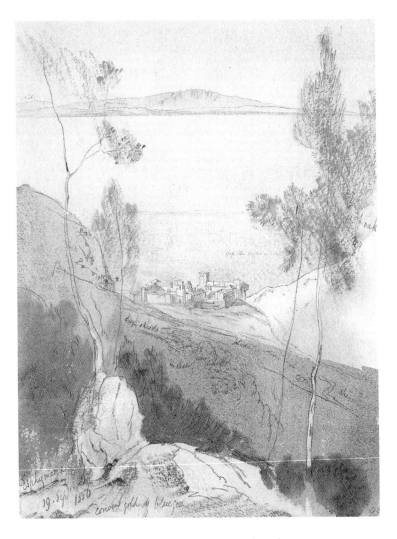

105 Edward Lear, *The Monastery of Esphigmenou, Mount Athos, Greece*, 1856 (cat. 192)

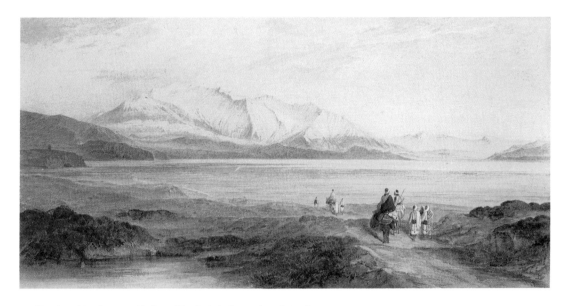

106 Edward Lear, *Mount Parnassus, with a Group of Travellers in the Foreground*, 1879 (cat. 194)

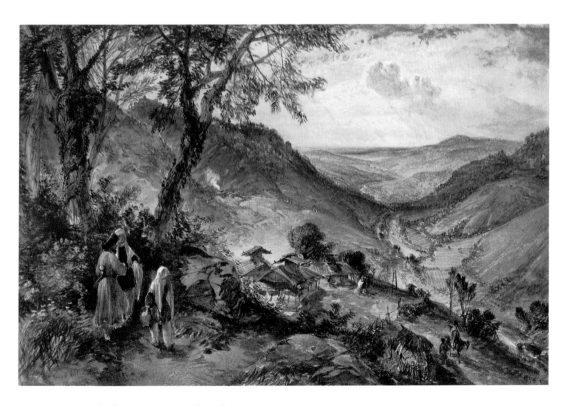

107 William Simpson, *Valley of Vardan, Caucasus*, 1855–8 (cat. 262)

III

NATURALISM

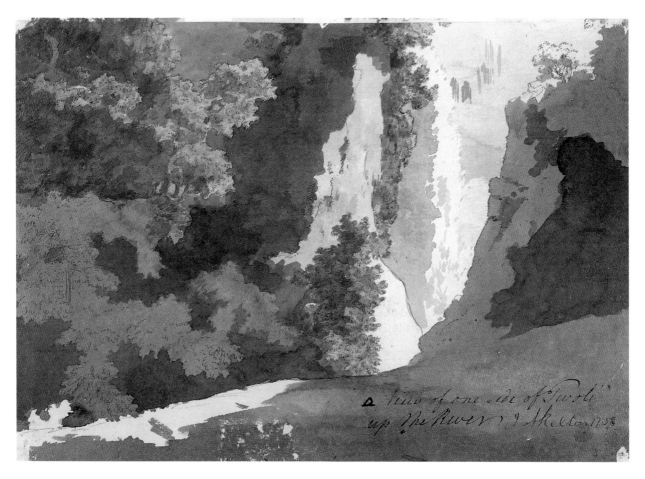

a View of one side of Tivoli
up the River I Skelton 1758

108 Jonathan Skelton, *A Study at Tivoli*, 1758 (cat. 264)

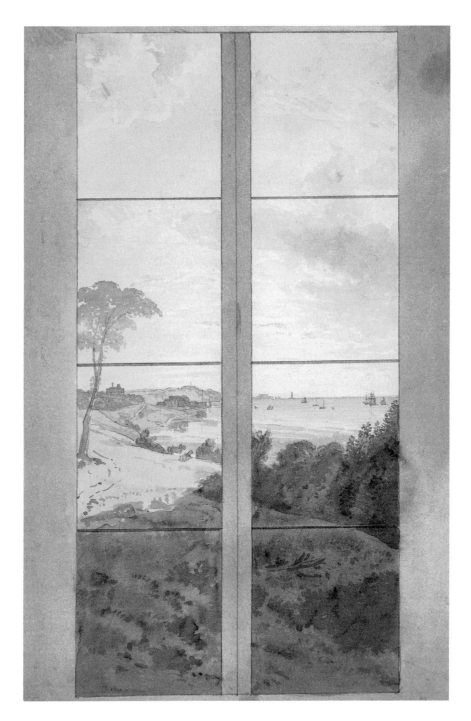

109 George Barret Jnr, *View on the Coast Seen through a Window*, c. 1815 (cat. 5)

110 John Downman, *View over Nice out of my Window*, 1773 (cat. 123)

111 Paul Sandby, *Bayswater*, 1793 (cat. 257)

112 Paul Sandby, *The Tide Rising at Briton Ferry*, 1773 (cat. 254)

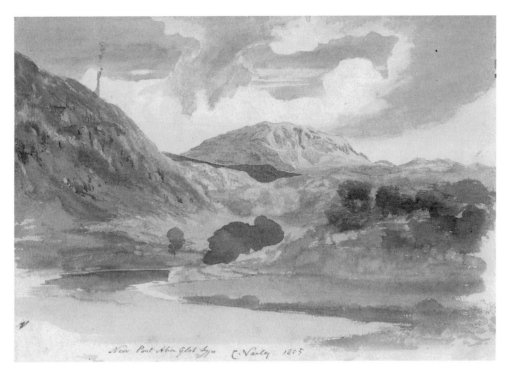

113 Cornelius Varley, *Near Pont Aberglaslyn, North Wales*, 1805 (cat. 312)

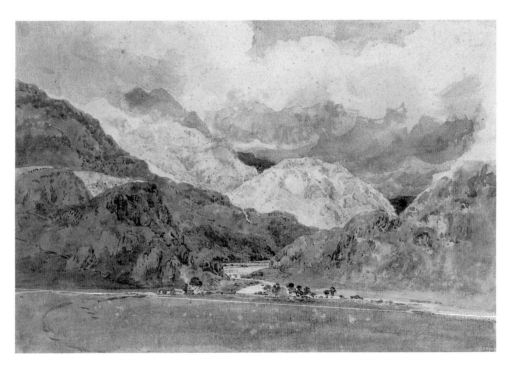

114 Thomas Girtin, *Near Beddgelert, North Wales*, c. 1798 (cat. 140)

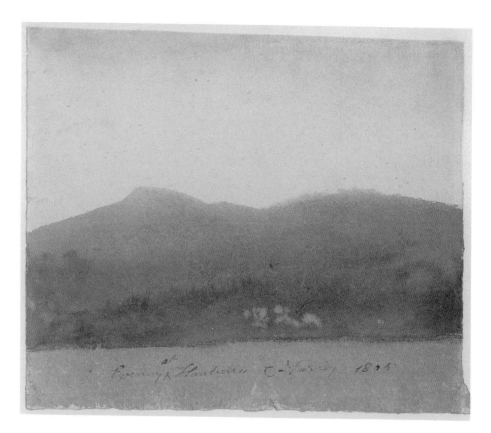

115 Cornelius Varley, *Evening at Llanberis, North Wales*, 1805 (cat. 313)

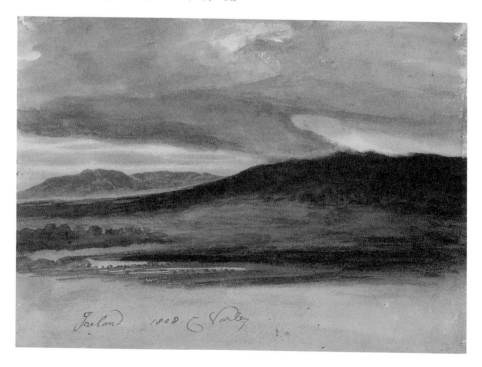

116 Cornelius Varley, *Mountainous Landscape, Ireland*, 1808 (cat. 314)

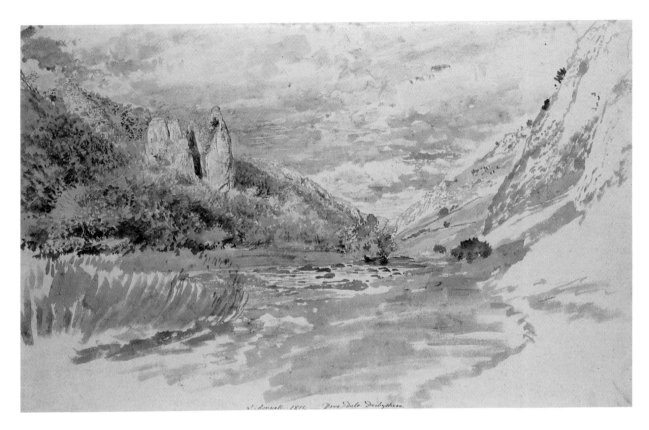

117 John Linnell, *Dovedale*, 1814 (cat. 206)

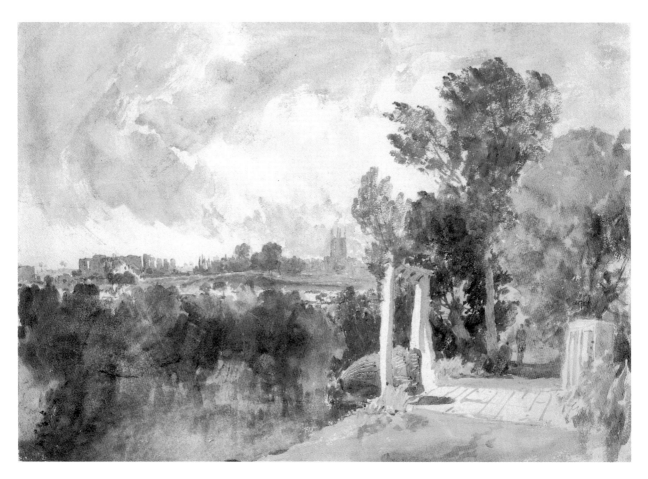

118 Joseph Mallord William Turner, *Benson (or Bensington), near Wallingford*, c. 1805 (cat. 285)

119 John Linnell, *Primrose Hill*, 1811 (cat. 203)

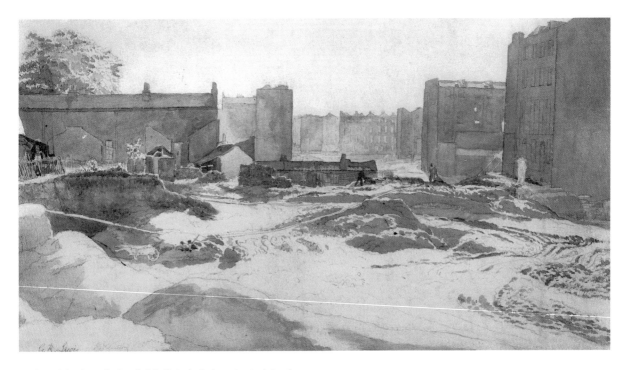

120 George Robert Lewis, *Clearing a Site in Paddington for Development*, c. 1820 (cat. 195)

121 Cornelius Varley, *Lord Rous's Park, Henham*, Suffolk, 1801 (cat. 311)

122 John Linnell, *Bayswater and Kensington Gardens*, 1811 (cat. 204)

123 Robert Hills, *Two Studies of Skies, at Windsor, c.* 1810 (cat. 164)

124 David Cox, *Landscape with Sunset,* (?) *c.* 1835 (cat. 72)

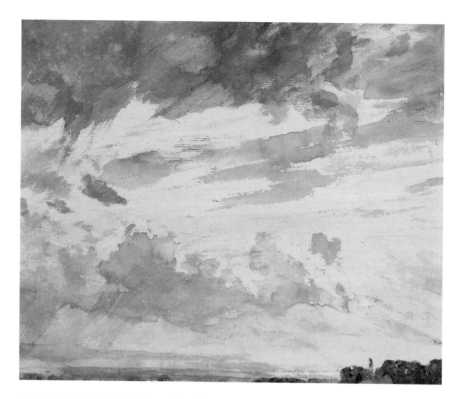

125 John Constable, *Study of Clouds at Hampstead*, 1830 (cat. 27)

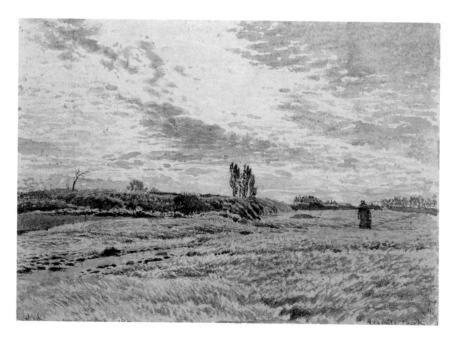

126 John Linnell, *Regent's Park*, 1812 (cat. 205)

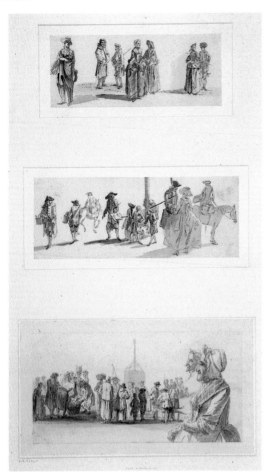

127 Paul Sandby, *Figure Studies at Edinburgh and in the Vicinity*, c. 1750 (cat. 250)

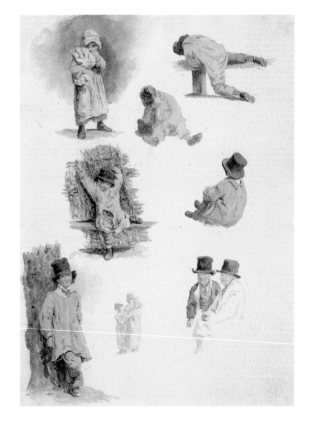

128 Robert Hills, *Sheet of Studies of Country Children*, c. 1815 (cat. 165)

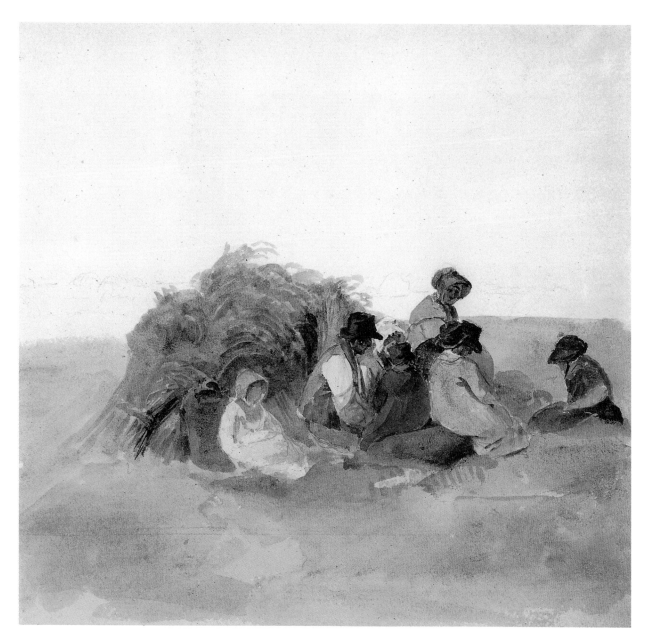

129 Peter de Wint, *Harvesters Resting*, c. 1820 (cat. 113)

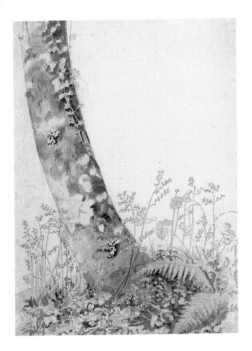

130 John Downman, *A Tree-trunk near Albano*, 1774 (cat. 124)

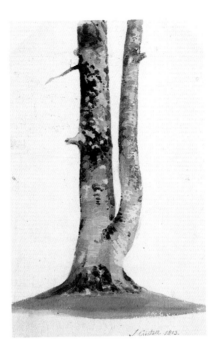

131 Joshua Cristall, *Study of a Beech-tree Stem*, 1803 (cat. 95)

132 John Linnell, *Tree Study at Tythrop*, 1817 (cat. 207)

133 John White Abbott, *Trees in Peamore Park, Exeter*, 1799 (cat. 1)

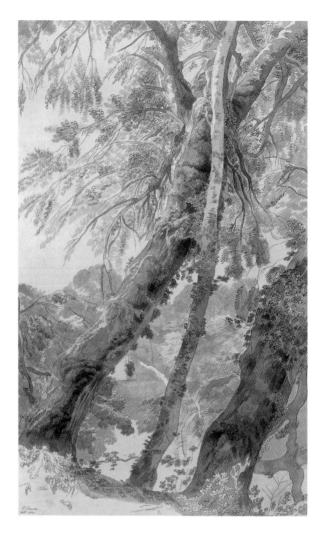

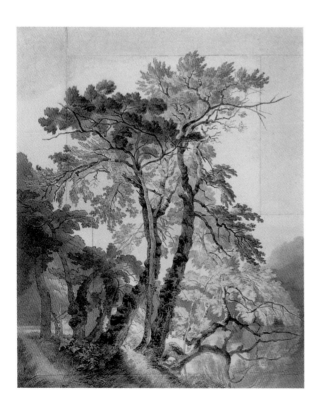

134 Francis Towne, *Trees Overhanging Water*, 1800 (cat. 276)

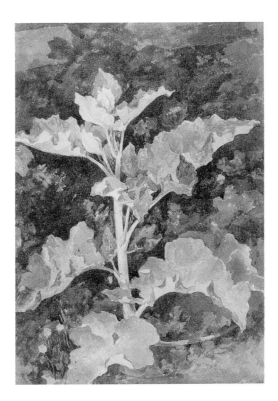

135 Patrick Nasmyth, *Burdock (Arctium)*, (?) c. 1810 (cat. 221)

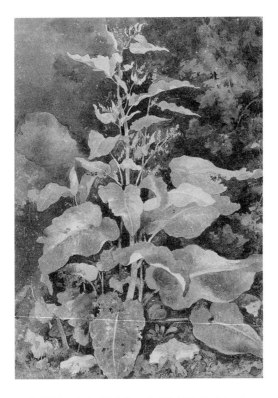

136 Patrick Nasmyth, *Broad Dock (Rumex obtusifolius)*, (?) c. 1810 (cat. 220)

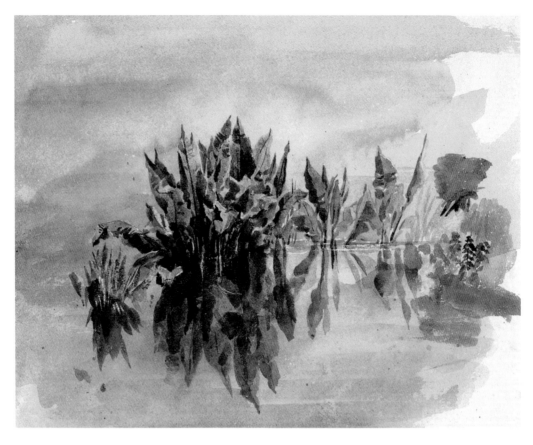

137 Peter de Wint, *Plants by a Stream*, c. 1810–15 (cat. 111)

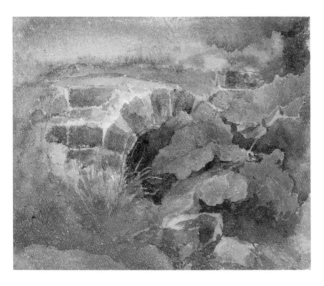

138 David Cox, *Plants by a Brick Culvert*, c. 1815–20 (cat. 63b)

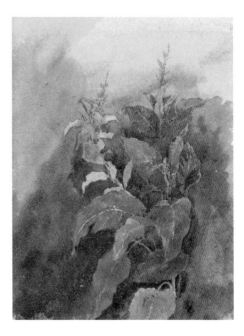

139 David Cox, *Dock Plants*, c. 1815-20 (cat. 63a)

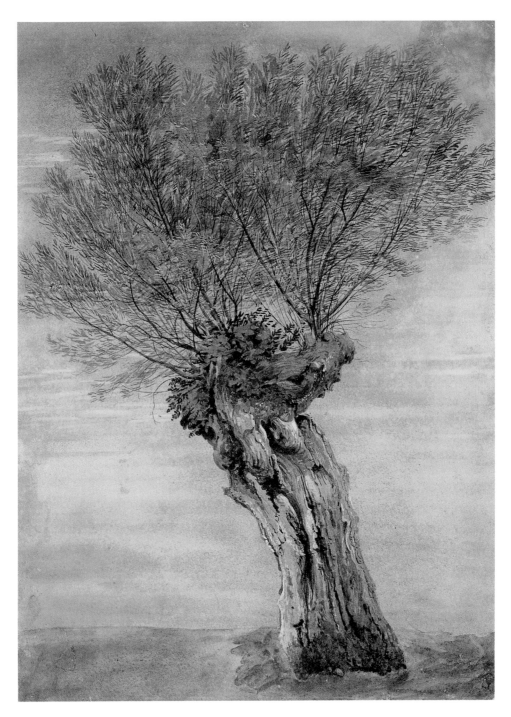

140 William Turner of Oxford, *A Pollarded Willow*, 1835 (cat. 308)

141 Albert Joseph Moore, *Study of an Ash Trunk*, 1857 (cat. 215)

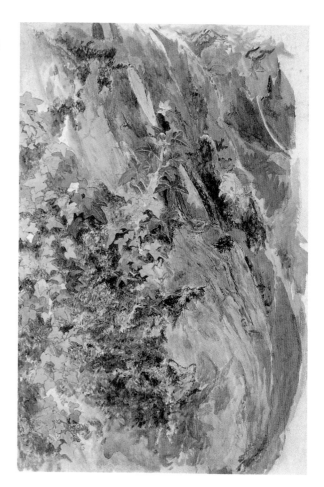

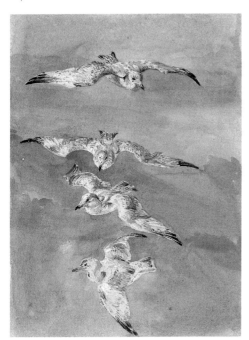

143 David Cox, *Studies of a Seagull in Flight*, c. 1825–30 (cat. 67)

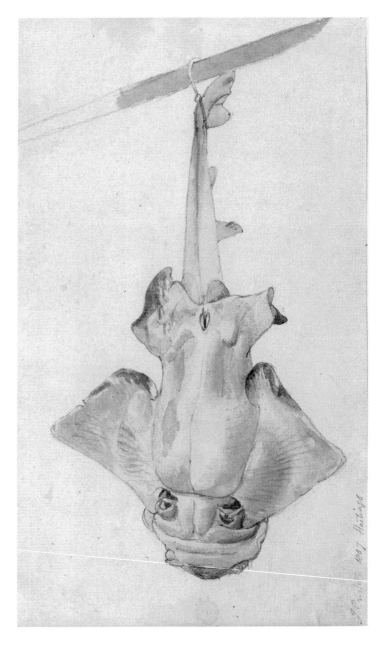

144 Joshua Cristall, *Study of a Skate*, 1807 (cat. 96)

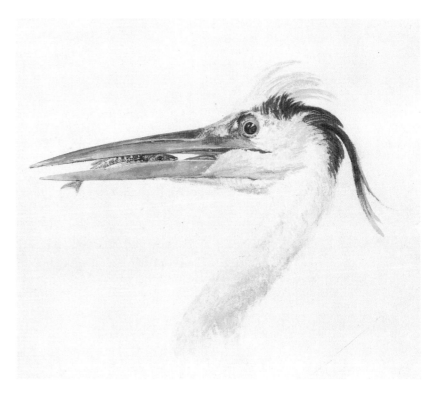

145 Joseph Mallord William Turner, *Head of a Heron*, c. 1815 (cat. 286)

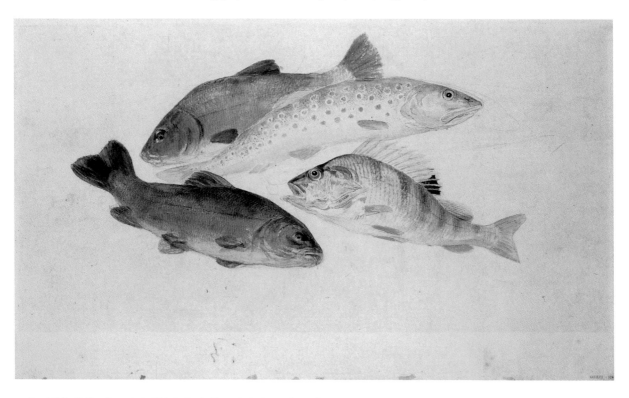

146 Joseph Mallord William Turner, *Study of Fish: Two Tench, a Trout and a Perch*, c. 1822 (cat. 290)

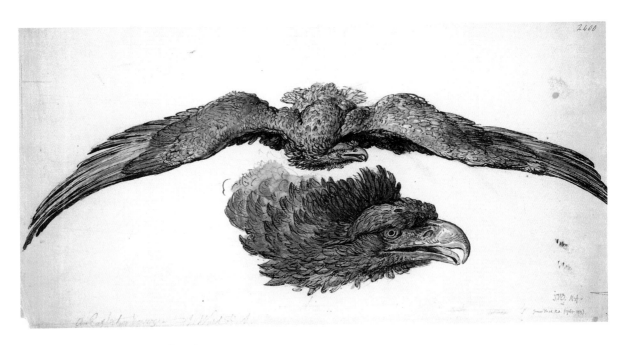

147 James Ward, *Two Studies of an Eagle*, c. 1815 (cat. 321)

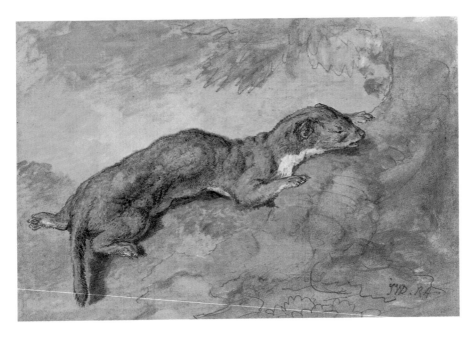

148 James Ward, *Study of a Weasel*, c. 1805 (cat. 320)

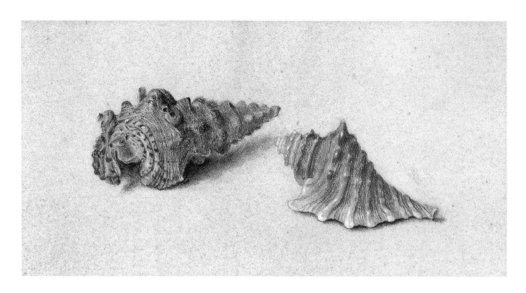

149 John Ruskin, *Study of Two Shells*, c. 1881 (cat. 248)

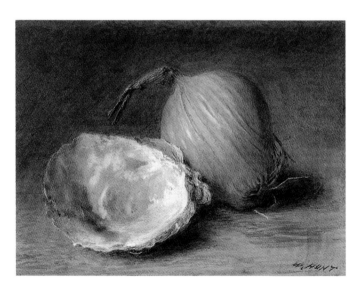

150 William Henry Hunt, *An Oyster Shell and an Onion*, c. 1859 (cat. 184)

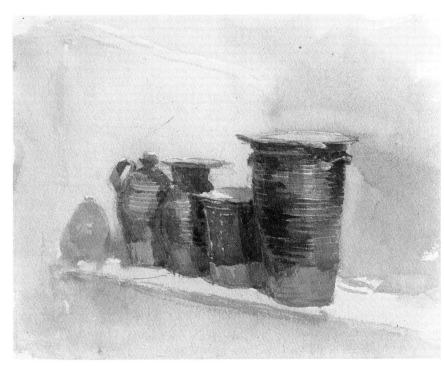

151 David Cox, *Still-life*, c. 1830 (cat. 70)

152 Peter de Wint, *Still-life with a Ginger Jar and Mushrooms*, (?) c. 1820 (cat. 114)

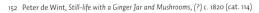

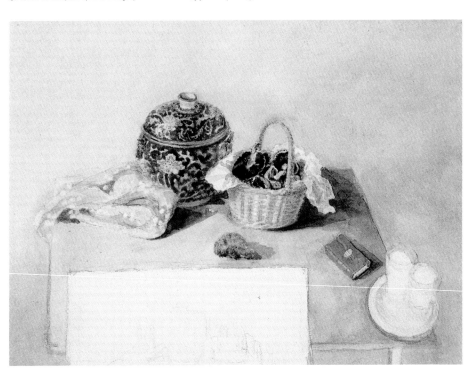

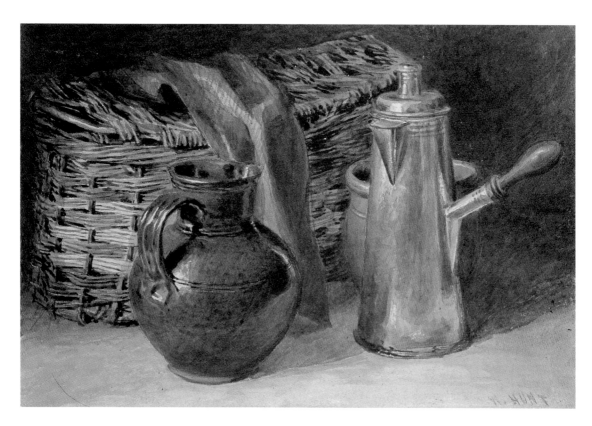

153 William Henry Hunt, *Still-life with Earthenware Pitcher, Coffee Pot and Basket*, c. 1825 (cat. 179)

154 Robert Hills, *Farm Buildings*, (?) c. 1815 (cat. 168)

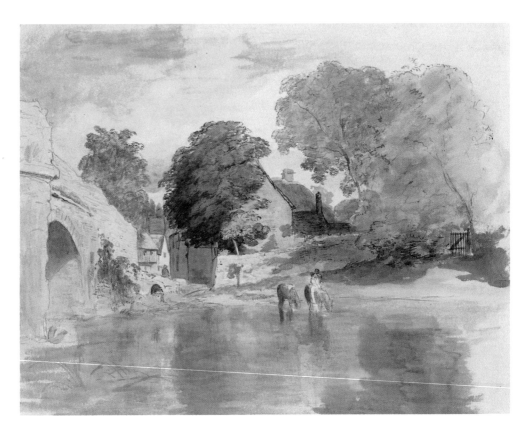

155 William Collins, *Horses Watering by a Bridge*, c. 1815 (cat. 25)

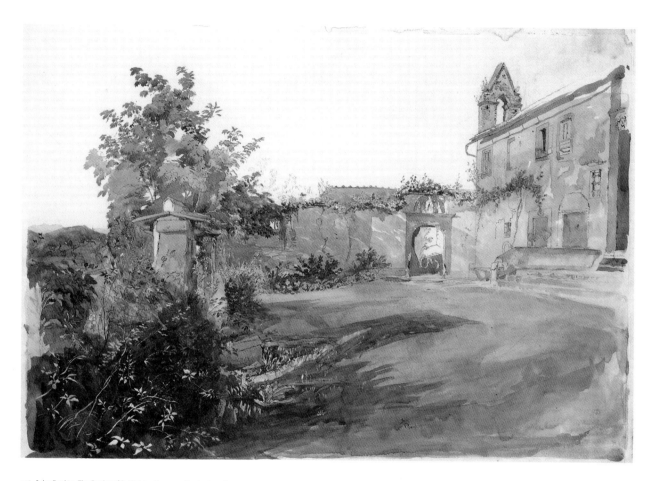

156 John Ruskin, *The Garden of S. Miniato, Florence*, 1845 (cat. 245)

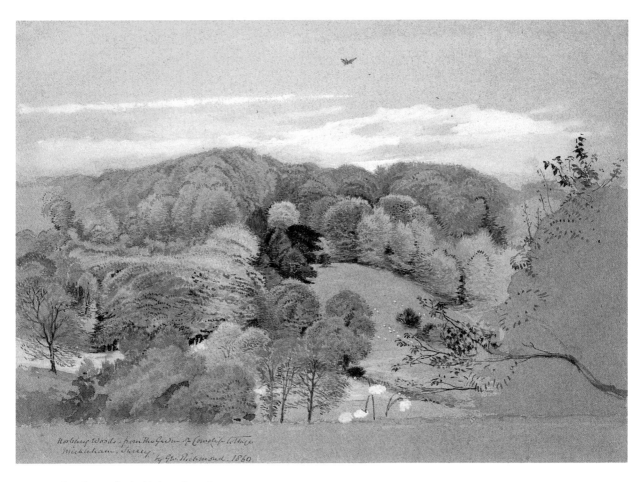

157 George Richmond, *A View of Norbury Woods*, 1860 (cat. 236)

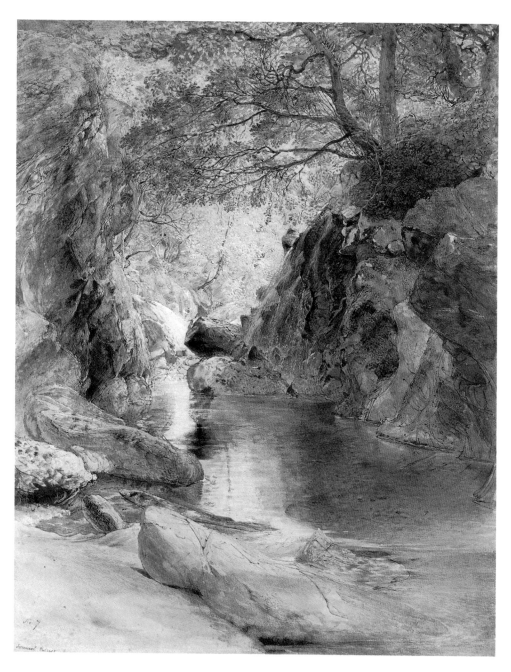

158 Samuel Palmer, *A Cascade in Shadow* c. 1835–6, (cat. 226)

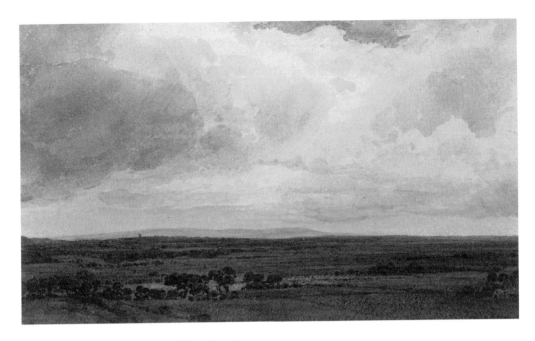

159 Frederick Nash, *Showery Day, Glastonbury Tor,* (?) c. 1820 (cat. 219)

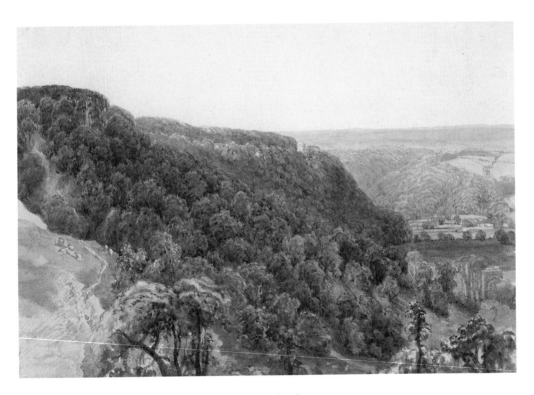

160 William Henry Bartlett, *View of Rievaulx Abbey from the Hills to the West,* c. 1829 (cat. 8)

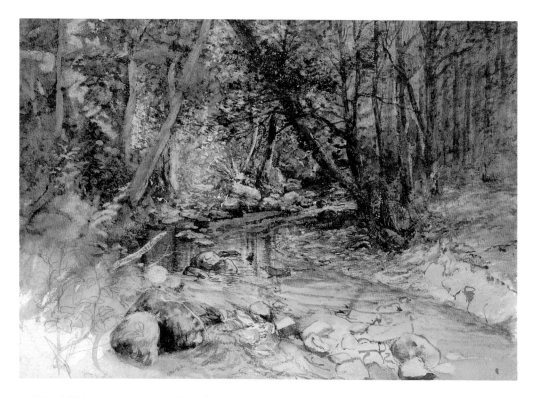

161 William Bell Scott, *Penwhapple Stream*, c. 1860 (cat. 261)

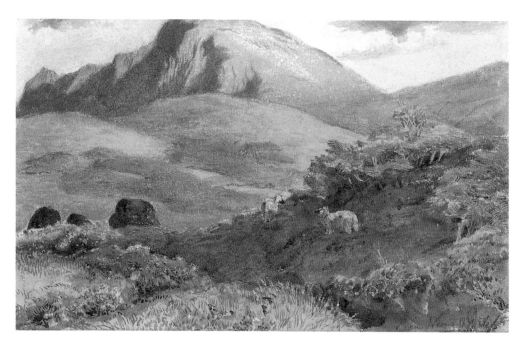

162 John Everett Millais, *A Mountainous Scene, Scotland – possibly Ben Nevis*, (?) 1854 (cat. 214)

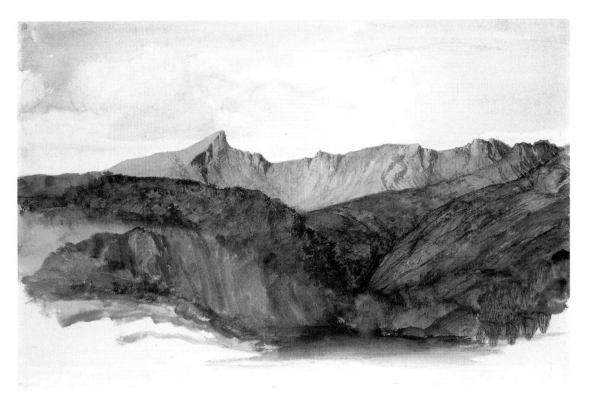

163 William Dyce, *Tryfan, Snowdonia*, c. 1860 (cat. 125)

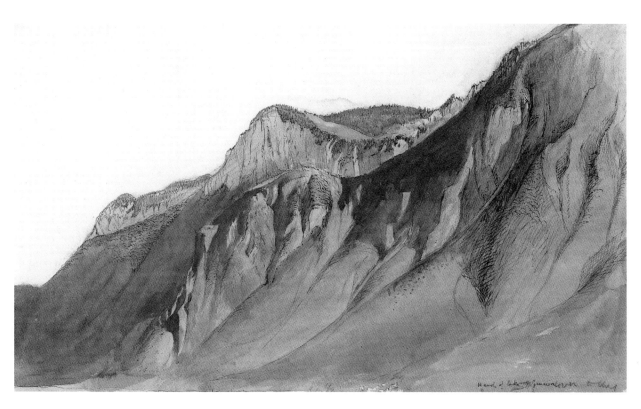

164 John Ruskin, *Head of Lake Geneva*, (?) 1846 (cat. 246)

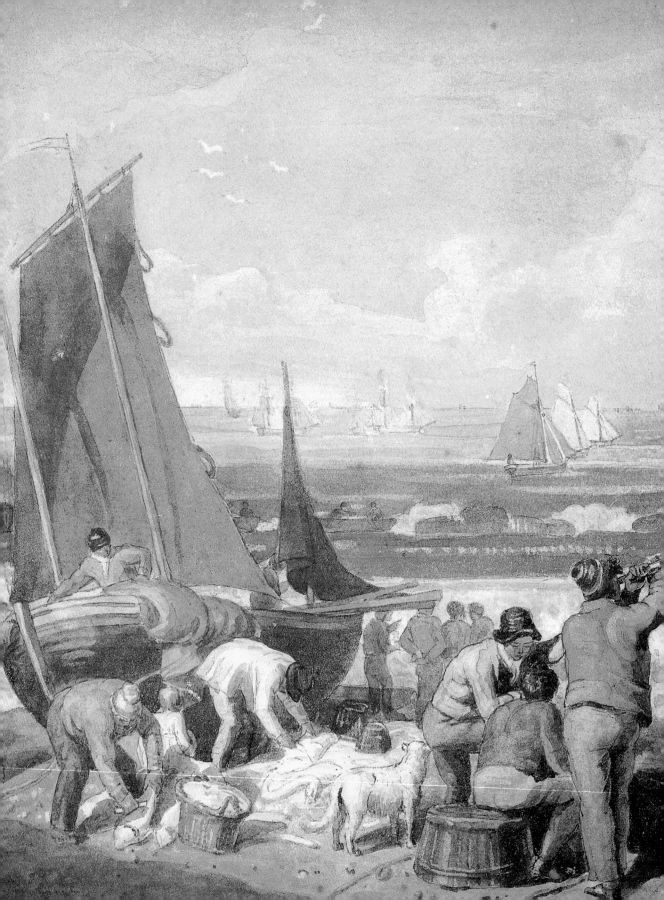

IV

PICTURESQUE, ANTIPICTURESQUE: THE COMPOSITION OF ROMANTIC LANDSCAPE

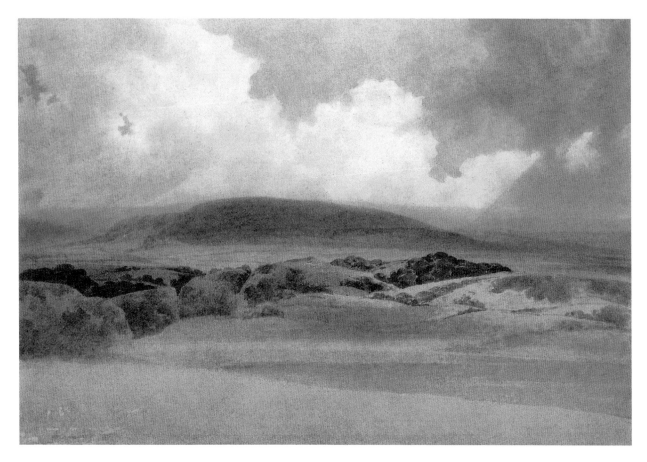

165 Thomas Girtin, *Storiths Heights, Wharfedale, Yorkshire*, c. 1802 (cat. 153)

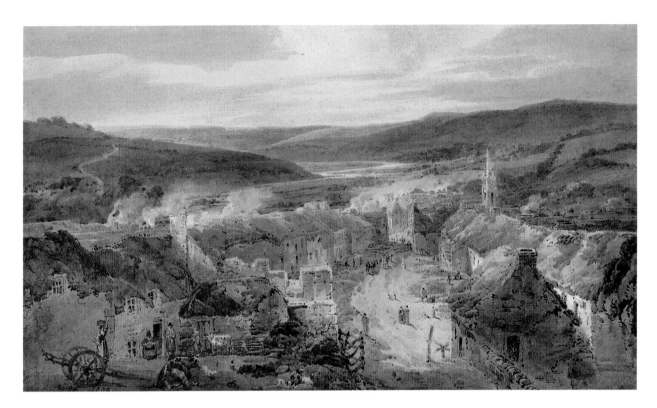

166 Thomas Girtin, *The Village of Jedburgh, Roxburghshire*, 1800 (cat. 142)

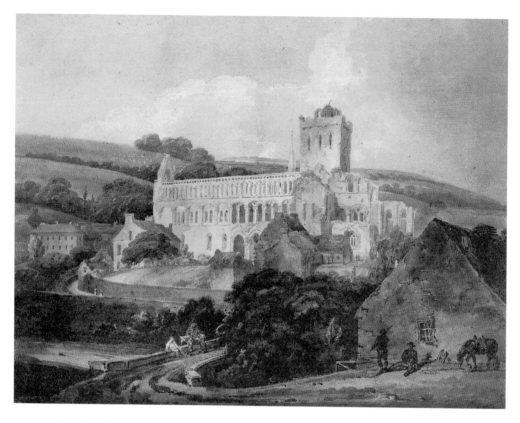

167 Thomas Girtin, *Jedburgh Abbey from the South-east*, c. 1800 (cat. 146)

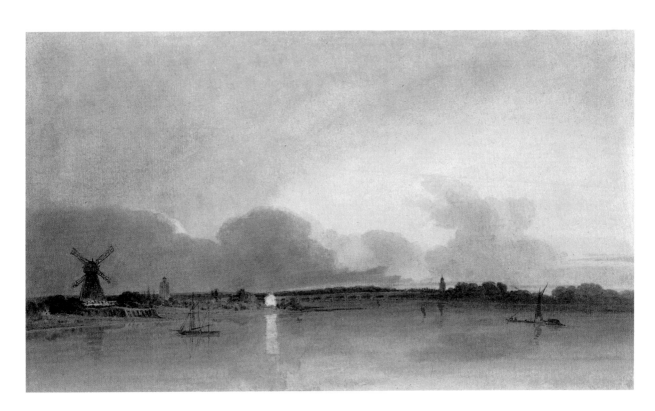

168 Thomas Girtin, *The White House at Chelsea*, 1800 (cat. 143)

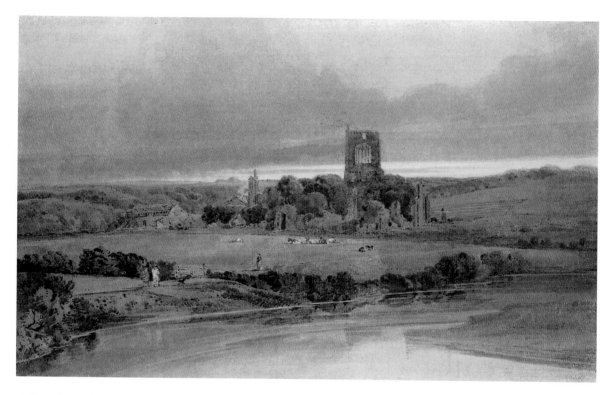

169 Thomas Girtin, *Kirkstall Abbey, Yorkshire: Evening*, c. 1800–1 (cat. 147)

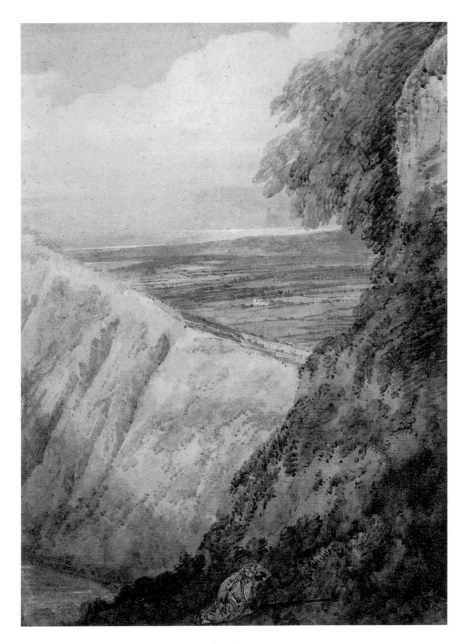

170 Thomas Girtin, *Coast of Dorset near Lulworth Cove*, c. 1798 (cat. 138)

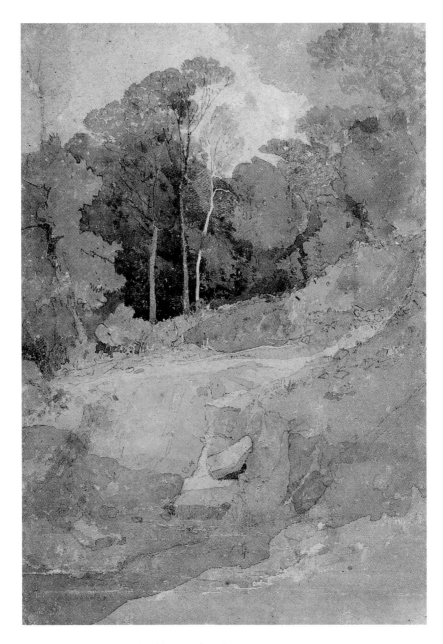

171 John Sell Cotman, *Duncombe Park, Yorkshire*, c. 1806 (cat. 44)

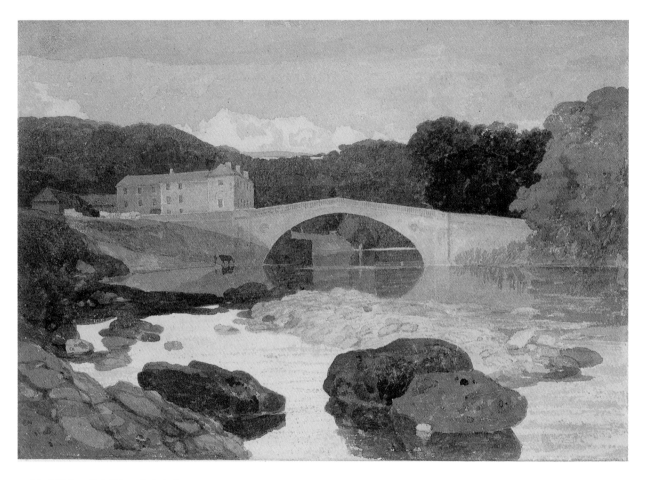

172 John Sell Cotman, *Greta Bridge*, c. 1807 (cat. 48)

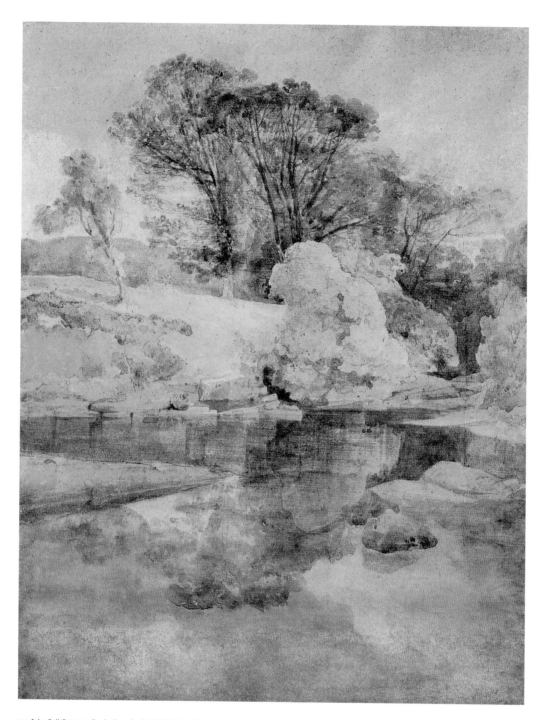

173 John Sell Cotman, *On the Greta (called 'Hell Cauldron')*, c. 1806 (cat. 42)

174 John Sell Cotman, *The Drop-gate, Duncombe Park*, c. 1806 (cat. 43)

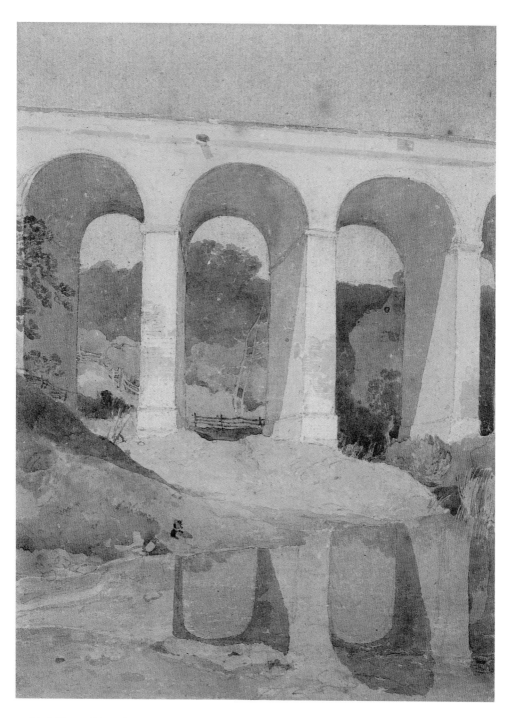

175 John Sell Cotman, *Chirk Aqueduct*, 1806–7 (cat. 47)

176 John Sell Cotman, *In Rokeby Park*, c. 1806 (cat. 45)

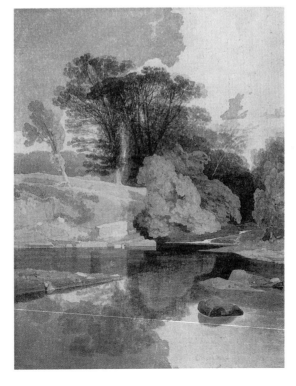

177 John Sell Cotman, *A Shady Pool*, 1807 (cat. 50)

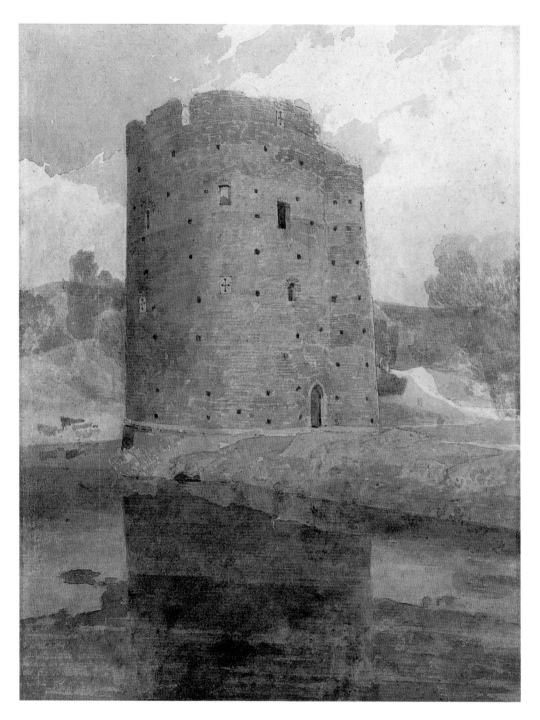

178 John Sell Cotman, *Norwich: The Cow Tower*, c. 1807 (cat. 49)

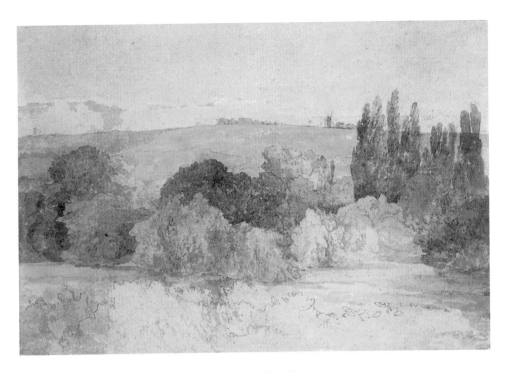

179 John Sell Cotman, *River Landscape (Probably on the Greta, Yorkshire)*, c. 1806 (cat. 46)

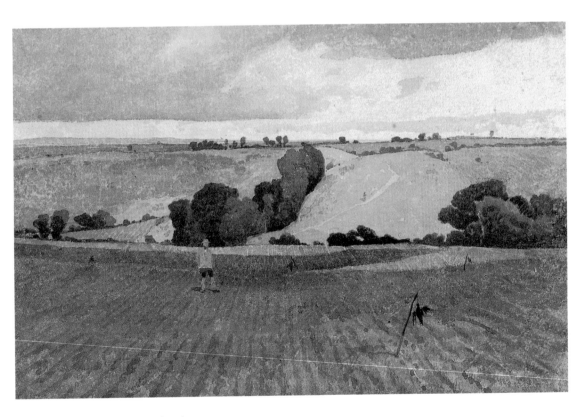

180 John Sell Cotman, *A Ploughed Field*, c. 1808 (cat. 51)

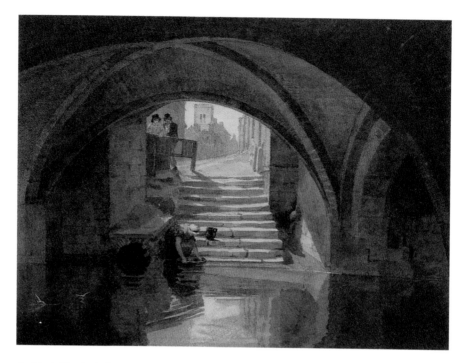

181 Peter de Wint, *Lincoln: The Devil's Hole*, c. 1810 (cat. 109)

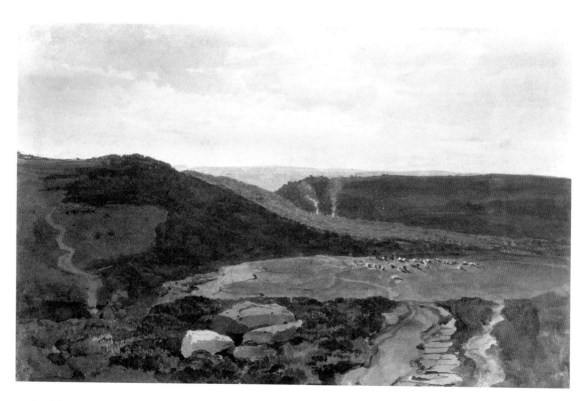

182 Peter de Wint, *Yorkshire Fells*, c. 1812 (cat. 112)

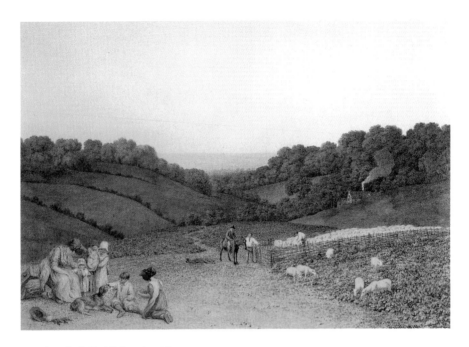

183 Robert Hills, *The Turnip Field*, 1819 (cat. 167)

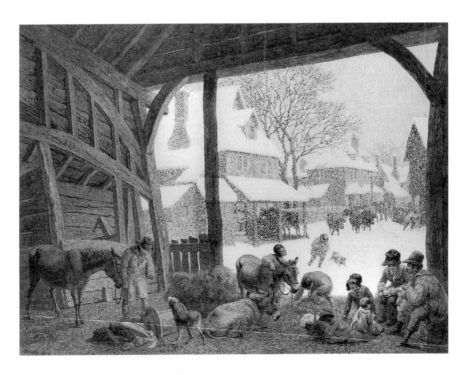

184 Robert Hills, *A Village Snow-scene*, 1819 (cat. 166)

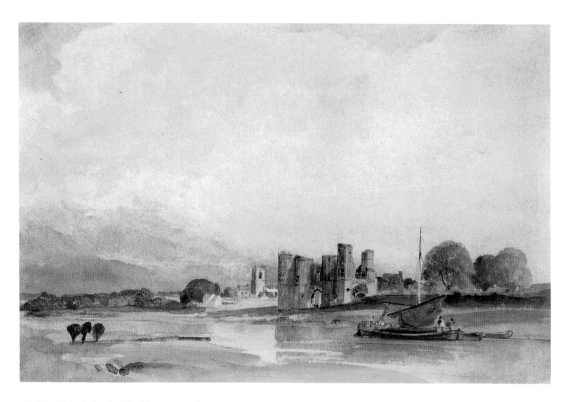

185 Peter de Wint, *Torksey Castle (Study)*, c. 1835 (cat. 117)

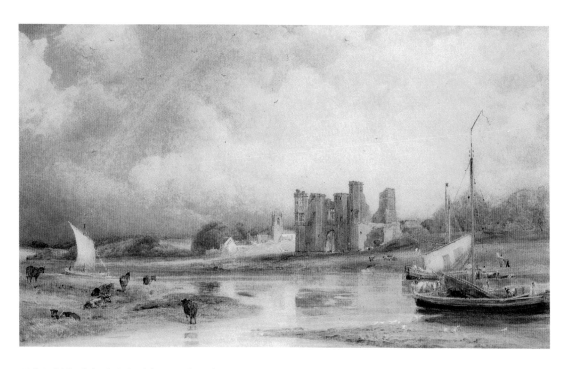

186 Peter de Wint, *Torksey Castle, Lincolnshire*, c. 1835 (cat. 118)

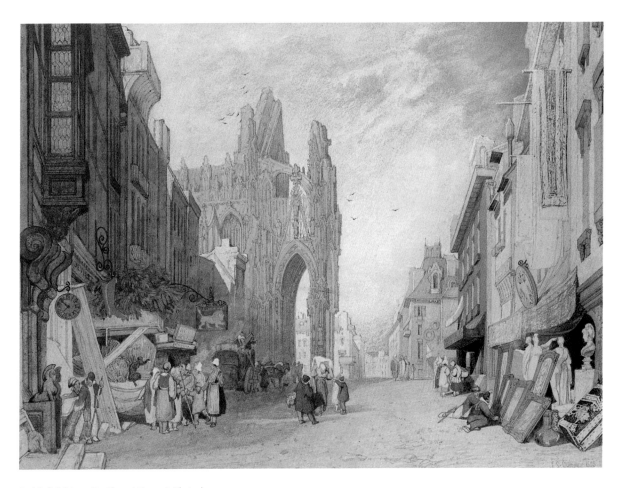

187 John Sell Cotman, *Street Scene at Alençon*, 1828 (cat. 57)

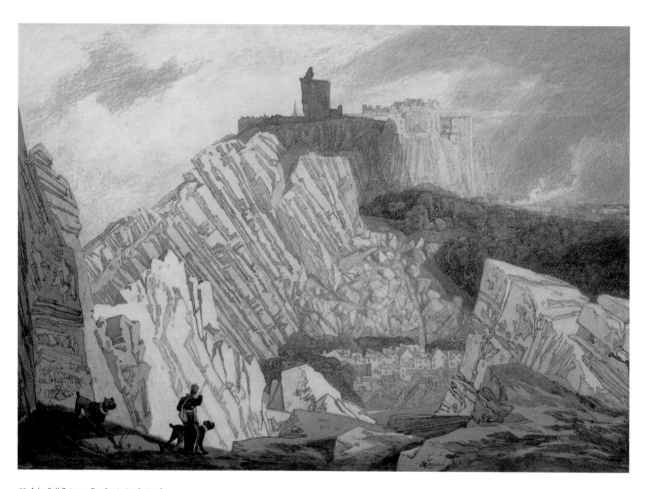

188 John Sell Cotman, *Domfront*, 1823 (cat. 55)

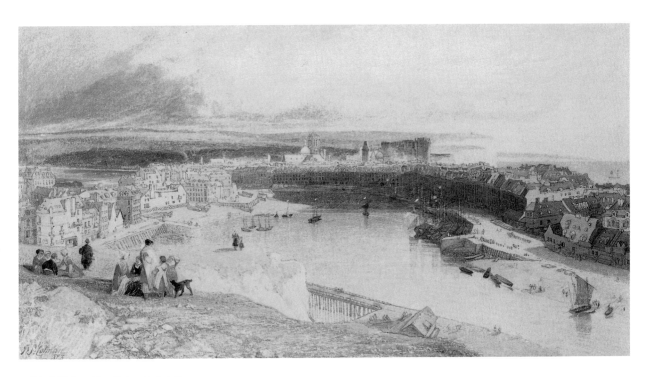

189 John Sell Cotman, *Dieppe Harbour*, 1823 (cat. 56)

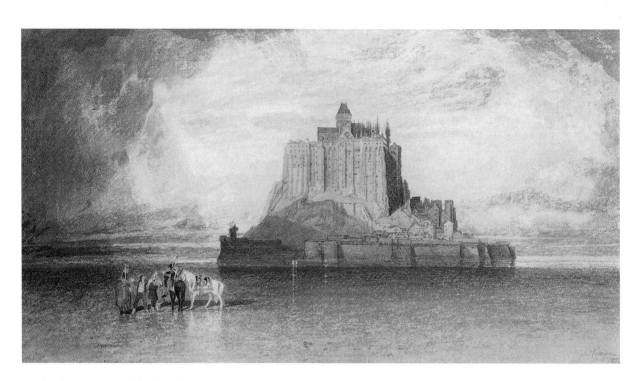

190 John Sell Cotman, *Mont St Michel*, 1828 (cat. 58)

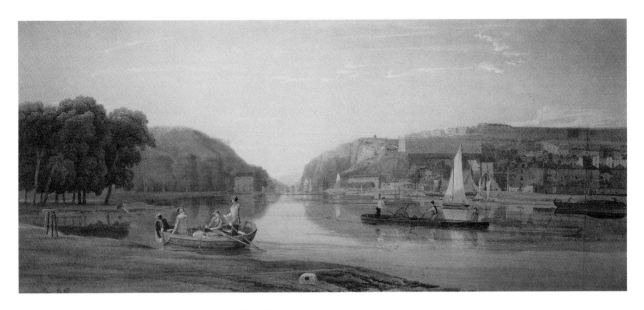

191 Samuel Jackson, *View of the Hotwells and Part of Clifton near Bristol*, (?) 1823 (cat. 187)

192 Joshua Cristall, *Coast Scene: The Beach at Hastings, with a Fleet in the Distance* , c. 1814 (cat. 97)

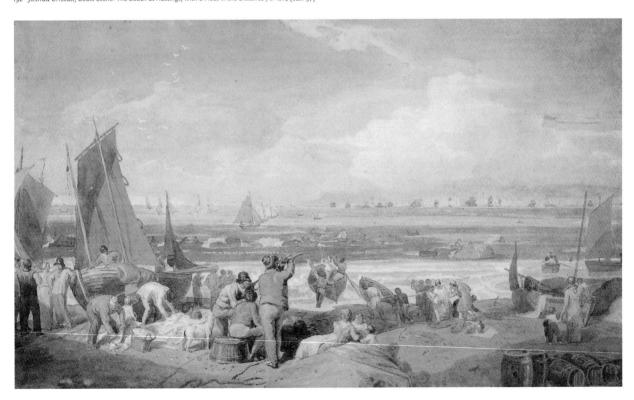

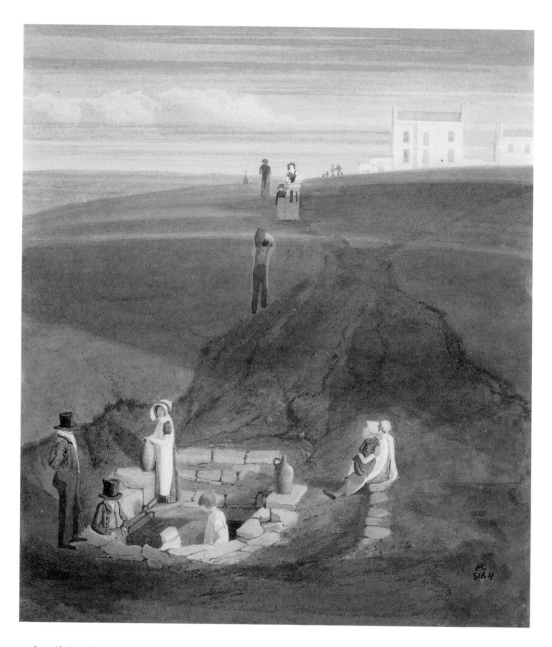

193 Samuel Jackson, *Mother Pugsley's Well, looking towards Somerset Street, Kingsdown*, 1823 (cat. 186)

194 Francis Danby, *The Avon at Clifton*, c. 1821 (cat. 101)

195 Francis Danby, *The Frome at Stapleton, Bristol*, c. 1823 (cat. 103)

196 Francis Danby, *The Avon from Durdham Down*, c. 1821 (cat. 102)

197 Francis Danby, *An Ancient Garden*, 1834 (cat. 104)

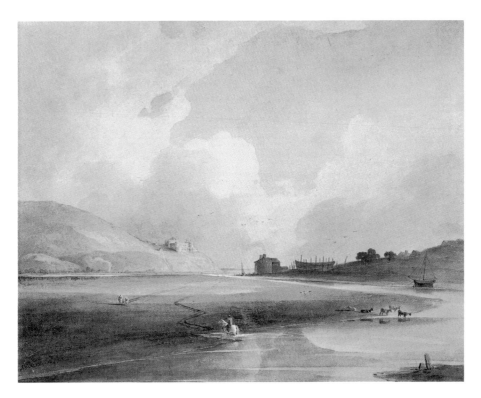

198 John Varley, *Harlech Castle and Tygwyn Ferry*, 1804 (cat. 317)

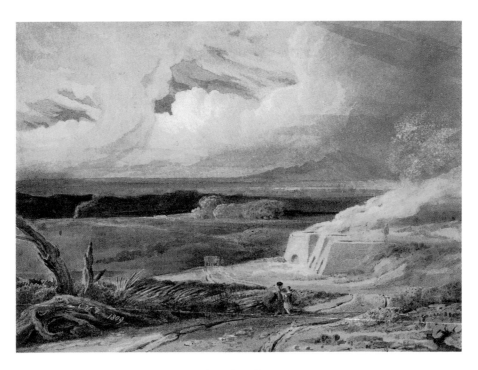

199 Anthony Vandyke Copley Fielding, *Landscape with Limekiln*, 1809 (cat. 127)

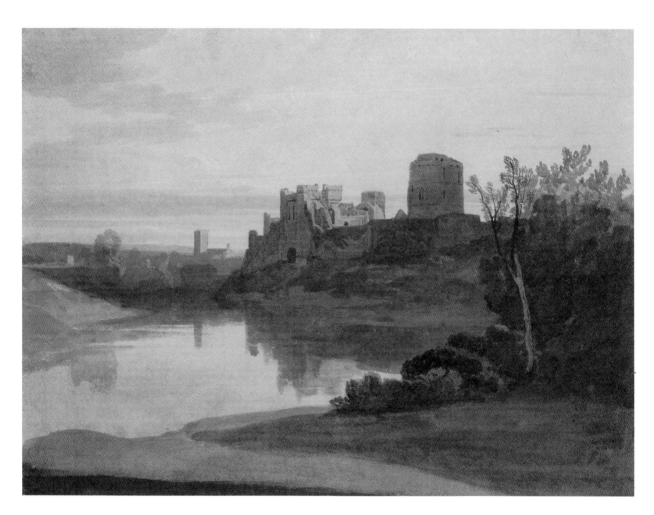

200 David Cox, *Pembroke Castle*, c. 1810 (cat. 62)

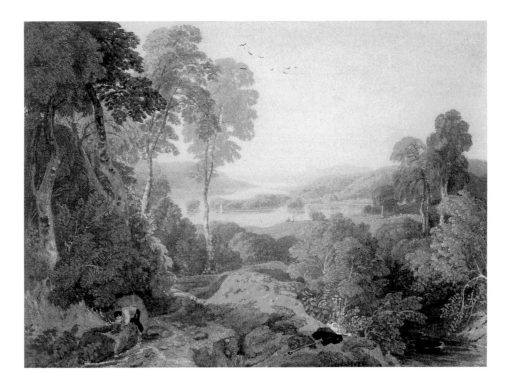

201 William Havell, *Windermere*, 1811 (cat. 160)

202 William Turner of Oxford, *Wychwood Forest, Oxfordshire*, 1809 (cat. 307)

203 William Havell, *View on the Brathay near Ambleside, Westmorland*, 1828 (cat. 161)

204 Francis Oliver Finch, *Arcadia*, (?) c. 1840 (cat. 131)

205 George Fennel Robson, *Tryfan, Caernarvonshire*, (?) 1827 (cat. 239)

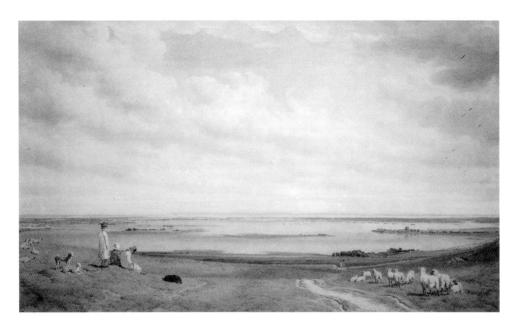

206 William Turner of Oxford, *Portsmouth Harbour from Portsdown Hill*, c. 1840 (cat. 310)

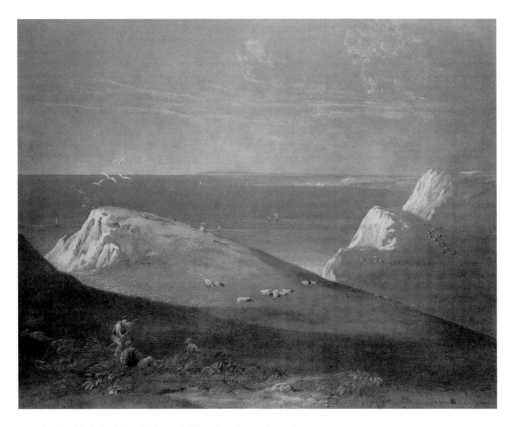

207 Anthony Vandyke Copley Fielding, *Shakespeare's Cliff, near Dover, (?)* c.1830 (cat. 128)

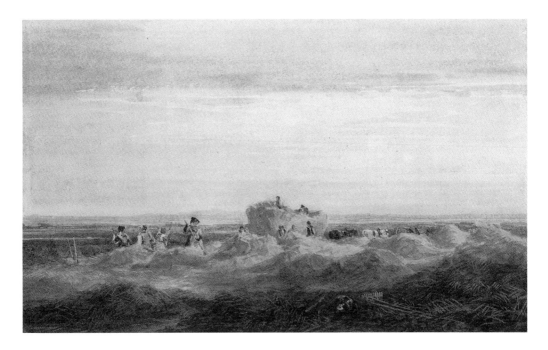

208 David Cox, *The Hayfield*, c. 1832 (cat. 71)

209 David Cox, *Cader Idris, with Women Washing Clothes in a Stream in the Foreground*, c. 1820 (cat. 64)

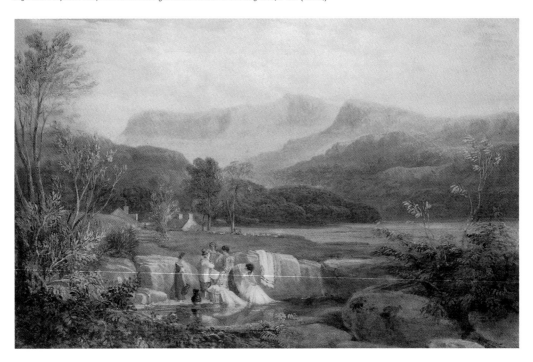

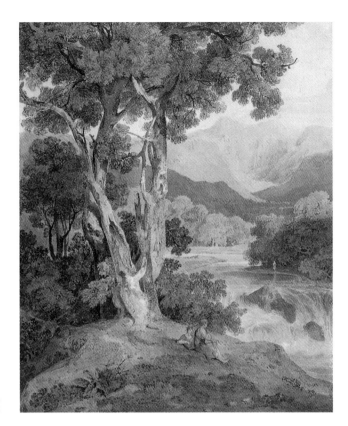

210 William Havell, *Classical Figures in a Mountainous Landscape (Moel Siabod)*, 1805 (cat. 159)

211 John Glover, *A Scene in Italy*, c. 1820 (cat. 155)

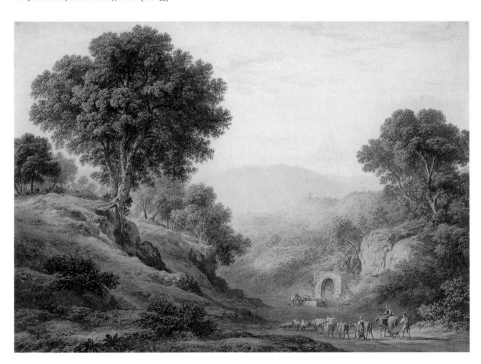

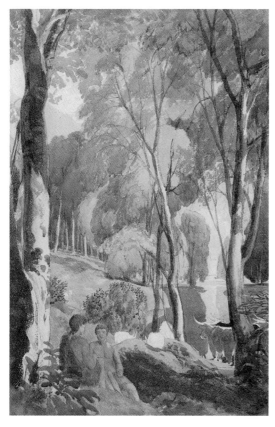

212 Cornelius Varley, *Pastoral, with Cattle and Figures in a Glade*, c. 1810 (cat. 315)

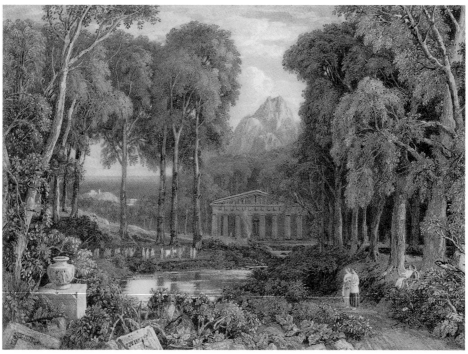

213 Francis Oliver Finch, *Religious Ceremony in Ancient Greece*, c. 1835 (cat. 130)

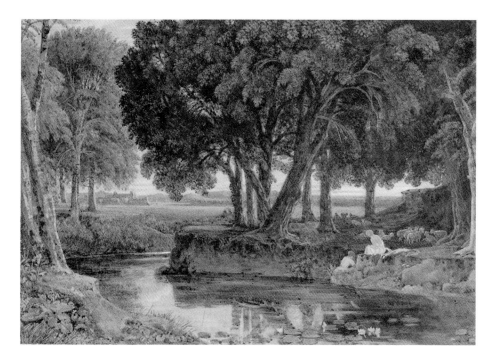

214 George Barret Jnr, *The Close of the Day*, 1829 (cat. 7)

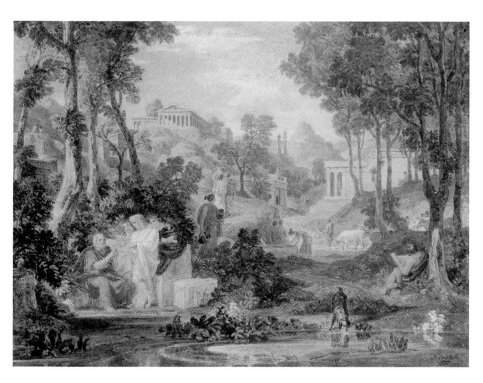

215 Joshua Cristall, *The Grove of Accademia – Plato Teaching*, 1820 (cat. 98)

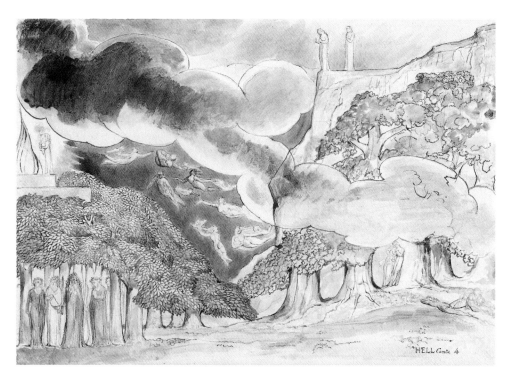

216 William Blake, *Homer and the Ancient Poets*, 1824–7 (cat. 11)

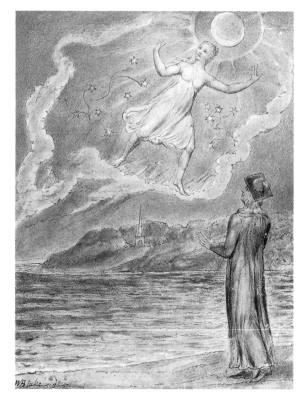

217 William Blake, *The Wand'ring Moon*, c. 1816–20 (cat. 9)

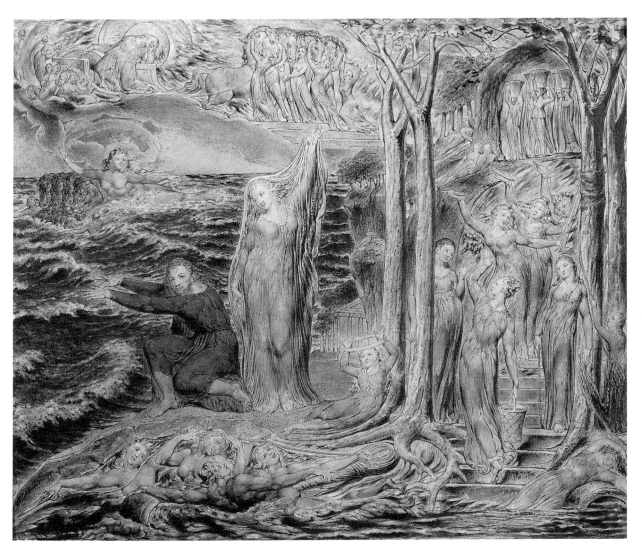

218 William Blake, *The Arlington Court Picture* ('*The Sea of Time and Place*'), 1821 (cat. 10)

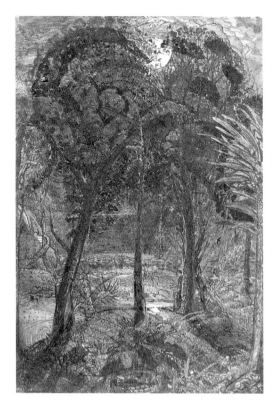

219 Samuel Palmer, *Moonlit Scene with a Winding River*, c. 1827 (cat. 223)

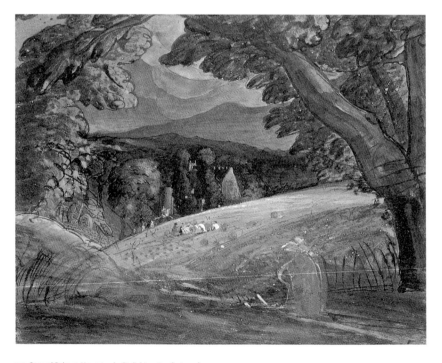

220 Samuel Palmer, *Harvesters by Firelight*, c. 1830 (cat. 224)

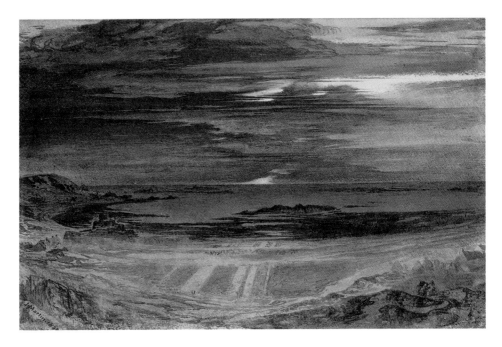

221 John Martin, *Sunset over a Rocky Bay*, 1830 (cat. 210)

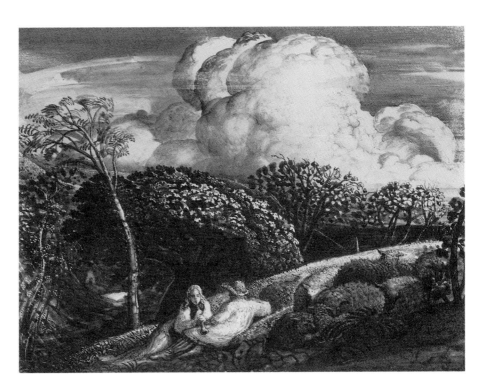

222 Samuel Palmer, *The Bright Cloud*, c. 1833–4 (cat. 225)

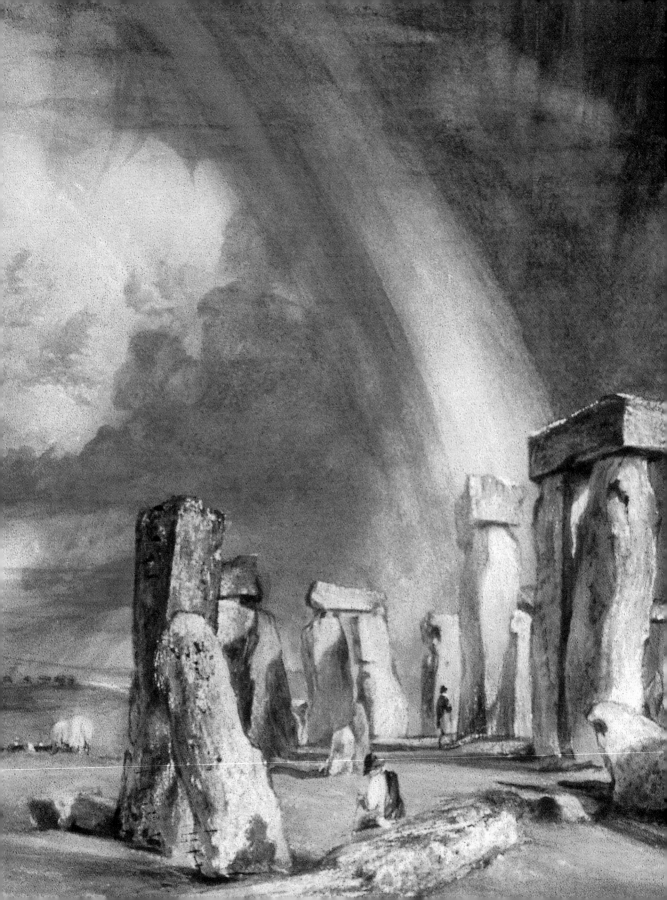

V

LIGHT AND ATMOSPHERE

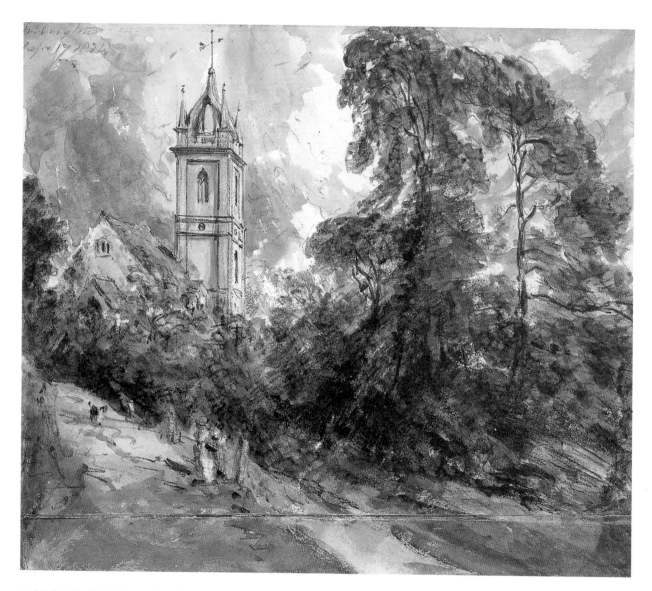

223 John Constable, *Tillington Church*, 1834 (cat. 32)

224 John Constable, *View over London from Hampstead*, c. 1830–3 (cat. 29)

225 John Constable, *London from Hampstead*, c. 1830–3 (cat. 28)

226 John Constable, *Hampstead Heath from near Well Walk*, 1834 (cat. 33)

227 John Constable, *Folkestone from the Sea*, 1833 (cat. 31)

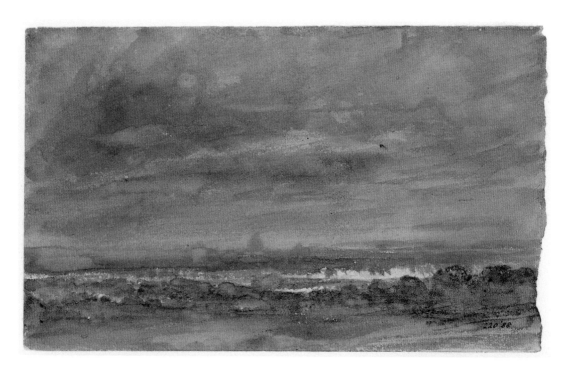

228 John Constable, *View at Hampstead, Looking towards London*, 1833 (cat. 30)

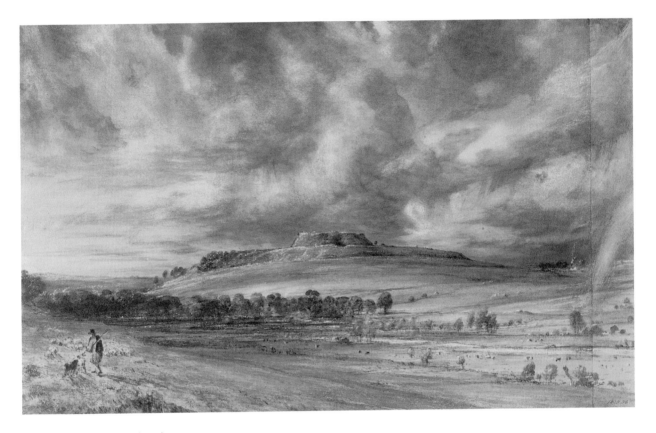

229 John Constable, *Old Sarum*, 1834 (cat. 34)

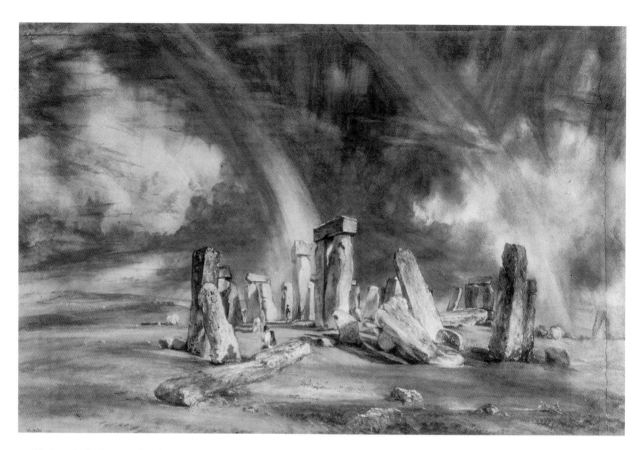

230 John Constable, *Stonehenge*, 1836 (cat. 35)

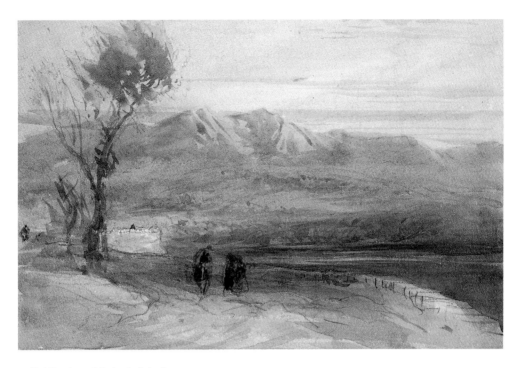

231 David Cox, *Barmouth Road*, c. 1850 (cat. 74)

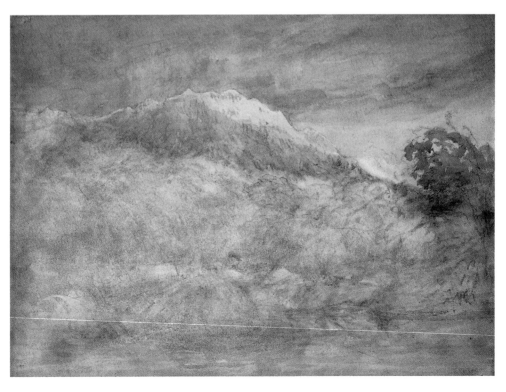

232 David Cox, *'An Impression': The Crest of a Mountain*, c. 1853 (cat. 76)

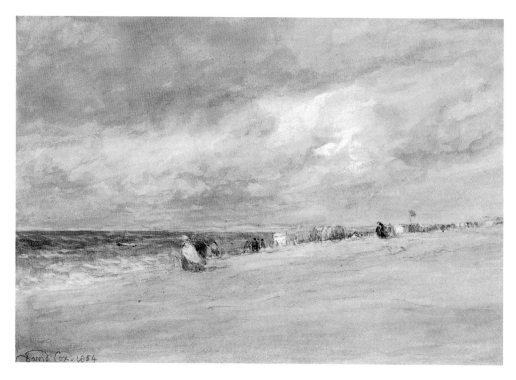

233 David Cox, *The Beach at Rhyl*, 1854 (cat. 77)

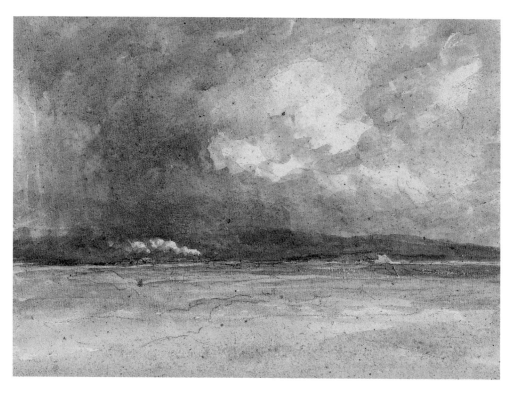

234 David Cox, *A Train near the Coast*, c. 1850 (cat. 75)

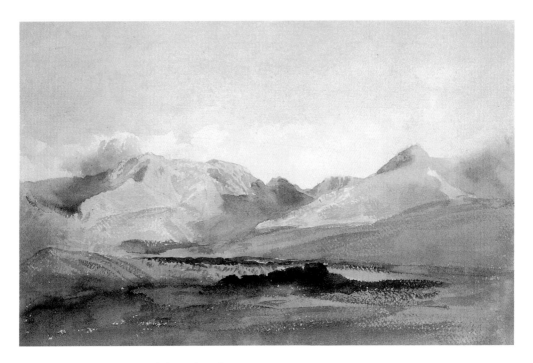

235 Peter de Wint, *Mountain Scene, Westmorland*, c. 1840 (cat. 119)

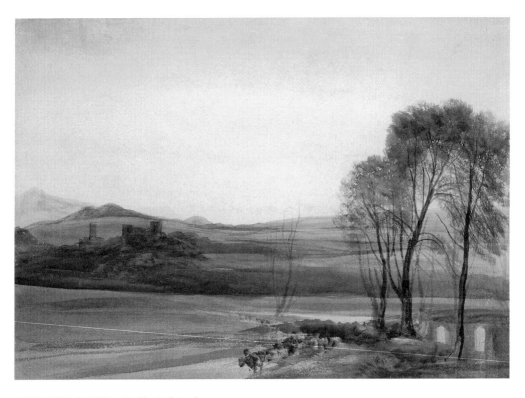

236 Peter de Wint, *Clee Hill, Shropshire*, (?) c. 1845 (cat. 122)

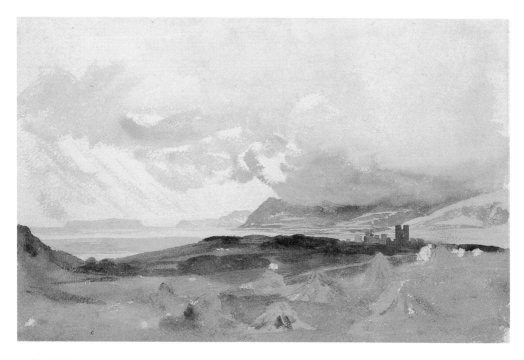

237 Peter de Wint, *View near Bangor, North Wales: Penrhyn Castle with Penmaenmawr beyond*, (?) c. 1840 (cat. 120)

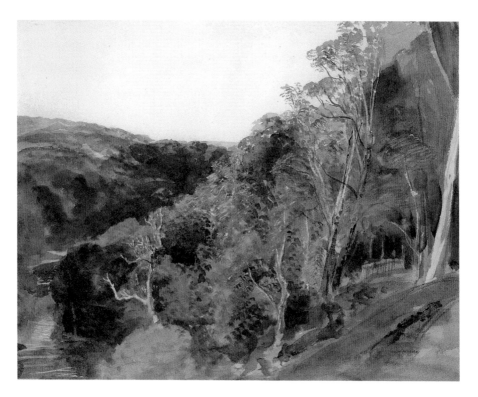

238 Peter de Wint, *Trees at Lowther, Westmorland*, c. 1840–5 (cat. 121)

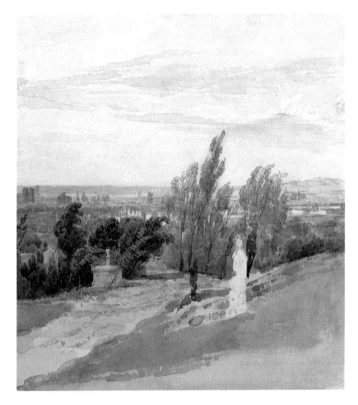

239 Richard Parkes Bonington, *Paris from Père Lachaise*, c. 1825 (cat. 12)

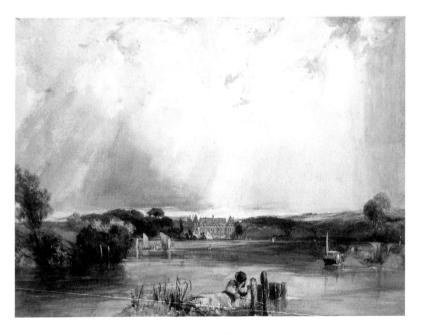

240 Richard Parkes Bonington, *Château of the Duchesse de Berri*, c. 1825 (cat. 13)

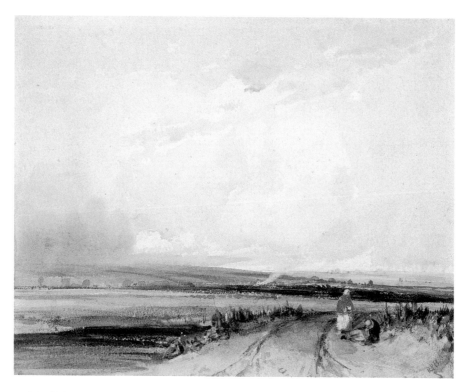

241 Richard Parkes Bonington, *Near Burnham, Norfolk*, c. 1825 (cat. 14)

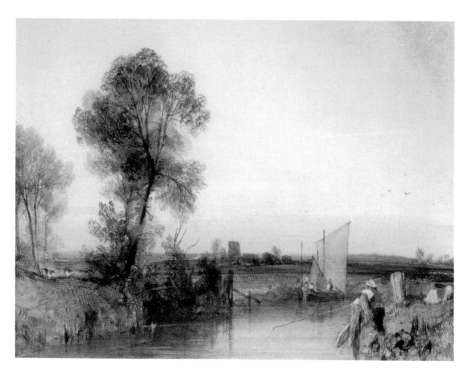

242 Richard Parkes Bonington, *A Fisherman on the Banks of a River, a Church Tower in the Distance*, c. 1825–6 (cat. 15)

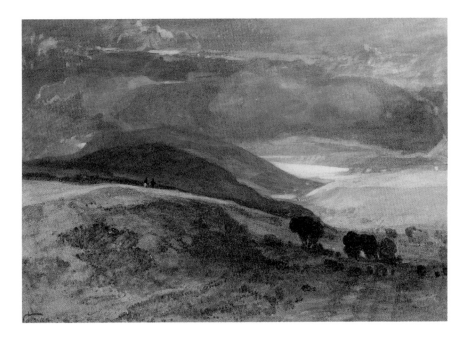

243 John Sell Cotman, *On the Downs*, c. 1840 (cat. 61)

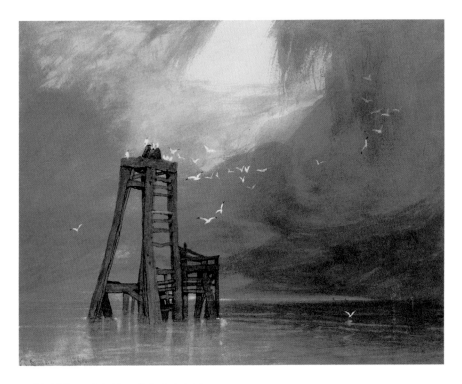

244 John Sell Cotman, *Study of Sea and Gulls*, 1832 (cat. 60)

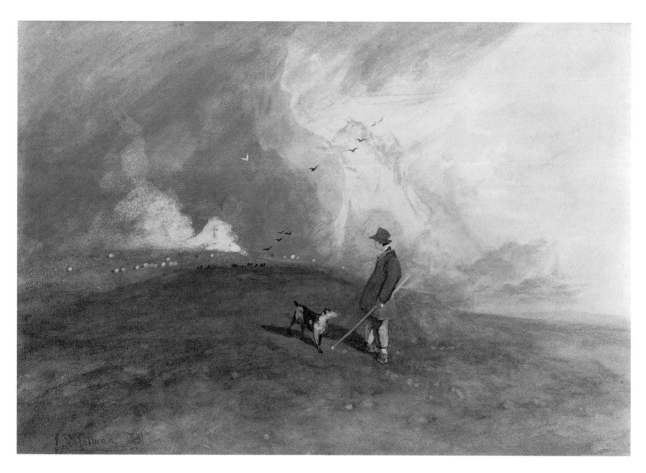

245 John Sell Cotman, *The Shepherd on the Hill*, 1831 (cat. 59)

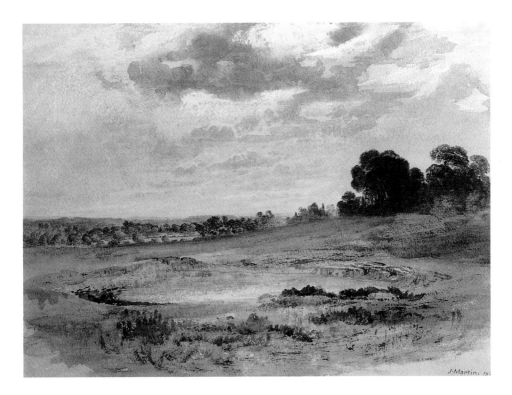

246 John Martin, *Landscape*, 1835 (? 1839) (cat. 211)

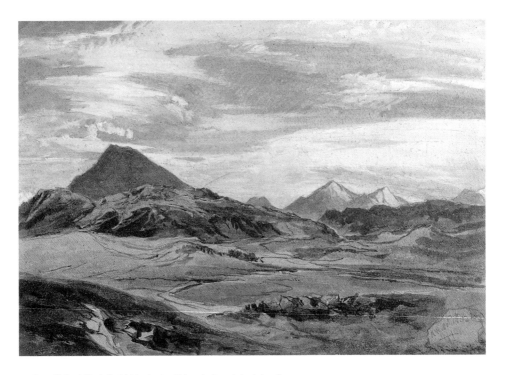

247 James Holland, *View in North Wales: Arenig, with Snowdon Beyond*, 1852 (cat. 172)

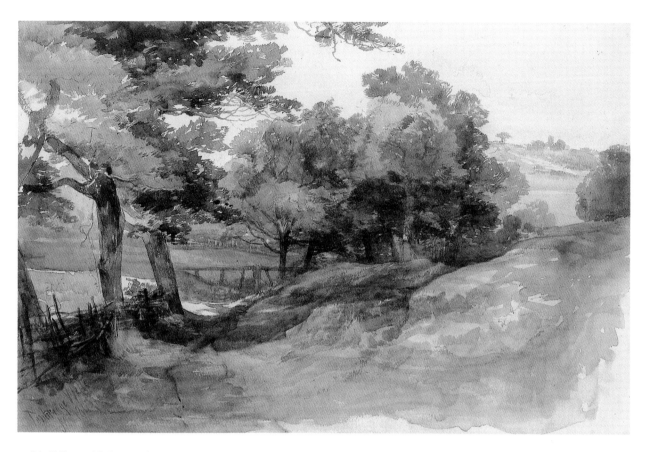

248 John Middletown, *A Shady Lane, Tunbridge Wells, Kent*, 1847 (cat. 213)

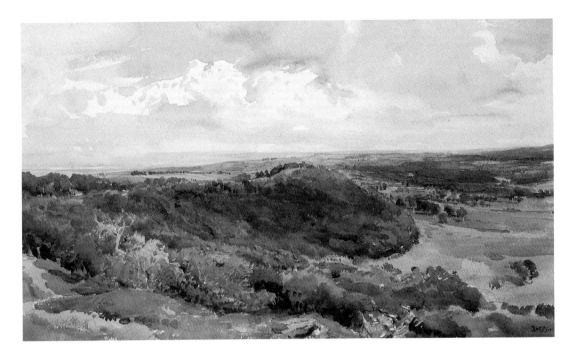

249 Thomas Collier, *Haresfield Beacon*, c. 1880 (cat. 23)

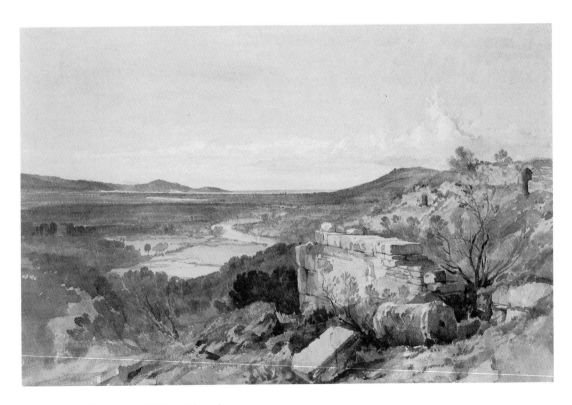

250 William James Müller, *Distant View of Xanthus*, 1843 (cat. 217)

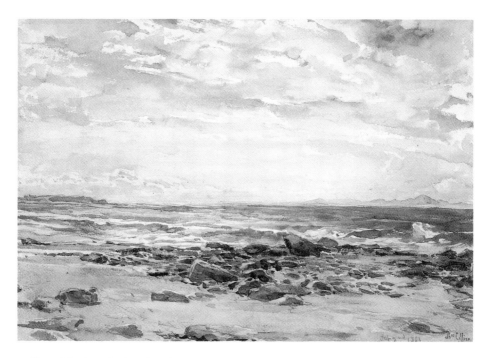

251 Thomas Collier, *Pensarn Beach*, 1886 (cat. 24)

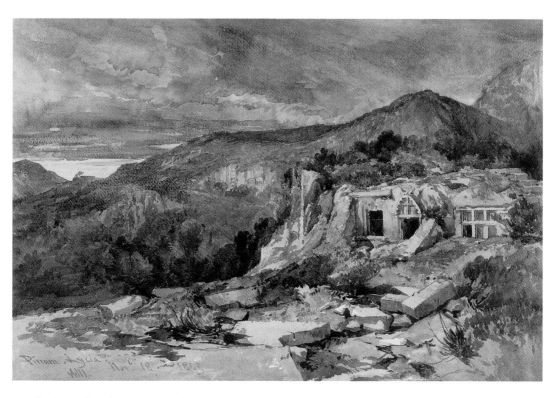

252 William James Müller, *Rock Tombs at Pinara*, 1843 (cat. 218)

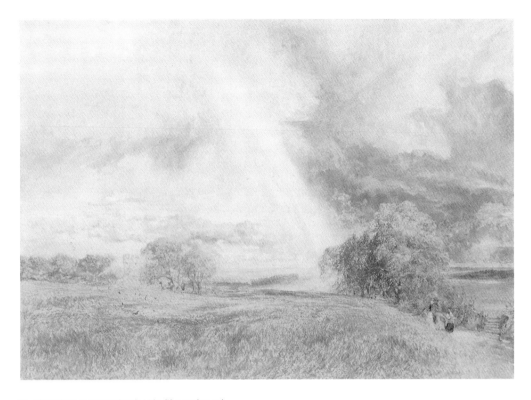

253 Alfred William Hunt, *Near Abergele, Wales,* (?) c. 1860 (cat. 174)

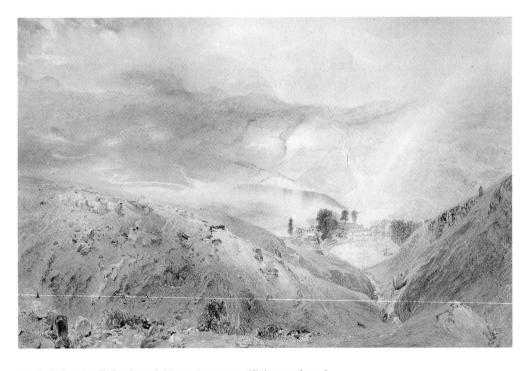

254 Alfred William Hunt, *The Tarn of Watendlath between Derwentwater and Thirlmere,* 1858 (cat. 173)

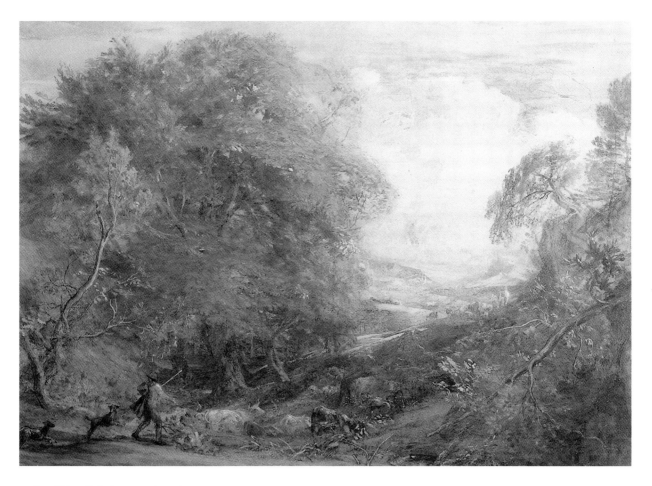

255 Samuel Palmer, *The Herdsman*, c. 1850 (cat. 227)

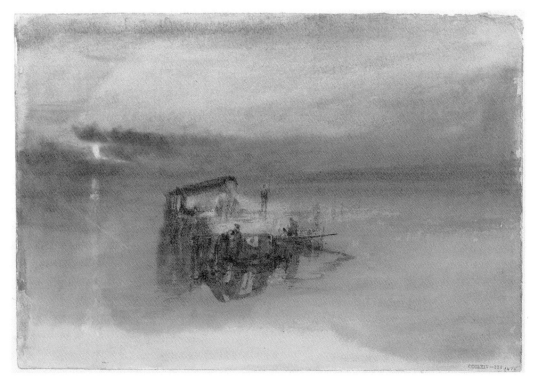

256 Joseph Mallord William Turner, *A Raft and Rowing-boat on a Lake by Moonlight*, c. 1840 (cat. 298)

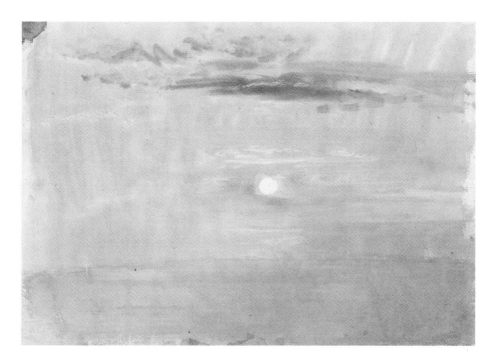

257 Joseph Mallord William Turner, *The Sun Setting over the Sea in Orange Mist*, c. 1825 (cat. 291)

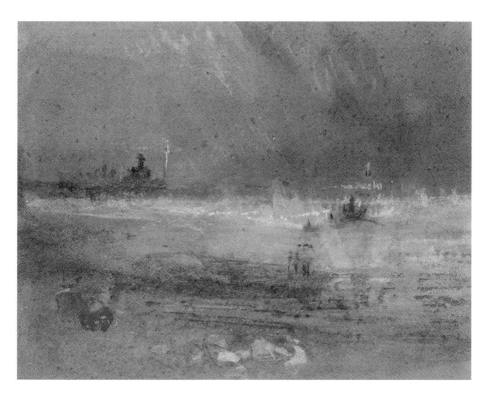

258 Joseph Mallord William Turner, *Storm off the East Coast*, (?) c. 1835 (cat. 296)

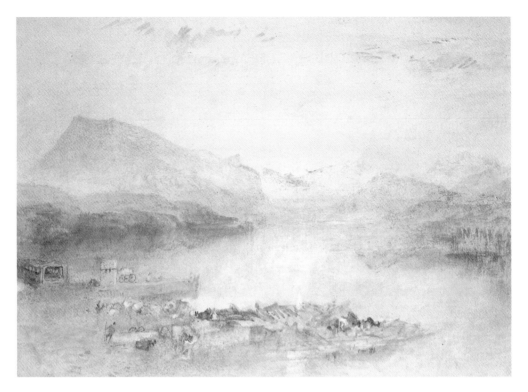

259 Joseph Mallord William Turner, *The Rigi at Sunset, c.* 1841 (cat. 303)

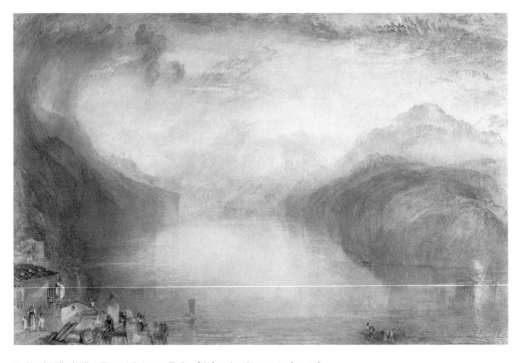

260 Joseph Mallord William Turner, *Lake Lucerne: The Bay of Uri from above Brunnen,* 1842 (cat. 304)

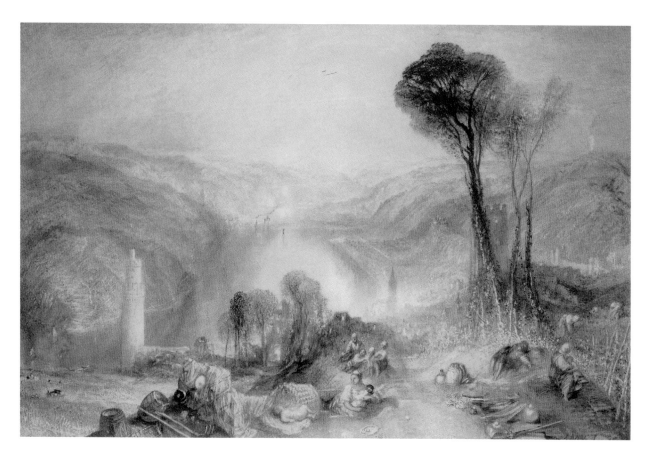

261 Joseph Mallord William Turner, *Oberwesel*, 1840 (cat. 297)

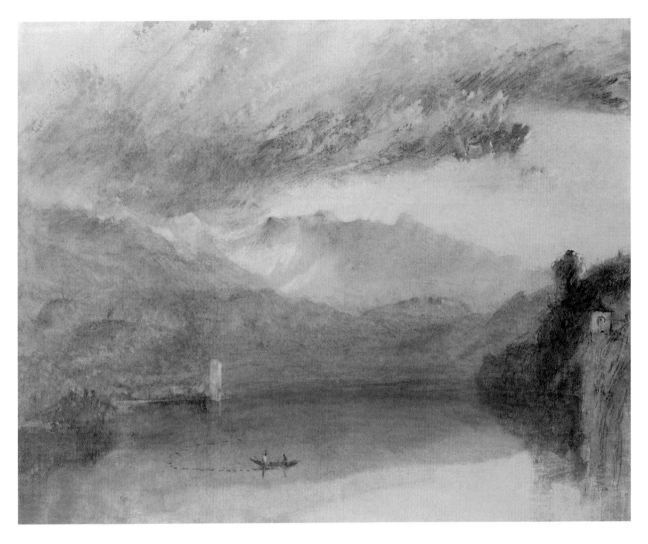

262 Joseph Mallord William Turner, *The Lake of Brientz*, 1841 (cat. 301)

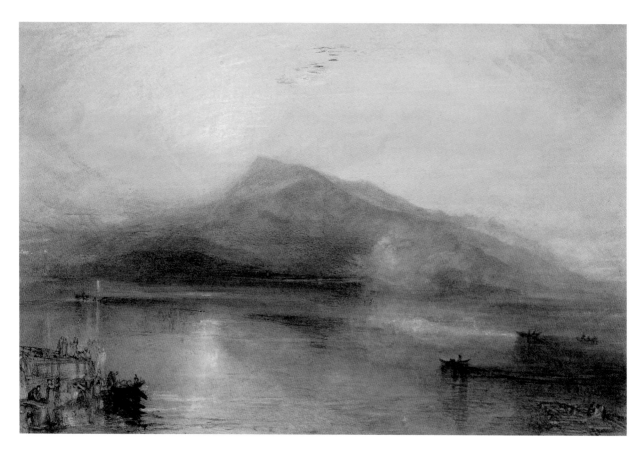

263 Joseph Mallord William Turner, *The Dark Rigi*, 1842 (cat. 305)

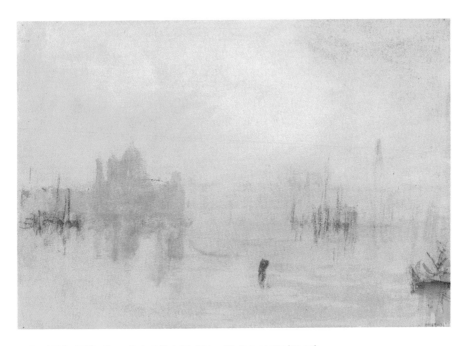

264 Joseph Mallord William Turner, *Venice: S. Maria della Salute and the Dogana*, c. 1840 (cat. 299)

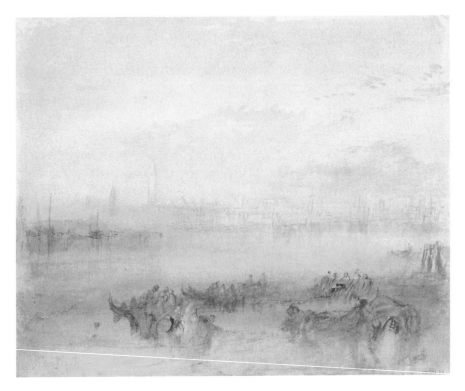

265 Joseph Mallord William Turner, *Venice: The Riva degli Schiavoni from the Channel to the Lido*, c. 1840 (cat. 300)

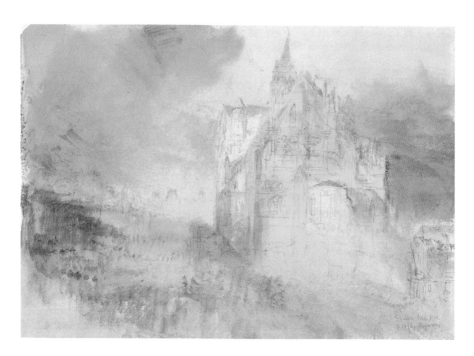

266 Joseph Mallord William Turner, *The Cathedral at Eu*, 1845 (cat. 306)

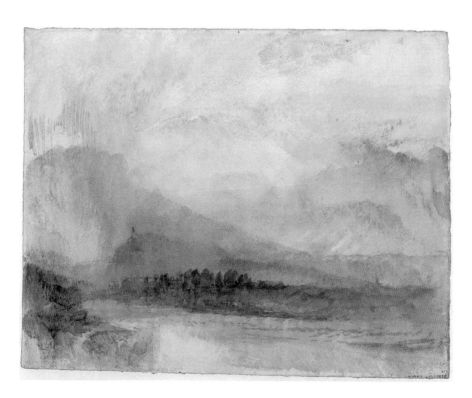

267 Joseph Mallord William Turner, *The Rhine at Reichenau*, (?) 1841 (cat. 302)

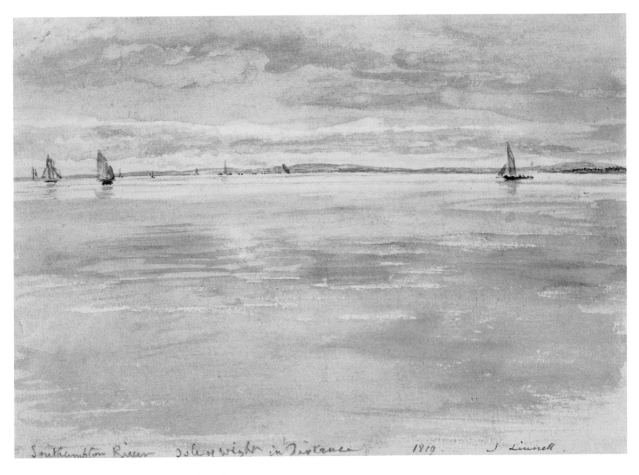

Southampton River Isle of Wight in Distance 1819. J. Linnell.

268 John Linnell, *Sailing-boats on Southampton Water*, 1819 (cat. 208)

269 James Abbott McNeill Whistler, *St Ives*, c. 1883 (cat. 324)

270 James Abbott McNeill Whistler, *Beach Scene*, c. 1883 (cat. 325)

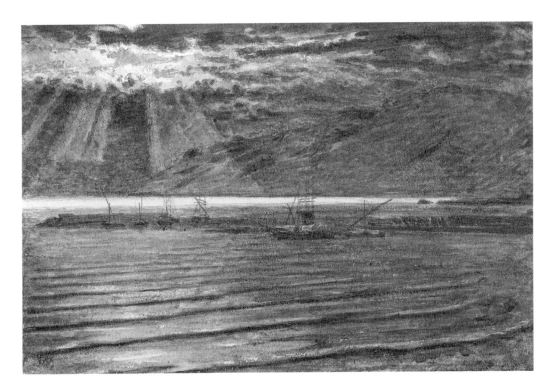

271 William Holman Hunt, *Fishing-boats by Moonlight*, c. 1869 (cat. 185)

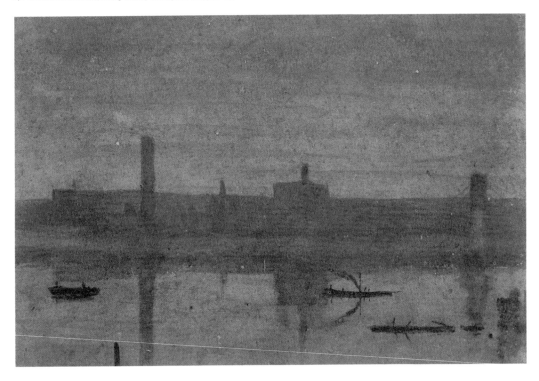

272 George Price Boyce, *Night Sketch of the Thames near Hungerford Bridge*, c. 1860-2 (cat. 18)

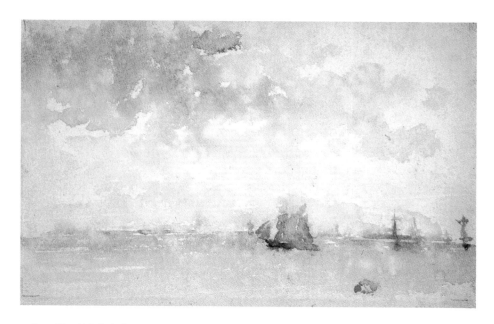

273 James Abbott McNeill Whistler, *Seascape, A Grey Note,* (?) c. 1880 (cat. 323)

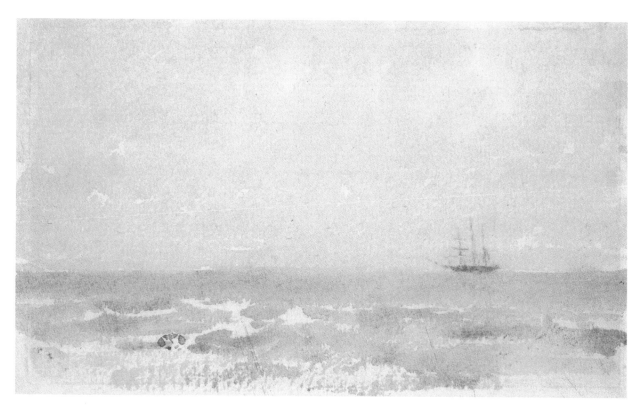

274 James Abbott McNeill Whistler, *Seascape with Schooner,* (?) c. 1880 (cat. 322)

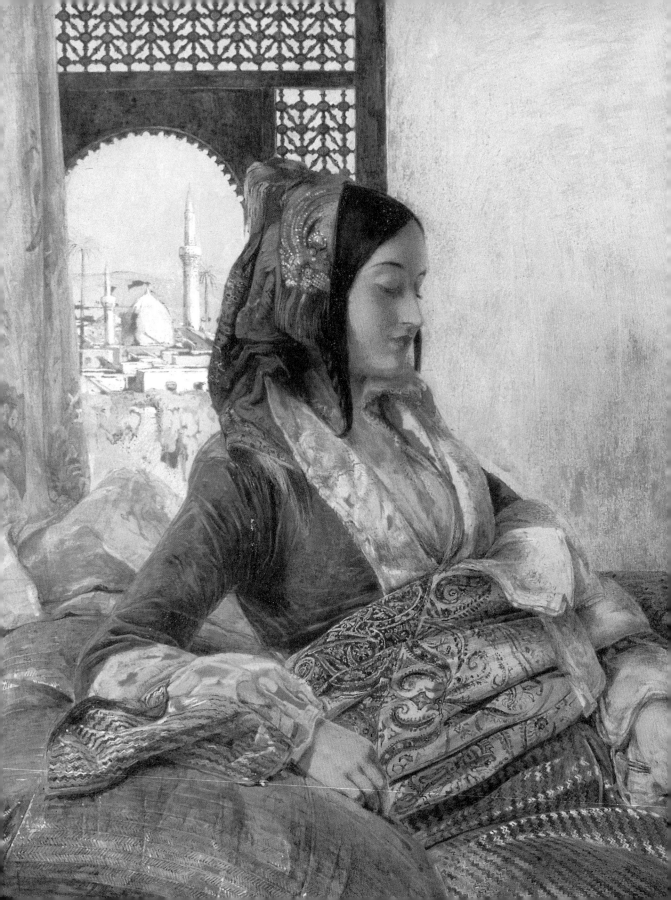

VI

THE EXHIBITION WATERCOLOUR

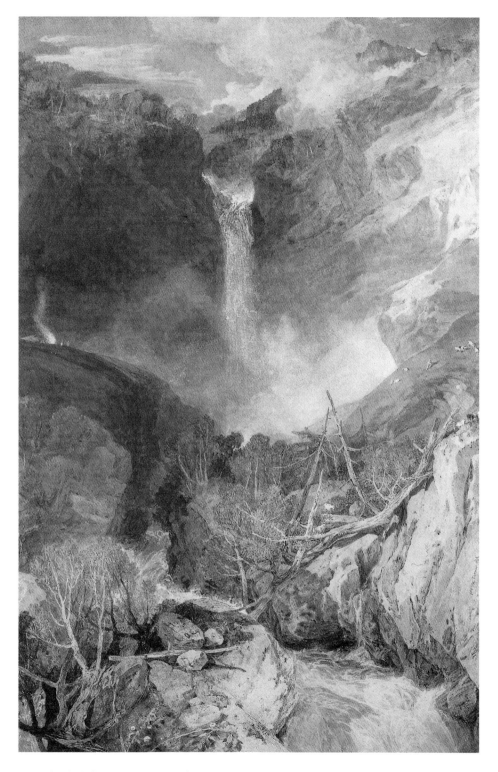

275 Joseph Mallord William Turner, *The Great Falls of the Reichenbach*, 1804 (cat. 284)

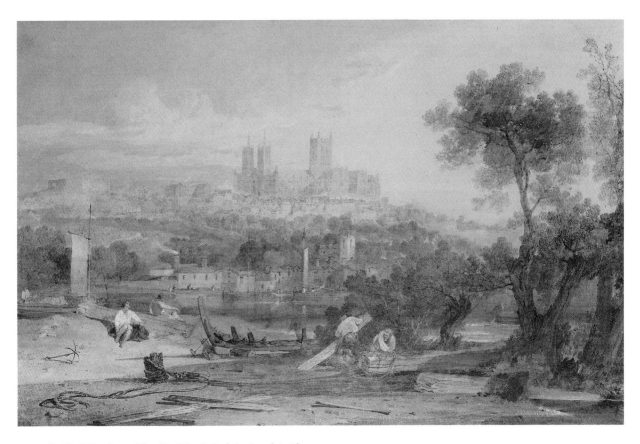

276 Joseph Mallord William Turner, *A View of Lincoln from the Brayford*, c. 1802–3 (cat. 283)

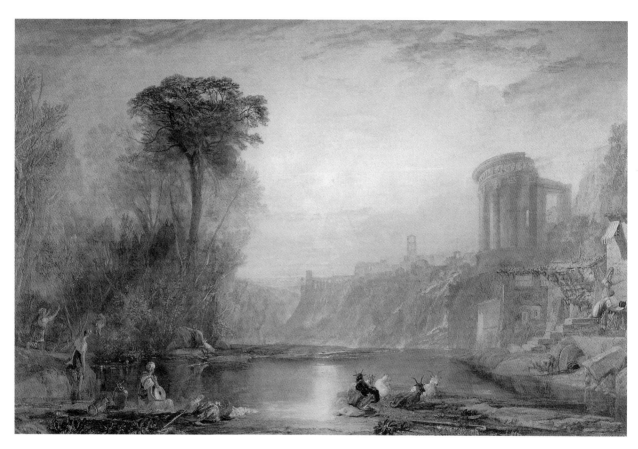

277 Joseph Mallord William Turner, *Landscape: Composition of Tivoli*, 1817 (cat. 287)

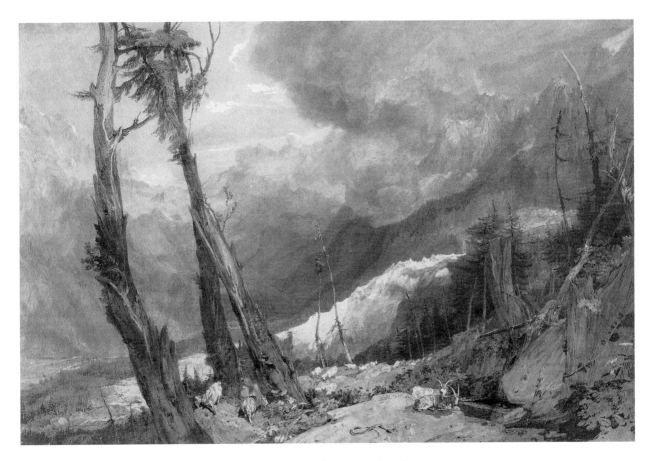

278 Joseph Mallord William Turner, *Glacier and Source of the Arveiron, Going up the Mer de Glace, Chamonix*, 1802–3 (cat. 282)

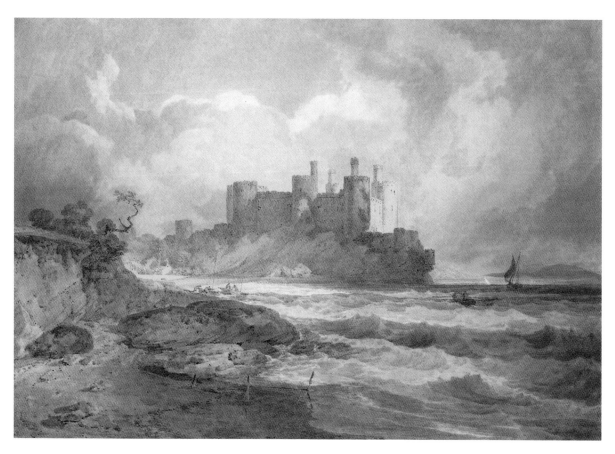

279 Joseph Mallord William Turner, *Conway Castle*, 1800 (cat. 281)

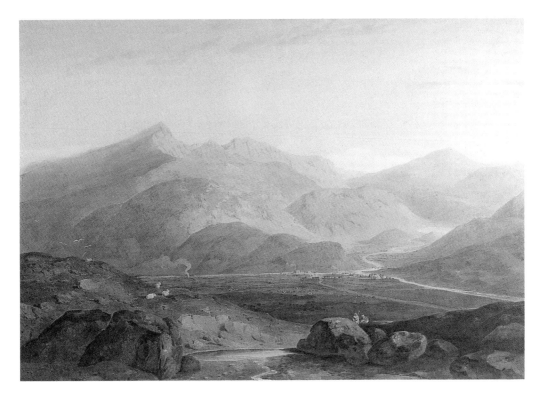

280 John Varley, *Snowdon from Moel Hebog*, 1805 (cat. 318)

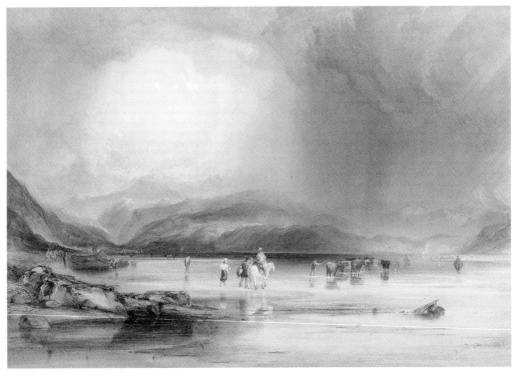

281 Anthony Vandyke Copley Fielding, *View of Snowdon from the Sands of Traeth Mawr, Taken at the Ford between Pont Aberglaslyn and Tremadoc*, 1834 (cat. 129)

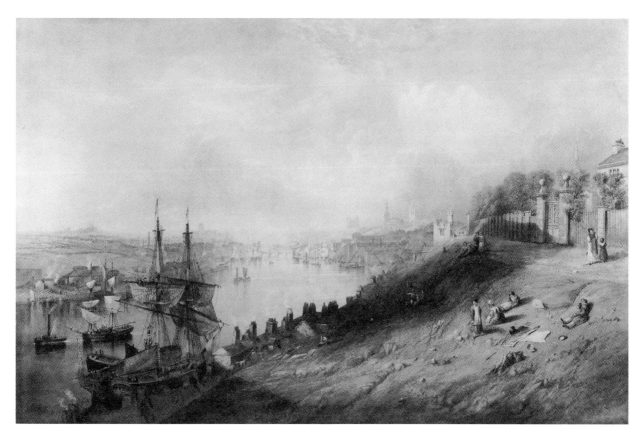

282 John Wilson Carmichael, *Newcastle from St Ann's*, 1835 (cat. 22)

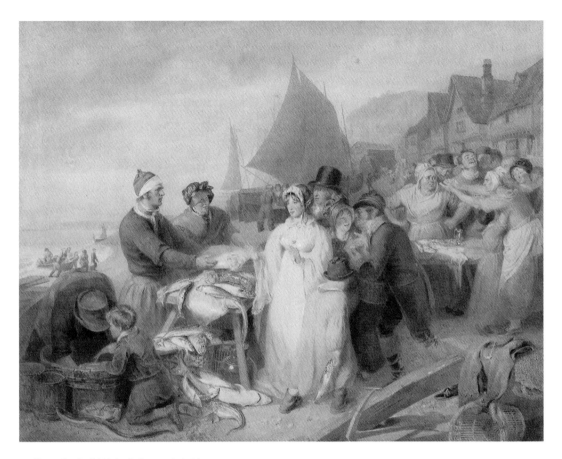

283 Thomas Heaphy, *Fish Market, Hastings*, 1809 (cat. 162)

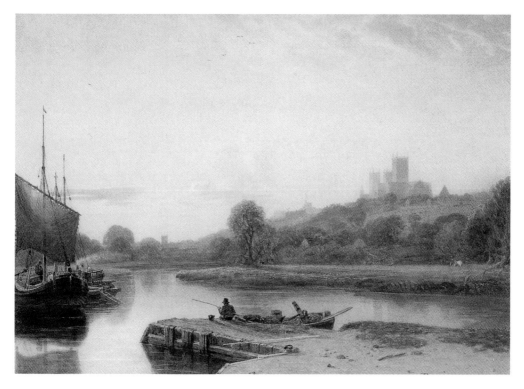

284 Peter de Wint, *Lincoln Cathedral from the River*, c. 1825 (cat. 115)

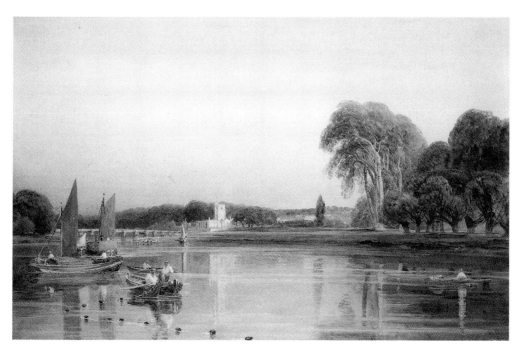

285 Peter de Wint, *Cookham on Thames*, (?) c. 1830 (cat. 116)

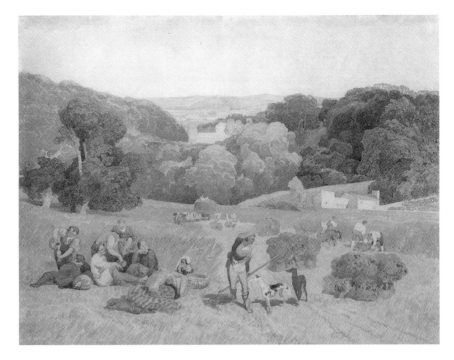

286 John Sell Cotman, *The Harvest Field, A Pastoral*, c. 1810 (cat. 53)

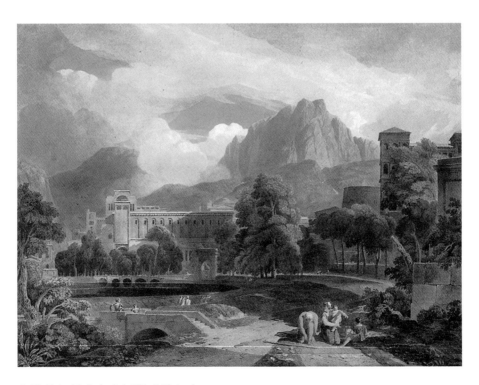

287 John Varley, *Suburbs of an Ancient City*, 1808 (cat. 319)

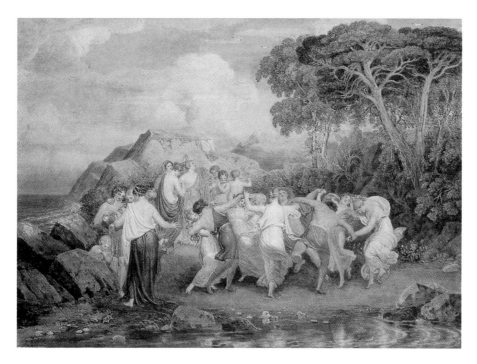

288 Joshua Cristall, *Nymphs and Shepherds Dancing*, c. 1825 (cat. 100)

289 Joshua Cristall, *A Woman Spinning ('Bessy and her Spinning Wheel')*, 1824 (cat. 99)

290 William Turner of Oxford, *Halnaker Mill, near Chichester, Sussex*, c. 1837 (cat. 309)

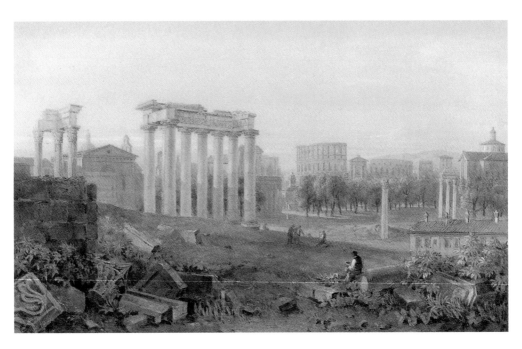

291 Hugh William 'Grecian' Williams, *View of the Forum in Rome*, 1828 (cat. 326)

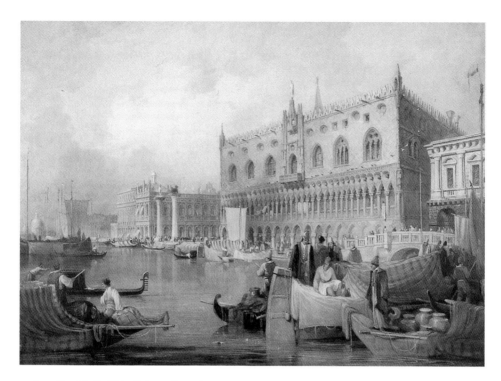

292 Samuel Prout, *The Ducal Palace, Venice*, 1830 (cat. 234)

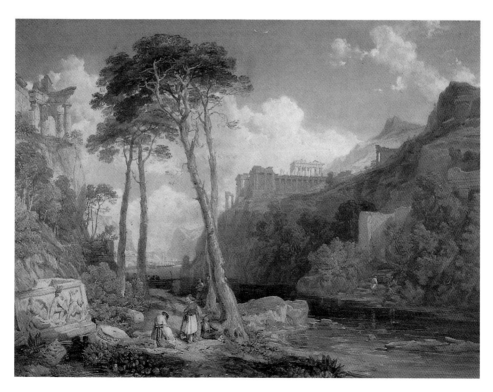

293 James Duffield Hardling, *Modern Greece*, 1828 (cat. 158)

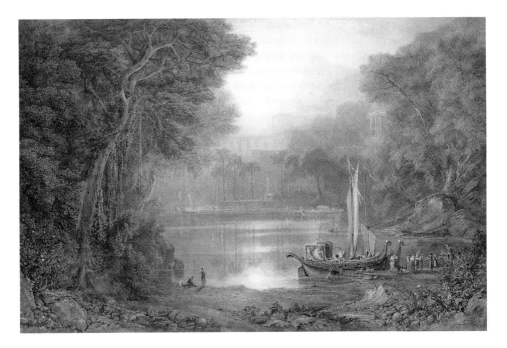

294 Samuel Jackson, *Composition: A Land of Dreams*, 1830 (cat. 190)

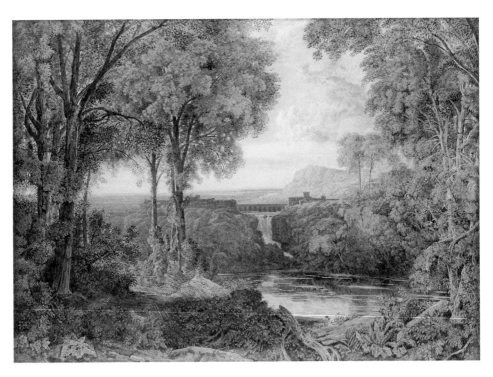

295 George Barret Jnr, *Solitude: An Italianate Landscape with a Figure Reclining beneath Trees*, 1823 (cat. 6)

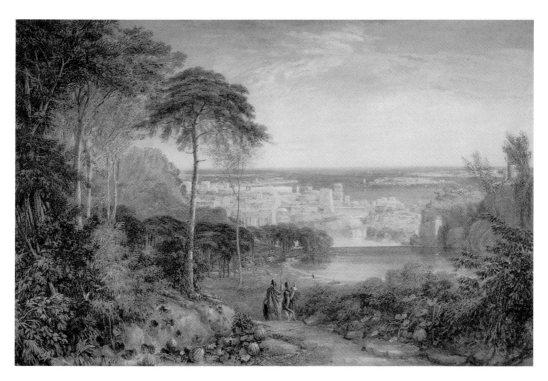

296 David Cox, *Carthage: Aeneas and Achates*, 1825 (cat. 66)

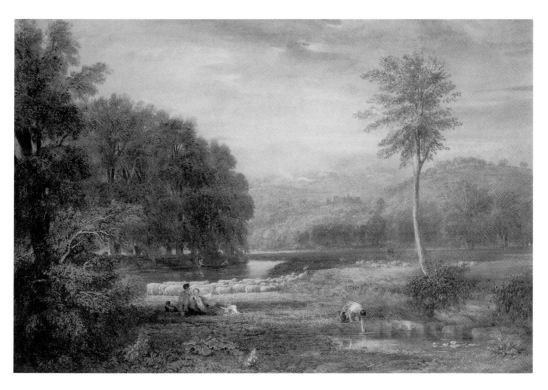

297 David Cox, *Pastoral Scene in Herefordshire*, (?) 1824 (cat. 65)

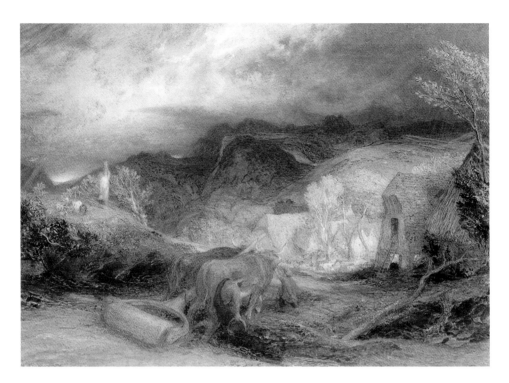

298 Samuel Palmer, *Morning (Illustration to Milton's 'Il Penseroso')*, 1869 (cat. 230)

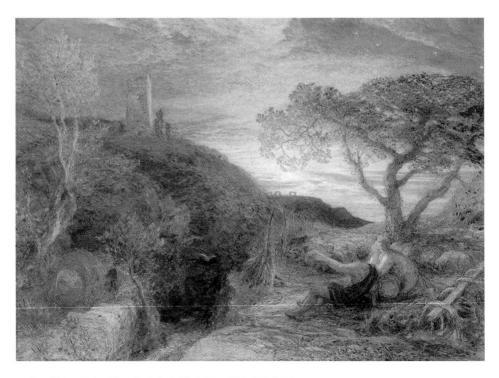

299 Samuel Palmer, *The Lonely Tower (Illustration to Milton's 'Il Penseroso')*, 1868 (cat. 228)

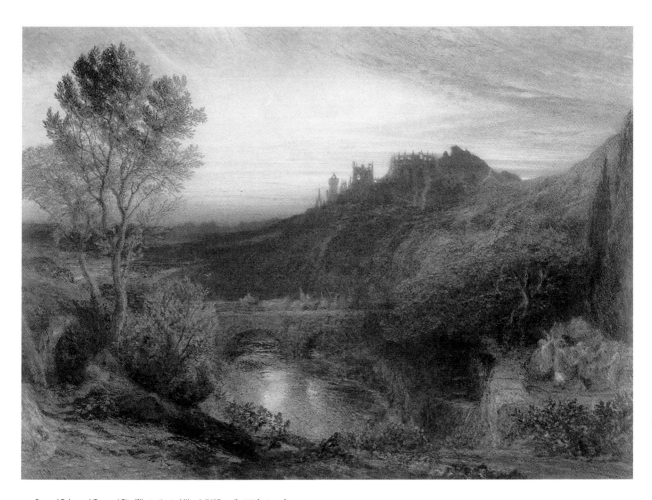

300 Samuel Palmer, *A Towered City (Illustration to Milton's 'L'Allegro')*, 1868 (cat. 229)

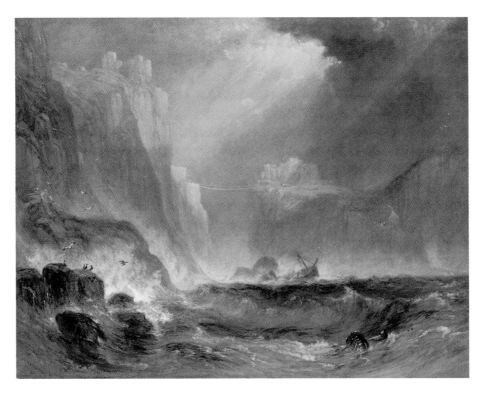

301 Henry Gastineau, *Carrick-y-Rede, Antrim*, 1839 (cat. 135)

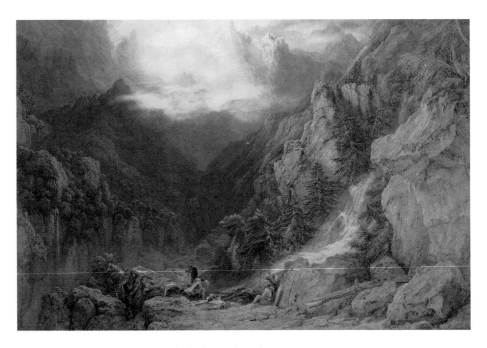

302 Samuel Jackson, *Composition: Hunters Resting after the Chase*, 1827 (cat. 189)

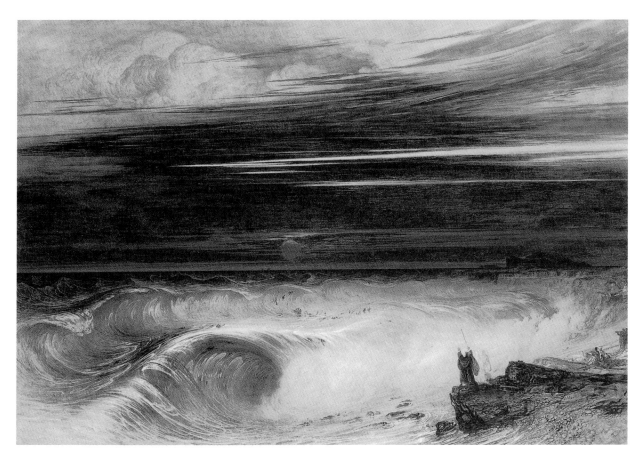

303 John Martin, *The Destruction of Pharaoh's Host*, 1836 (cat. 212)

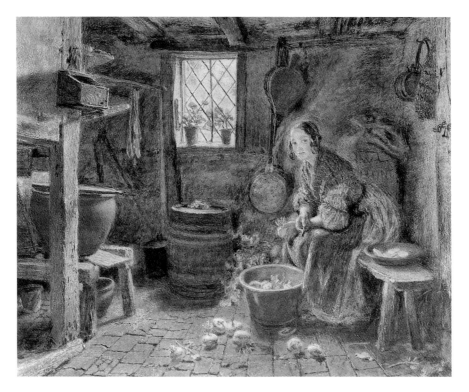

304 William Henry Hunt, *The Kitchen Maid*, c. 1833 (cat. 181)

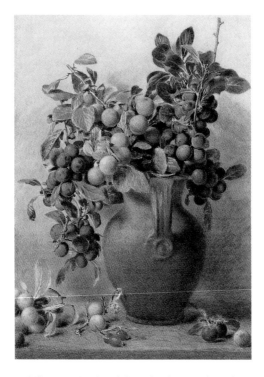

305 William Henry Hunt, *Jug with Plums and Rosehips*, c. 1840 (cat. 182)

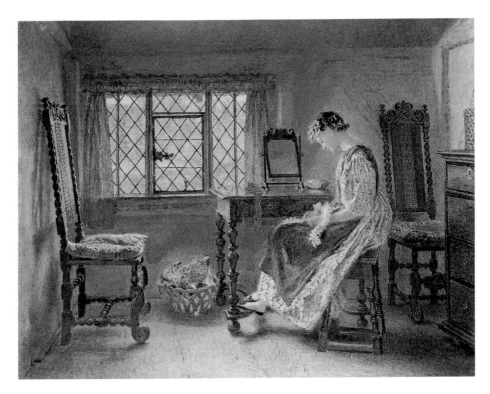

306 William Henry Hunt, *Preparing for Sunday*, c. 1832 (cat. 180)

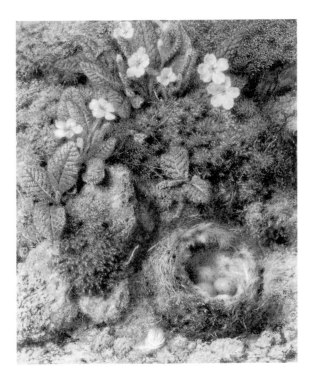

307 William Henry Hunt, *Primroses with Bird's Nest*, c. 1850 (cat. 183)

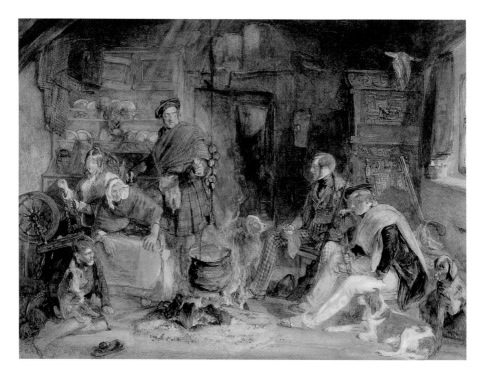

308 John Frederick Lewis, *Highland Hospitality*, 1832 (cat. 196)

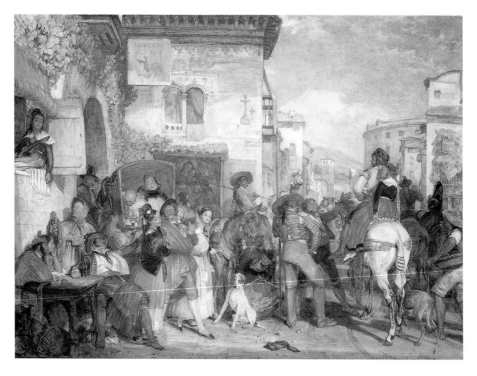

309 John Frederick Lewis, *The Suburbs of a Spanish City (Granada) on the Day of a Bull-fight*, 1836 (cat. 198)

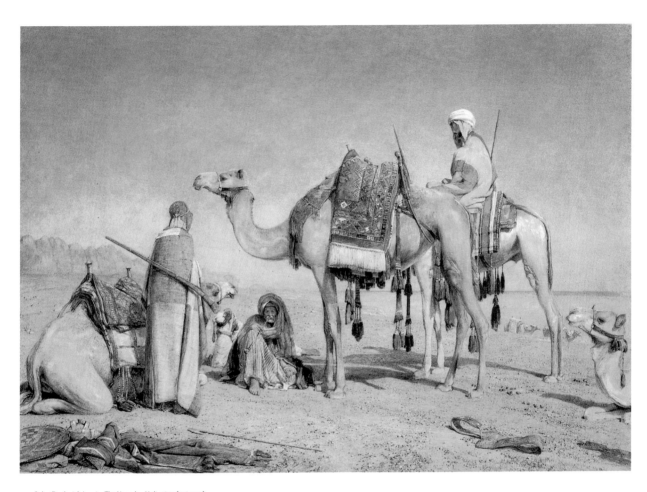

310 John Frederick Lewis, *The Noonday Halt*, 1853 (cat. 199)

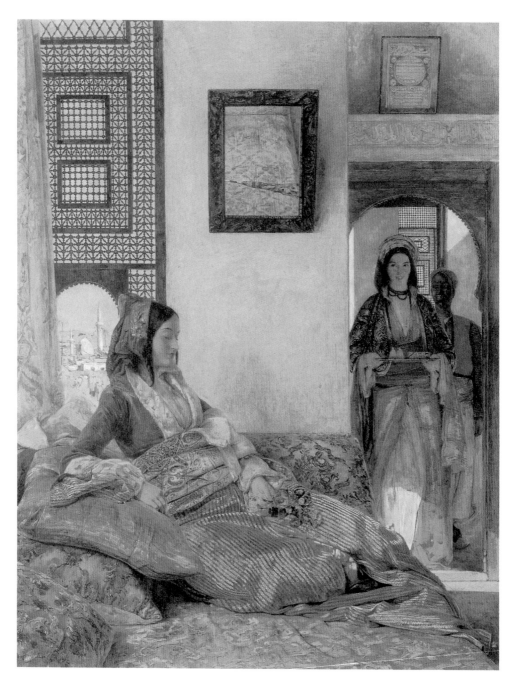

311 John Frederick Lewis, *Life in the Hhareem, Cairo*, 1858 (cat. 200)

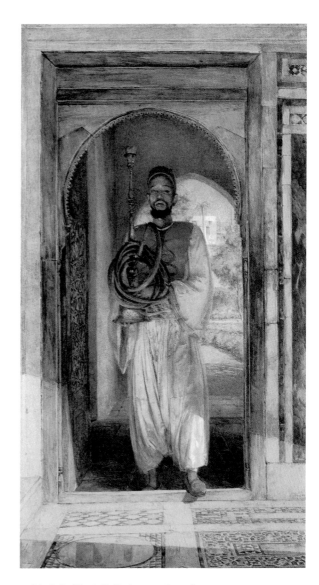

312 John Frederick Lewis, *Girl with Two Caged Doves*, 1864 (cat. 202)

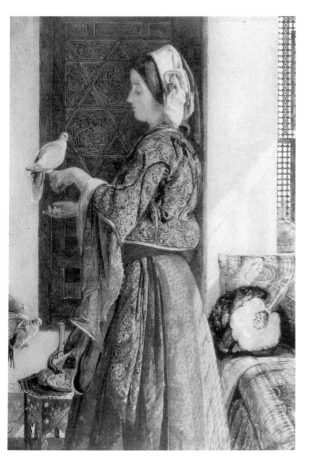

313 John Frederick Lewis, *The Pipe-bearer*, 1859 (cat. 201)

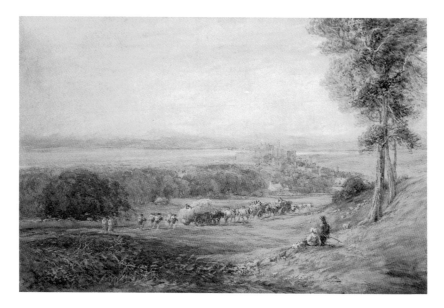

314 David Cox, *Lancaster: Peace and War*, 1842 (cat. 73)

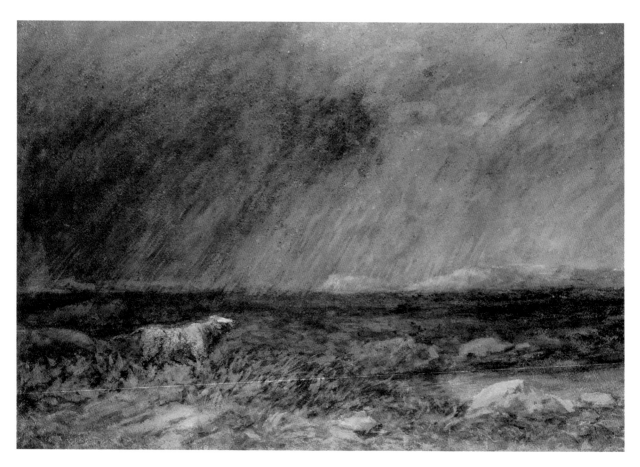

315 David Cox, *The Challenge: A Bull in a Storm on a Moor*, c. 1856 (cat. 78)

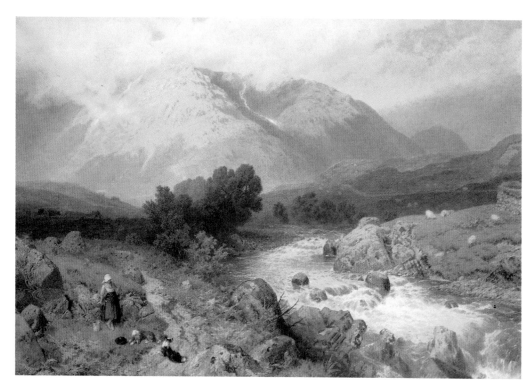

316 Myles Birket Foster, *Highland Scene near Dalmally*, 1885 (cat. 132)

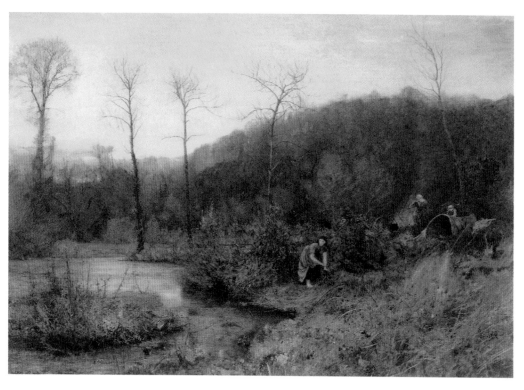

317 John William North, *Gypsy Encampment*, 1873 (cat. 222)

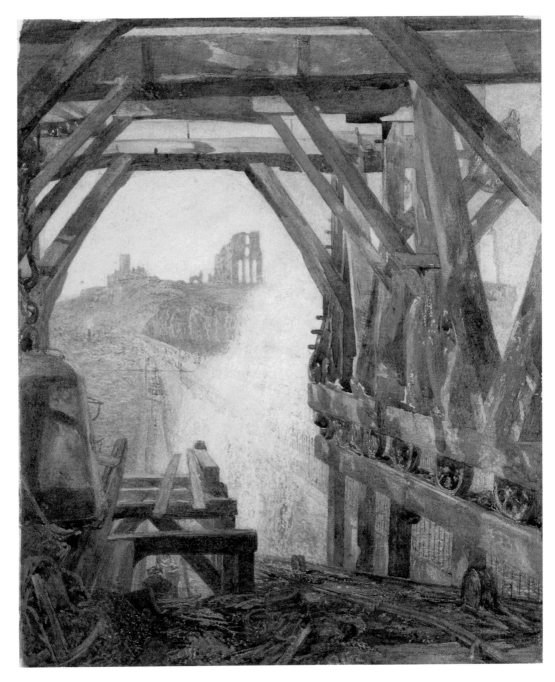

318 Alfred William Hunt, *Travelling Cranes, Diving Bells, etc. on the Extremity of Tynemouth Pier*, c. 1867 (cat. 175)

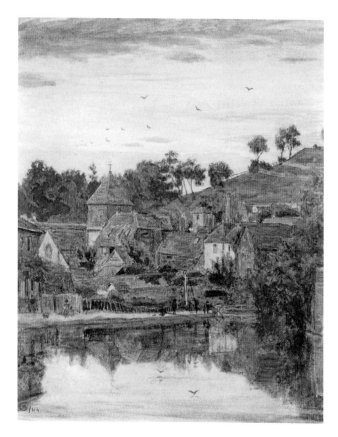

319　Albert Goodwin, *Near Winchester*, 1864 (cat. 156)

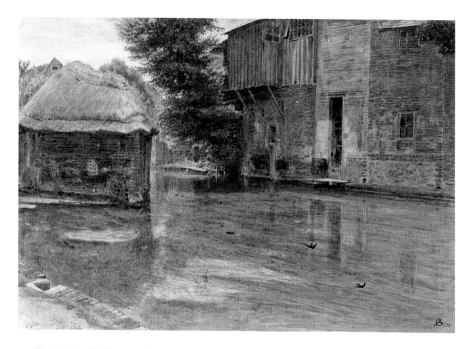

320　Albert Goodwin, *Old Mill, near Winchester*, 1875 (cat. 157)

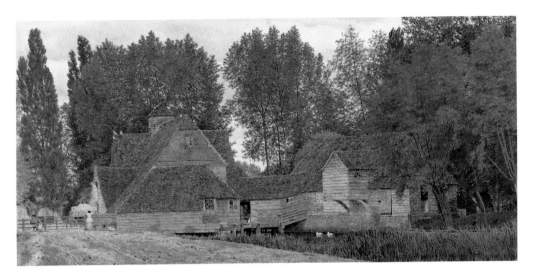

321 George Price Boyce, *The Mill on the Thames at Mapledurham, Oxfordshire*, 1860 (cat. 17)

322 George Price Boyce, *Black Poplars at Pangbourne, Berkshire*, (?) 1868 (cat. 19)

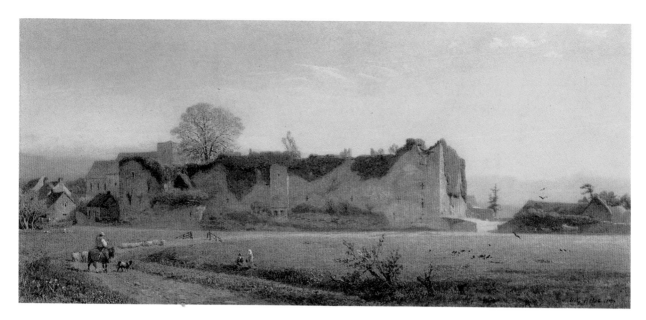

323 Henry George Hine, *Amberley Castle, Sussex, Seen from the Marshes*, 1867 (cat. 169)

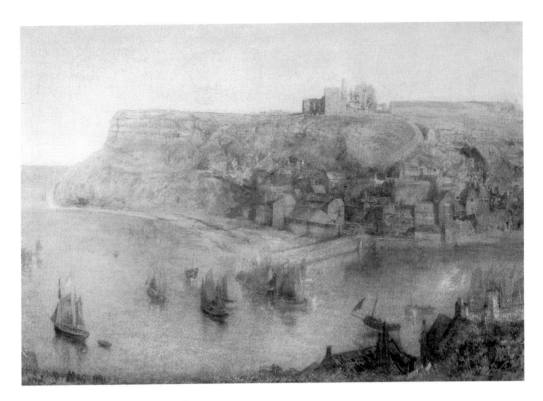

324 Alfred William Hunt, *Whitby,* (?) *c.* 1878 (cat. 177)

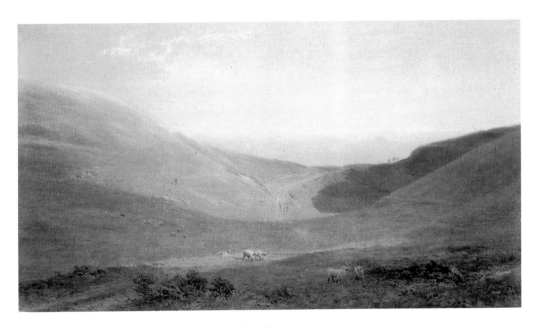

325 Henry George Hine, *Nine Barrow Down near Swanage, Dorset, c.* 1875 (cat. 170)

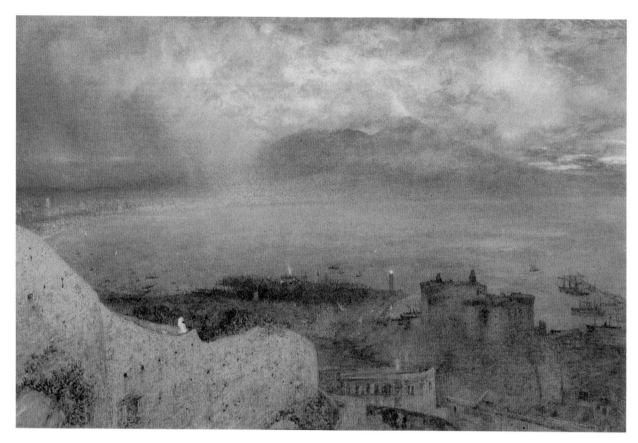

326 Alfred William Hunt, *Naples, or Land of Smouldering Fire*, 1871 (cat. 176)

GLOSSARY OF TECHNICAL TERMS

BODYCOLOUR

Lead white mixed with watercolour pigment to make it opaque. Lead white has a tendency to discolour (it blackens on exposure to hydrogen sulphide), and was gradually replaced by the more stable zinc white ('Chinese white'), manufactured by Winsor & Newton from 1834. A 'watercolour' can be executed entirely in bodycolour, or the use of bodycolour can be restricted to highlights, especially white highlights.

BRUSH

Watercolour brushes (known as 'pencils' in the eighteenth century) were mostly made of the hair of red sable, which is durable yet pliant and firm, and can be readily twisted to a point.

CAMERA OBSCURA

An apparatus that projects the image of an object or scene on to a sheet of paper, ground glass or other surface so that its outlines can be traced. It consists of a closed box (it can also be a room) that admits light through a small hole or lens, projecting an inverted image on the principle of the photographic camera. A mirror is usually installed in order to reflect the image the right way up. The *camera lucida* (patented in 1807 by W. H. Wollaston) is a more portable version of the *camera obscura* with a wider field of vision, and is so called because it performs the same function in full daylight. It consists of a glass prism that can be revolved on the end of an adjustable arm: the user looks down it with one eye while looking past it with the other at a reduced image projected on to the paper. The Graphic Telescope that Cornelius Varley patented in 1811 has a more compact shape than the *camera lucida* and a greater facility for adjustment. Internal mirrors automatically correct the direction of the image. Originally designed for landscapes, it was also used for portraits and architectural drawings, and when reducing images for the engraver.

CHALK

Natural *black chalk* is a mineral, a species of carbonaceous shale whose principal ingredients are carbon and clay. It is very adhesive to paper and makes an indelible mark. Natural *white chalk* is of two varieties: carbonate of calcium, or soapstone (steatite). Although chalk can be sharpened to a point, it quickly wears down, hence it produces a softer line than one made by a pencil.

CLAUDE GLASS

A darkened, slightly convex mirror, cased like a pocket-book, that was used extensively in the late eighteenth century to obtain an image of Nature. The artist or traveller turned his back to the landscape in order to use it. The low-key reflections of Nature in the mirror resemble the landscape effects to be seen in paintings by Claude Lorrain. A silvered mirror was available for days too overcast for effective use of the darkened kind. The Claude Glass was both a viewing-glass and a popular drawing device.

GOUACHE see BODYCOLOUR

GUM ARABIC

A vegetable gum obtained from the acacia tree. It differs from resins in being soluble in water, and is thus well suited for binding watercolour pigment.

INK

Used by some eighteenth-century topographers as the foundation of a 'stained' or 'tinted' drawing, or as a reinforcement to a finished watercolour, ink was applied with a brush, quill pen or reed pen. *Carbon ink* is generally made from soot (or some other easily available carbon) dissolved in water, often with a binder such as **GUM ARABIC**. *Indian ink* is a waterproof form of carbon ink in which some kind of resin has been dissolved. A more brown ink can be made with bistre, obtained from the soot of burning wood, resin or peat. Sepia is made from the secretion of the cuttle-fish, although the term is often used to mean dark brown ink in general.

PAPER

The basis of all paper is cellulose fibre, which is derived from plants. Until the 1840s, when wood pulp was introduced, most papers were made from cotton or linen rags. Hand-made paper is made in a mould that has a fine wire grid as its base. The mould is dipped into liquid pulp, and then removed for drying. Until c. 1750 all paper made in Europe was *laid* paper, identifiable by the ribbed (or 'chain') pattern impressed by the mould's wire grid. By the end of the eighteenth century watercolourists were beginning to prefer the smoother and more even appearance of wove papers, produced by using a wire mesh woven much like a piece of fabric. The majority of papers used by watercolourists were white, but some artists, such as J. M. W. Turner, experimented with coloured papers and papers prepared with a coloured wash.

PENCIL

Made of graphite, a crystalline form of carbon also known as plumbago, it leaves a shiny deposit on paper.

SCRAPING-OUT

Sometimes described as *scratching-out*, this is a means of creating a highlight by removing an area of watercolour with a knife, the point of a brush or even a fingernail to expose the paper beneath.

SCUMBLING

A method of dragging almost dry colour (either watercolour or bodycolour) across the support in order to obtain a crumbly surface texture.

SPONGING-OUT

Like SCRAPING-OUT, this is a method of creating a highlight, but by removing an area of watercolour with a soft sponge.

STAMP

A small, distinctive mark, sometimes embossed and usually composed of initials, often found on drawings. A *studio stamp* was applied to material sold from an artist's studio after his or her death. If the stamp is impressed on the sheet without ink, it is known as a *blind stamp*. Drawings in private collections were also often given a stamp: this is known as a *collector's mark*. In the late nineteenth century, facsimiles of artists' signatures were sometimes printed on drawings as a form of studio stamp.

STIPPLE

The application of minute spots or flecks of watercolour using the point of a fine brush, or of lifting spots of colour from a wash so as to break up the colour into myriad dots or specks.

STOPPING-OUT

A method of preserving a highlight by masking a selected area of watercolour pigment with a 'stopping-out' agent, such as gum, in order to prevent that area being obscured or qualified by subsequent layers of wash.

VARNISH

Watercolours destined for exhibition alongside oils, or intended to compete with oils in size or force, were sometimes varnished, either over the whole surface or in the darkest areas of the composition, especially shadows. Varnishes were usually made from GUM ARABIC, although other recipes, such as isinglass dissolved in water or Zapon mixed with alcohol, were sometimes preferred.

WASH

An application of colour over a larger field than can conveniently be covered by the brush at one stroke. A wash must be continued and extended while the colour is still wet, and show no joins; great skill is required when laying a flat or, especially, a gradated one. Washes can be broken (or *dragged*) by charging a brush with almost dry colour, and then dragging the brush on its side to deposit particles of pure colour – a useful method for obtaining texture or sparkle. Washes can also be run or 'bled' into one another when still wet.

WASHLINE MOUNT

A type of mount commonly used in the eighteenth century that incorporates a tinted border, and sometimes additional ruled borders. Watercolours mounted in this way were often stored in a portfolio rather than framed and hung.

WATERCOLOUR

A finely ground pigment combined with a watersoluble binding agent, commonly GUM ARABIC. It is usually distributed either in tubes or cakes. Water is used as the vehicle to spread and dilute the colour, and it subsequently evaporates. It is the gum arabic that binds the pigments to the surface of the support, which is invariably PAPER. Watercolour papers tend to have a granular surface that make for variations in the reflective luminosity in the surface of the sheet; the chief source of brilliancy in pure watercolour, however, derives from the white of the paper shining through the transparent pigment. Because the watercolour painting has its technical origins in the 'tinted' or 'stained' drawing, it is sometimes referred to as a watercolour drawing, and thus the terms 'watercolour' and 'drawing' are sometimes used synonymously.

CATALOGUE OF WORKS

This Catalogue is organised alphabetically by artist; works are listed by date of execution, earliest first. Dimensions refer to image size and are given in centimetres, height before width. Unless otherwise specified, the support is white, wove paper. Inscriptions on the front or back (verso) of a work are tran-scribed literally, but are recorded only when (or assumed to be) in the artist's own hand. Related engravings are given only for items occuring in section II, and confined to the earliest prints. Exhibition history is restricted to the first appearance of a work at the Royal Academy or at one of the watercolour societies. Abbreviations: Engr. = engraved; Exh. = exhibited; Inscr. = inscribed; NSA: Norwich School of Artists (founded 1803); NWCS: 'New Water-Colour Society' (founded 1832); OWCS: 'Old Water-Colour Society' (founded 1804); RA: Royal Academy of Arts (founded 1768).

JOHN WHITE ABBOTT 1763–1851
1 (section III)
Trees in Peamore Park, Exeter 1799
Watercolour with pen and black ink, 43.1 x 35.5
Inscr. lower left: JWA (monogram) 1799 and verso: *Peamore – 1799. Given to John Abbott, March 1. 1832.*
Lent by the Syndics of the Fitzwilliam Museum, Cambridge (PD 42-1980)
plate 133

ROBERT ADAM 1728–1792
2 (section I)
River Landscape with a Castle c. 1780
Pencil and watercolour with pen and brown ink, 30.1 x 44.5
National Gallery of Art, Washington DC, Ailsa Mellon Bruce Fund (1988.23.1)
plate 10

WILLIAM ALEXANDER 1767–1816
3 (section II)
The Pagoda of Lin-ching-shih, on the Grand Canal, Peking c. 1795
Pencil and watercolour, 28.6 x 43.2
Inscr. below centre: W. Alexander f.
Engr. by William Byrne in Sir G. L. Staunton, *An Authentic Account of an Embassy from the King of Great Britain to the Emperor of China*, 1797, pl. 33
John Swire & Sons Ltd
plate 57

SAMUEL AUSTIN 1796–1834
4 (section II)
EXHIBITED LONDON ONLY
Dort, Holland c. 1830
Pencil and watercolour, 21.7 x 50.2
Oldham Art Gallery (9.88/64)
plate 97

GEORGE BARRET JNR 1767–1842
5 (section III)
View on the Coast Seen through a Window c. 1815
Watercolour with pen and black ink, 40 x 26
Royal Library, Windsor Castle (RL 13371)
plate 109

6 (section VI)
Solitude: An Italianate Landscape with a Figure Reclining beneath Trees 1823
Pencil and watercolour with gum arabic, 114 x 160
Inscr. below, centre: G. Barret / 1823
Exh. OWCS 1823 (no. 221)
James Swartz Esq.
plate 295

7 (section IV)
The Close of the Day 1829
Watercolour over pencil with gum arabic, sponging, stopping-out and scraping-out, 35.8 x 51.9
Inscr. lower left: George Barret / 1829
Birmingham Museums and Art Gallery (P40'53)
plate 214

WILLIAM HENRY BARTLETT 1809–1854
8 (section III)
View of Rievaulx Abbey from the Hills to the West c. 1829
Watercolour over pencil, 21.7 x 31.6
Leeds City Art Galleries (9.7/52)
plate 160

WILLIAM BLAKE 1757–1827
9 (section IV)
EXHIBITED WASHINGTON ONLY
The Wand'ring Moon c. 1816–20
Watercolour with pen and black ink, 16.2 x 12.2
Inscr. lower left: W Blake inv
This subject is an illustration to Milton's *Il Penseroso*, ll. 67–76
The Pierpont Morgan Library, New York, Purchased with the support of the Fellows, with the special assistance of Mrs Landon K. Thorne and Mr Paul Mellon (1949.4:8)
plate 217

10 (section IV)
EXHIBITED LONDON ONLY
The Arlington Court Picture ('The Sea of Time and Place') 1821
Watercolour with pen and black ink with bodycolour over a gesso ground, 40 x 49.5
Inscr. lower left: W Blake inventor 1821
The title in parentheses is a quotation from Blake's Prophetic Book *Vala, or the Four Zoas*
Arlington Court, Devon, The Chichester Collection (The National Trust)
plate 218

11 (section IV)
Homer and the Ancient Poets 1824–7
Pencil and watercolour with pen and black ink, 37.1 x 52.8
Inscr. lower right: HELL Canto 4
This subject is an illustration to Dante's *Inferno*
The Tate Gallery, London, Purchased with the assistance of a special grant from the National Gallery and donations from The National Art Collections Fund, Lord Duveen and others, and presented through the National Art Collections Fund 1919
plate 216

RICHARD PARKES BONINGTON 1802–1828
12 (section V)
Paris from Père Lachaise c. 1825
Pencil and watercolour, 23.5 x 21.5
Private Collection
plate 239

13 (section V)
EXHIBITED LONDON ONLY
Château of the Duchesse de Berri c. 1825
Watercolour and bodycolour, 20.3 x 27.2
Trustees of the British Museum, London (1910-2-12-223)
plate 240

14 (section V)
Near Burnham, Norfolk c. 1825
Watercolour and scraping-out, 14.3 x 18.2
Inscr. lower right: RPB
The identification of this subject is doubtful
Sheffield City Art Galleries
plate 241

15 (section V)
A Fisherman on the Banks of a River, a Church Tower in the Distance c. 1825–6
Pencil and watercolour, 17.5 x 23.7
Inscr. lower left: R P Bonington
Private Collection, New York
plate 242

16 (section II)
Verona: The Castelbarco Tomb 1827
Watercolour and bodycolour over pencil, 19.1 x 13.3
Inscr. lower left: RPB 1827
City of Nottingham Museums: Castle Museum and Art Gallery (53-22)
plate 85

GEORGE PRICE BOYCE 1826–1897
17 (section VI)
EXHIBITED LONDON ONLY
The Mill on the Thames at Mapledurham, Oxfordshire 1860
Watercolour, 27.3 x 56.8
Inscr. lower left: G.P. Boyce. July 1860; and verso: Mill at Mapledurham Oxfordshire / Boyce – July 1860 – forenoon
Lent by the Syndics of the Fitzwilliam Museum, Cambridge (PD 52–1971)
plate 321

18 (section V)
Night Sketch of the Thames near Hungerford Bridge c. 1860-2
Watercolour, 22.2 x 33.7
Inscr. on artist's mount (removed): Southern Bank of the Thames between Hungerford and Waterloo Bridges, and From my studio window 15 Buckingham St. Adelphi / GP Boyce
Exh. OWCS 1866-7 (no. 364)
The Tate Gallery, London, Bequeathed by Miss Morris 1939 (N 0500)
plate 272

19 (section VI)
Black Poplars at Pangbourne, Berkshire (?)1868
Watercolour with scraping-out, 36.7 x 53.3
Inscr. lower left: *G.P. Boyce 18[?68]*
Exh. OWCS 1871 (no. 258)
Christopher and Jenny Newall
plate 322

THOMAS SHOTTER BOYS 1803–1874
20 (section II)
EXHIBITED LONDON ONLY
Paris: Le Pavillon de Flore, Tuileries c. 1830
Watercolour and pen and brown ink, 45.2 x 33
Engr. in chromolithography by Boys for *Picturesque Architecture in Paris, Ghent, Antwerp, Rouen etc.*, 1839, pl. XXI
Lent by the Syndics of the Fitzwilliam Museum, Cambridge (PDI-1967)
plate 94

WILLIAM CALLOW 1812–1908
21 (section II)
Paris: Quai de l'Horloge c. 1835
Watercolour and bodycolour with scraping-out, 31.8 x 74.3
City of Nottingham Museums: Castle Museum and Art Gallery (1953–2)
plate 92

JOHN WILSON CARMICHAEL 1799–1868
22 (section VI)
Newcastle from St Ann's 1835
Pencil, watercolour and bodycolour with scraping-out, 63.2 x 97.5
Inscr. lower right: *J.W. Carmichael 1835*
Laing Art Gallery, Newcastle upon Tyne (Tyne and Wear Museums) (G 9629)
plate 282

THOMAS COLLIER 1840–1891
23 (section V)
Haresfield Beacon c. 1880
Pencil and watercolour, 30.9 x 52.7
Inscr. lower left: (?)*Augst 14^{th}*; stamped lower right: *Th.^{os} Collier*
Lent by the Syndics of the Fitzwilliam Museum, Cambridge (73-1950)
plate 249

24 (section V)
Pensarn Beach 1886
Pencil and watercolour, 23.6 x 34.7
Inscr. lower right: *Oct. 2^{nd} 1886* and stamped *Th^{os} Collier*
Lent by the Syndics of the Fitzwilliam Museum, Cambridge (PD 68-1950)
plate 251

WILLIAM COLLINS 1788–1847
25 (section III)
Horses Watering by a Bridge c. 1815
Pencil, watercolour and pen and brown ink on grey paper, 26.5 x 34.7
Private Collection
plate 155

JOHN CONSTABLE 1776–1837
26 (section I)
View in Langdale 1806
Pencil and grey wash, 34.4 x 48.6
Inscr. verso: *19 Oct 1806 Langdale*
The Board of Trustees of the Victoria and Albert Museum, London (1256-1888)
plate 47

27 (section III)
Study of Clouds at Hampstead 1830
Pencil and watercolour, 19 x 22.8
Inscr. verso: *about 11 – Noon – Sepr 15 1830. Wind–W.*
The Board of Trustees of the Victoria and Albert Museum, London (240-1888)
plate 125

28 (section V)
EXHIBITED LONDON ONLY
London from Hampstead c. 1830–3
Watercolour, 11.2 x 18.7

Trustees of the British Museum, London (1888-2-15-53)
plate 225

29 (section V)
EXHIBITED LONDON ONLY
View over London from Hampstead c. 1830–3
Watercolour, 11.2 x 17.8
Trustees of the British Museum, London (1888-2-15-52)
plate 224

30 (section V)
View at Hampstead, Looking towards London 1833
Watercolour, 11.5 x 19
Inscr. verso: *Hampd December 7, 1833 3 oclock – very stormy afternoon – & High Wind –*; and: *21*
The Board of Trustees of the Victoria and Albert Museum, London (220-1888)
plate 228

31 (section V)
EXHIBITED LONDON ONLY
Folkestone from the Sea 1833
Pencil and watercolour, 12.7 x 21
Inscr. lower right: *16 Oct 1833 / Folkestone*
Trustees of the British Museum, London (1888-2-15-46)
plate 227

32 (section V)
EXHIBITED LONDON ONLY
Tillington Church 1834
Pencil and watercolour, 23.2 x 26.4
Inscr. upper left: *Tillington / Sepr 17 1834*
Trustees of the British Museum, London (1888-2-15-49)
plate 223

33 (section V)
Hampstead Heath from near Well Walk 1834
Watercolour, 11.1 x 18
Inscr. verso: *Spring Clouds – Hail Squalls – April 12. 1834 – Noon Well Walk –*
The Board of Trustees of the Victoria and Albert Museum, London (175-1888)
plate 226

34 (section V)
EXHIBITED LONDON ONLY
Old Sarum 1834
Watercolour and scraping-out, 30 x 48.7
Exh. RA 1834 (no. 481)
The Board of Trustees by the Victoria and Albert Museum, London (1628-1888)
plate 229

35 (section V)
EXHIBITED WASHINGTON ONLY
Stonehenge 1836
Watercolour, 38.7 x 59.1
Exh. RA 1836 (no. 581)
Inscr. on artist's mount: Stonehenge 'The mysterious monument of Stonehenge, standing remote on a bare and boundless heath, as much unconnected with the events of past ages as it is with the uses of the present, carries you bad beyond all historical records into the obscurity of a totally unknown period.'
The Board of Trustees of the Victoria and Albert Museum, London (1629-1888)
plate 230

RICHARD COOPER JNR c. 1740–c. 1814
36 (section I)
Landscape: Trees and Rocky Hills c. 1780
Pencil and wash with pen and brown ink on laid paper (oval image on rectangular sheet), 37.5 x 53.2
Inscr. lower right on artist's mount: *R Cooper del^{t}*
Leeds City Art Galleries (13.66/53)
plate 9

JOHN SELL COTMAN 1782–1842
37 (section I)
Brecknock c. 1801
Watercolour with gum arabic, scraping-out and stopping-out, 37.6 x 54.6
Exh. RA 1801 (no. 311)
Private Collection
plate 43

38 (section I)
EXHIBITED LONDON ONLY
St Mary Redcliffe, Bristol: Dawn c. 1802
Pencil and watercolour, 38 x 53.5
Trustees of the British Museum, London (1859-528-117)
plate 42

39 (section I)
Bedlam Furnace, near Ironbridge, Shropshire 1802–3
Pencil and watercolour with scraping-out and stopping-out, 26 x 48.6
Private Collection
plate 44

40 (section I)
EXHIBITED LONDON ONLY
Croyland Abbey, Lincolnshire c. 1804
Pencil and watercolour with scraping-out on laid paper, 29.5 x 53.7
Inscr. lower right: *J. S. Cotman*
Exh. (?) NSA 1807 (no. 45)
Trustees of the British Museum, London (1859-5-28-118)
plate 45

41 (section I)
York: The Water Tower 1804
Pencil and watercolour on laid paper, 22.3 x 43.2
Inscr. lower right: *J. S. Cotman 1804*; and verso: *York*
Whitworth Art Gallery, University of Manchester (D 1914-4)
plate 46

42 (section IV)
EXHIBITED LONDON ONLY
On the Greta (called 'Hell Cauldron') c. 1806
Pencil and watercolour on laid paper, 43.7 x 33.9
Leeds City Art Galleries (16.2/55)
plate 173

43 (section IV)
EXHIBITED LONDON ONLY
The Drop-gate, Duncombe Park c. 1806
Pencil and watercolour on laid paper, 33 x 23
Trustees of the British Museum, London (1902-5-14-14)
plate 174

44 (section IV)
EXHIBITED LONDON ONLY
Duncombe Park, Yorkshire c. 1806
Pencil and watercolour on laid paper, 33 x 23
Trustees of the British Museum, London (1902-5-14-13)
plate 171

45 (section IV)
EXHIBITED WASHINGTON ONLY
In Rokeby Park c. 1806
Pencil and watercolour on laid paper, 32.9 x 22.9
Yale Center for British Art, New Haven, Paul Mellon Collection (B 1977.14.4671)
plate 176

46 (section IV)
EXHIBITED WASHINGTON ONLY
River Landscape (Probably on the Greta, Yorkshire) c. 1806
Pencil and watercolour, 27.3 x 40
Mellon Bank Corporation, Pittsburgh
plate 179

47 (section IV)
Chirk Aqueduct 1806–7
Pencil and watercolour on laid paper, 31.5 x 23.1
The Board of Trustees of the Victoria and Albert Museum, London (115-1892)
plate 175

48 (section IV)
EXHIBITED LONDON ONLY
Greta Bridge c. 1807
Pencil and watercolour, 22.7 x 32.9
Trustees of the British Museum, London (1902-5-14-17)
plate 172

49 (section IV)
EXHIBITED WASHINGTON ONLY
Norwich: The Cow Tower c. 1807
Pencil and watercolour on laid paper, 35 x 26.5
Private Collection
plate 178

50 (section IV)
EXHIBITED WASHINGTON ONLY
A Shady Pool 1807
Pencil and watercolour on laid paper, 45.4 x 35.2
National Galleries of Scotland, Edinburgh (DNG 1136)
plate 177

51 (section IV)
EXHIBITED LONDON ONLY
A Ploughed Field c. 1808
Pencil and watercolour, 22.8 x 35
Leeds City Art Galleries (508/23)
plate 180

52 (section II)
Norwich Market Place c. 1809
Watercolour, 40.6 x 64.8
Engr. in aquatint by Freeman c. 1809; later lithographed
by Henry Ninham
Exh. (?) NSA 1809 (no. 208)
The Tate Gallery, London, Presented by Francis E. Halsey
1933 (N 05636)
plate 73

53 (section VI)
The Harvest Field, A Pastoral c. 1810
Pencil and watercolour with gum arabic, 53.7 x 70.7
Exh. NSA 1810 (no. 124)
Leeds City Art Galleries (1.6/39)
plate 286

54 (section II)
Interior of Walsoken Church, Norfolk: The Chancel, North
Arcade c. 1811
Pencil and watercolour, 25 x 32.5
Inscr. top left: Very grey and This zig-zag more to the left;
lower left: ?Walsoken; lower right: J. S. Cotman
A finished watercolour of this subject dated 1830 (Christie,
29 March 1983, lot 128), was engr. by Cotman for A series of
etchings illustrative of the Architectural Antiquities of Norfolk,
1818
Birmingham Museums and Art Gallery
(147´22)
plate 84

55 (section IV)
EXHIBITED LONDON ONLY
Domfront 1823
Pencil and watercolour, reed pen and brown ink with
scraping-out, 29.5 x 41.6
Inscr. lower left: J.S. Cotman /1823
Courtauld Institute Galleries, London
(Spooner Bequest 1967)
plate 188

56 (section IV)
EXHIBITED LONDON ONLY
Dieppe Harbour 1823
Pencil, watercolour and bodycolour, reed pen and brown
ink with scraping-out, 28.7 x 53.2
Inscr. lower left: J. S: Cotman 1823
The Board of Trustees of the Victoria and Albert Museum,
London (P 26-1934)
plate 189

57 (section IV)
Street Scene at Alençon 1828
Pencil and watercolour with bodycolour, 42.8 x 57.8
Inscr. lower right: J. S. Cotman 1828
Exh. NSA 1828 (no. 163)
Birmingham Museums and Art Gallery
(28'08)
plate 187

58 (section IV)
Mont St Michel 1828
Pencil, watercolour and bodycolour with scraping-out,
29.2 x 54.3
Inscr. lower right: J. S. Cotman / 1828
Exh. (?) NSA 1829 (no. 159)
Manchester City Art Galleries (1917–72)
plate 190

59 (section V)
The Shepherd on the Hill 1831
Watercolour, 23 x 33.6
Inscr. lower left: JS Cotman 1831
Trustees of the National Museums and Galleries on
Merseyside Walker, Art Gallery (154)
plate 245

60 (section V)
Study of Sea and Gulls 1832
Watercolour and bodycolour with pen and black ink, and
scraping-out, 23.3 x 29.8
Inscr. lower left: J.S. Cotman – 1832
The Board of Trustees of the Victoria and Albert Museum,
London (P 17-1973)
plate 244

61 (section V)
On the Downs c. 1840
Watercolour with stopping-out, 23.5 x 33
Inscr. lower left: Cotman
Private Collection
plate 243

DAVID COX 1783–1859
62 (section IV)
Pembroke Castle c. 1810
Pencil and watercolour on laid paper with stopping-out,
44.9 x 60.3
Private Collection
plate 200

63 (section III)
Two Studies of Plants:
(a) Dock Plants c.1815-20
Watercolour, 19 x 14.5
(b) Plants by a Brick Culvert c. 1815–20
Watercolour, 14 x 16.9
Birmingham Museums and Art Gallery (681-682´27)
plates 139, 138

64 (section IV)
Cader Idris, with Women Washing Clothes in a Stream in the
Foreground c. 1820
Pencil and watercolour with bodycolour, gum arabic,
stopping-out and scraping-out, 52 x 82
Exh. (?) OWCS 1820 (no. 362)
Abbott and Holder, London
plate 209

65 (section VI)
Pastoral Scene in Herefordshire (?) 1824
Watercolour with gum arabic, stopping-out and scraping-
out, 73.6 x 106.7
Exh. (?) OWCS 1824 (no. 65, as Shepherds Collecting their
Flocks – Evening, from Scenery in Herefordshire)
Private Collection, Courtesy Agnew's, London
plate 297

66 (section VI)
Carthage: Aeneas and Achates 1825
Watercolour and bodycolour with gum arabic, stopping-
out and scraping-out, 76 x 116
Exh. OWCS 1825 (no. 107, as Carthage – Aeneas and Achates,
'they climb the next ascent, and looking down...', Eneid, Book
I)
Birmingham Museums and Art Gallery
(1985.P.31)
plate 296

67 (section III)
Studies of a Seagull in Flight c. 1825–30

Pencil, watercolour and bodycolour, 18.6 x 14
Birmingham Museums and Art Gallery
(38'31)
plate 143

68 (section II)
Paris: (?) A Street in the Marais c.1829
Pencil and watercolour, 34 x 25
Inscr. on building at right: No 233 /... No. 253
Birmingham Museums and Art Gallery
(P 30'48)
plate 100

69 (section II)
Rouen: Tour d'Horloge 1829
Pencil and watercolour, 34.3 x 25.7
The Tate Gallery, London, Presented by the National Art
Collections Fund (Herbert Powell Bequest) 1967 (T 00977)
plate 101

70 (section III)
Still-life c. 1830
Black chalk and watercolour, 17.2 x 22.2
The Tate Gallery, London, Bequeathed by J.R. Holliday
1927 (N 04307)
plate 151

71 (section IV)
The Hayfield c. 1832
Watercolour with stopping-out, 15.3 x 24.7
University of Liverpool Art Gallery and Collections, Sir
Sydney Jones Collection (210)
plate 208

72 (section III)
Landscape with Sunset (?)c. 1835
Pencil and watercolour on coarse off-white paper,
25.5 x 37.9
Private Collection
plate 124

73 (section VI)
EXHIBITED WASHINGTON ONLY
Lancaster: Peace and War 1842
Watercolour and gum arabic, 49.7 x 76
Exh. OWCS 1842 (no. 33)
Art Institute of Chicago, Gift of Dr William D. Shorey, H.
Karl and Nancy von Maltitz Endowment (1990.144)
plate 314

74 (section V)
Barmouth Road c.1850
Black chalk and watercolour with scraping-out, 16.5 x 25
Lent by the Syndics of the Fitzwilliam Museum,
Cambridge (1272)
plate 231

75 (section V)
A Train near the Coast c. 1850
Pencil and watercolour, 26.9 x 37.2
National Museum of Wales, Cardiff (3036)
plate 234

76 (section V)
'An Impression': The Crest of a Mountain c. 1853
Black chalk and watercolour, 27 x 38
Birmingham Museums and Art Gallery (329'25)
plate 232

77 (section V)
The Beach at Rhyl 1854
Pencil and watercolour, 25.4 x 36.9
Inscr. lower left: David Cox. 1854
University of Liverpool Art Gallery and Collections,
Sir Sydney Jones Collection (209)
plate 233

78 (section VI)
The Challenge: A Bull in a Storm on a Moor c. 1856
Watercolour with bodycolour and scraping-out,
45.4 x 64.8

Inscr. verso: *on the Moors near Bettws y Coed – N.W.*
Exh. (?) OWCS 1856 (no. 179)
The Board of Trustees of the Victoria and Albert Museum,
London (1427-1869)
plate 315

ALEXANDER COZENS c. 1717–1786
79 (section I)
Figures by a Pool below a Fortress in an Italianate Landscape
c. 1765
Brown and black washes with some body-colour on laid
paper, varnished, 48.5 x 65
Inscr. upper right: *I*
Hazlitt, Gooden & Fox, London
plate 4

80 (section I)
The Prophet Elijah Fed by Ravens c. 1765
Pen and black and brown washes on laid paper, 48 x 68.5
Private Collection, through Hazlitt, Gooden & Fox,
London
plate 3

81 (section I)
A Villa by a Lake (?)c. 1770
Pencil, brown and black washes on laid paper, 15 x 19.1
Inscr. on artist's washline mount, lower left *Alex.ʳ Cozens.*
Agnew's, London
plate 7

82 (section I)
EXHIBITED LONDON ONLY
Mountain Peaks c. 1785
Brown and black washes on pale buff, prepared laid
paper, 22.9 x 30.3
Inscr. on artist's washline mount lower left:
Alexʳ Cozens
Engr. in etching and aquatint for *A New Method of Assisting
the Invention in Drawing Original Compositions of Landscape*,
1785–6,
Blot no. 2
Trustees of the British Museum, London
(1928-4-17-4)
plate 1

83 (section I)
A Rocky Island c. 1785
Pen and brown ink and wash on tinted laid paper,
46.3 x 62.4
Whitworth Art Gallery, University of Manchester
(D 1926–26)
plate 2

84 (section I)
Mountain Landscape with a Hollow
c. 1785
Watercolour with pen and brown ink and gum arabic on
laid paper, 23 x 30.3
Inscr. upper right: *13*
This drawing is a version of Blot drawing no. 13 in *A New
Method*, 1785–6
National Gallery of Art, Washington DC, Ailsa Mellon
Bruce Collection (1984.68.1)
plate 5

JOHN ROBERT COZENS 1752–1797
85 (section I)
EXHIBITED LONDON ONLY
The Reichenbach between Grindelwald and Oberhaslital c. 1776
Pen and brown ink and grey wash on laid paper,
23.2 x 35.5
Trustees of the British Museum, London (1900-4-11-14)
plate 25

86 (section I)
Cavern in the Campagna 1778
Pencil and watercolour on laid paper,
38.1 x 50.8
Inscr. on artist's washline mount lower left: *Jn° Cozens.
Rome. 1778*
The Board of Trustees of the Victoria and Albert Museum,
London (P. 6-1986)
plate 29

87 (section I)
Interior of the Colosseum 1778
Pencil and watercolour on laid paper, 36.1 x 51.6
Inscr. lower left on artist's washline mount:
Jn° Cozens Rome 1778
Leeds City Art Galleries (13.92/53)
plate 26

88 (section I)
EXHIBITED LONDON ONLY
Ruins of Paestum, near Salerno: The Three Temples c. 1782
Pencil and watercolour with pen and black ink on laid
paper, 25.5 x 37
Oldham Art Gallery
plate 30

89 (section I)
EXHIBITED LONDON ONLY
The Two Great Temples at Paestum
c. 1782
Pencil and watercolour with pen and black ink on laid
paper, 25.5 x 37
Oldham Art Gallery
plate 31

90 (section I)
*Entrance to the Valley of the Grande Chartreuse in the
Dauphiné* c. 1783
Watercolour, 26.2 x 37.3
Inscr. on verso: *Approach to the Grand Chartreuse in
Dauphiny*
The Visitors of the Ashmolean Museum, Oxford
plate 28

91 (section I)
Florence from a Wood near the Cascine c. 1785
Pencil and watercolour on laid paper, 26.2 x 36.8
Private Collection
plate 32

92 (section I)
Lake Albano and Castel Gandolfo c. 1790
Watercolour, 44.1 x 62.2
Leeds City Art Galleries (846/28)
plate 33

93 (section I)
EXHIBITED LONDON ONLY
Lake Albano and Castel Gandolfo – Sunset c. 1790
Pencil and watercolour on laid paper, 43 x 62
Stamped lower left by Thomas Lawrence: TL (monogram)
Private Collection, UK
plate 34

94 (section I)
Cetara, on the Gulf of Salerno 1790
Pencil and watercolour, 36.5 x 52.5
Inscr., on artist's washline mount (removed): *Jn° Cozens.
1790*
National Gallery of Art, Washington DC, Gift in honor of
Paul Mellon by the Patrons' Permanent Fund, with addi-
tional support from Dick and Ritchie Scaife, Catherine
Mellon Conover, Rachel Mellon Walton, Mr and Mrs
James M. Walton and an anonymous donor (1992.19.1)
plate 27

JOSHUA CRISTALL 1768–1847
95 (section III)
EXHIBITED LONDON ONLY
Study of a Beech-tree Stem 1803
Pencil and watercolour, 23.4 x 14.9
Inscr. lower right: *J. Cristall 1803.*
Trustees of the British Museum, London (1876-12-9-1043)
plate 131

96 (section III)
Study of a Skate 1807
Pencil and watercolour on laid paper, 25.5 x 15.2
Inscr. on lower right-hand edge of sheet: *J. Cristall 1807
Hastings*
Hereford City Museum and Art Gallery (227)
plate 144

97 (section IV)
EXHIBITED LONDON ONLY

*Coast Scene: The Beach at Hastings, with a Fleet in the
Distance* c. 1814
Watercolour, 38.4 x 65.7
Exh. OWCS 1814 (no. 117, as *Fleet sailing up Channel off
Hastings*)
National Galleries of Scotland, Edinburgh (482)
plate 192

98 (section IV)
EXHIBITED WASHINGTON ONLY
The Grove of Accademia – Plato Teaching 1820
Watercolour with stopping-out, 29.9 x 39.7
Inscr. lower right: *J. Cristall/1820 –*
Exh. OWCS 1821 (no. 7, as *Instruction – A Composition*)
National Galleries of Scotland, Edinburgh (DNG 476)
plate 215

99 (section VI)
A Woman Spinning ('Bessy and her Spinning Wheel') 1824
Watercolour on paper, 51.8 x 60
Inscr. lower right: *J. Cristall 1824*
Exh. OWCS 1824 (no. 232, as *Bess and her Spinning Wheel, 'I'll
sit me down and sing and spin...', Vide Burns.*)
Hereford City Museum and Art Gallery (1176)
plate 289

100 (section VI)
Nymphs and Shepherds Dancing c. 1825
Pencil and watercolour with stopping-out and sponging-
out, 79.5 x 112.5
Hereford City Museum and Art Gallery (583)
plate 288

FRANCIS DANBY 1793–1861
101 (section IV)
The Avon at Clifton c. 1821
Pencil, watercolour and bodycolour, 12.9 x 21.7
Inscr. lower left: F. DANBY
Bristol City Museums and Art Gallery (K 4658)
plate 194

102 (section IV)
The Avon from Durdham Down c. 1821
Watercolour and bodycolour, 12.7 x 19.7
Inscr. lower left: F. DANBY
Bristol City Museums and Art Gallery (K 4659)
plate 196

103 (section IV)
The Frome at Stapleton, Bristol c. 1823
Pencil, watercolour and bodycolour, 14.6 x 21.5
Inscr. lower left: F. DANBY
Bristol City Museums and Art Gallery (K 195)
plate 195

104 (section IV)
An Ancient Garden 1834
Watercolour and bodycolour, 17.4 x 25.7
Bristol City Museums and Art Gallery (K 4654)
plate 197

WILLIAM DANIELL 1769–1837
105 (section II)
Windsor 1827
Pencil and watercolour with scraping-out, 30.5 x 30.5
Inscr. lower left: W. DANIELL / 1827
National Museum of Wales, Cardiff (431 a)
plate 93

EDWARD DAYES 1763–1804
106 (section II)
Queen Square, London 1786
Watercolour, 37.2 x 53.2
Inscr. lower left: *E Dayes / 1786*
Engr. in aquatint by Dodd and Pollard, 1 July 1789, as one
in a set of four London Squares.
Yale Center for British Art, New Haven, Paul Mellon
Collection (B 1977.14.4639)
plate 66

JAMES DEACON c. 1728–1750
107 (section I)
Landscape Fantasy 1740–3
Pencil and watercolour with pen and black ink and varnish
on laid paper, 22 x 23.5

Inscr. verso: *James Deacon fecit / 1743 / Drawn by Jm.ˢ Deacon / 1740*
Private Collection
plate 13

108 (section I)
Rocky Landscape with Classical Buildings, 1745–50
Pencil and watercolour with pen and black ink on laid paper, 18.3 x 23.2
Yale Center for British Art, New Haven, Paul Mellon Collection (B 1977.14.5653)
plate 15

PETER DE WINT 1784–1849
109 (section IV)
Lincoln: The Devil's Hole c. 1810
Pencil and watercolour with scraping-out,
38.7 x 51.5
Private Collection
plate 181

110 (section II)
Winchester Gateway c. 1810–15
Watercolour, 51 x 68.6
The Trustees of the Cecil Higgins Art Gallery, Bedford (P 706)
plate 82

111 (section III)
EXHIBITED WASHINGTON ONLY
Plants by a Stream c. 1810–15
Watercolour with scraping-out, 26.1 x 33.1
National Galleries of Scotland, Edinburgh (D 4700)
plate 137

112 (section IV)
EXHIBITED LONDON ONLY
Yorkshire Fells c. 1812
Pencil and watercolour with gum arabic,
36.3 x 56.6
Lent by the Syndics of the Fitzwilliam Museum, Cambridge (PD 130–1950)
plate 182

113 (section III)
EXHIBITED LONDON ONLY
Harvesters Resting c. 1820
Pencil and watercolour with gum arabic,
32.4 x 34
Lent by the Syndics of the Fitzwilliam Museum, Cambridge (1583)
plate 129

114 (section III)
EXHIBITED LONDON ONLY
Still-life with a Ginger Jar and Mushrooms (?)c. 1820
Pencil and watercolour, 21.5 x 29.2
Trustees of the British Museum, London
(1890-5-12-61)
plate 152

115 (section VI)
Lincoln Cathedral from the River c. 1825
Watercolour and scraping-out, 49.5 x 69.8
Lincolnshire County Council: Usher Art Gallery, Lincoln
(U.G. 2270)
plate 284

116 (section VI)
Cookham on Thames (?)c. 1830
Watercolour with scraping-out, 46.7 x 74.6
University of Liverpool Art Gallery and Collections, Sir Sydney Jones Collection (222)
plate 285

117 (section IV)
Torksey Castle (Study) c. 1835
Pencil and watercolour, 29.8 x 46.6
Lincolnshire County Council: Usher Art Gallery, Lincoln
(U.G.71/88)
plate 185

118 (section IV)
Torksey Castle, Lincolnshire c. 1835
Pencil and watercolour with scraping-out, 46 x 77
Exh. OWCS 1835 (no. 31)
Lincolnshire County Council: Usher Art Gallery, Lincoln
(U.G.86/13)
plate 186

119 (section V)
Mountain Scene, Westmorland c. 1840
Watercolour, 29.2 x 45.5
Lent by the Syndics of the Fitzwilliam Museum, Cambridge (PD 135–1950)
plate 235

120 (section V)
View near Bangor, North Wales: Penrhyn Castle with Penmaenmawr beyond (?) c. 1840
Pencil and watercolour, 29.5 x 46.5
Private Collection
plate 237

121 (section V)
Trees at Lowther, Westmorland c. 1840–5
Pencil and watercolour, 44.5 x 57.7
Private Collection
plate 238

122 (section V)
Clee Hill, Shropshire (?)c. 1845
Watercolour, 38.1 x 52.7
Private Collection
plate 236

JOHN DOWNMAN 1750–1824
123 (section III)
View over Nice out of my Window 1773
Pencil and watercolour with pen and black ink on laid paper, 26.5 x 36.5
Inscr. top left: *City of Nice Dec.ʳ 20th.1773*; lower right: *View of the Tops of Buildings / from my Bed Room window in the City of Nice on a bad Day / 1773 J.D*
Private Collection
plate 110

124 (section III)
A Tree-trunk near Albano 1774
Watercolour with pen and black ink on laid paper,
54 x 36.5
Inscr. lower left: *in the Wood near Albano 1774 by JᵒD*
Private Collection
plate 130

WILLIAM DYCE 1806–1864
125 (section III)
Tryfan, Snowdonia 1860
Watercolour, 22.8 x 34.9
The Visitors of the Ashmolean Museum, Oxford
plate 163

HENRY EDRIDGE 1769–1821
126 (section II)
Old Houses, with a Castellated Wall c. 1810
Pencil and watercolour on laid paper, 26 x 21.3
Private Collection
plate 80

ANTHONY VANDYKE COPLEY FIELDING 1787–1855
127 (section IV)
Landscape with Limekiln 1809
Pencil and watercolour with gum arabic and scraping-out, 23.2 x 32.1
Inscr. lower left: *C.V.F. 1809*
Yale Center for British Art, New Haven, Paul Mellon Collection (B 1977.14.4678)
plate 199

128 (section IV)
Shakespeare's Cliff, near Dover (?) c.1830
Watercolour with scraping-out, 44 x 55.7

Inscr. on verso: *View from the Top of Shakespeare's Cliff near Dover with Fokestone in the middle distance. Extreme distance is Fairlight Down above Hastings, Sussex.*
Exh. (?) OWCS 1846 (no. 290)
Private Collection, Courtesy Martyn Gregory Gallery
plate 207

129 (section VI)
View of Snowdon from the Sands of Traeth Mawr, Taken at the Ford between Pont Aberglaslyn and Tremadoc 1834
Pencil, watercolour and bodycolour with gum arabic and scraping-out, 64.7 x 92
Inscr. lower right: *Copley Fielding 1834*
Exh. OWCS 1834 (no. 93)
Yale Center for British Art, New Haven, Paul Mellon Collection (B.1977.14.4640)
plate 281

FRANCIS OLIVER FINCH 1802–1862
130 (section IV)
Religious Ceremony in Ancient Greece c. 1835
Watercolour and bodycolour with gum arabic and scraping-out, 46.8 x 64.7
Yale Center for British Art, New Haven, Paul Mellon Collection (B 1975.3.1245)
plate 213

131 (section IV)
Arcadia (?)c. 1840
Watercolour and gum arabic with scraping-out and stopping-out, 23.7 x 31
The Visitors of the Ashmolean Museum, Oxford (1952.82)
plate 204

MYLES BIRKET FOSTER 1825–1899
132 (section VI)
Highland Scene near Dalmally 1885
Watercolour and bodycolour with scraping-out,
73.7 x 124.5
Inscr. lower left BF (monogram), and verso with artist's name and address
Exh. OWCS 1885-6 (no. 88)
Private Collection, Courtesy Peter Nahum, London
plate 316

THOMAS GAINSBOROUGH 1727–1788
133 (section I)
Wooded Landscape with Shepherd and Sheep c. 1780
Pen and black ink and wash, with white chalk on laid paper, 28 x 36.5
Private Collection
plate 11

134 (section I)
Figures in a Wooded Landscape c. 1785
Black and white chalk and grey wash on laid paper,
26.6 x 39
Private Collection, Courtesy the Leger Galleries, London
plate 12

HENRY GASTINEAU 1791–1876
135 (section VI)
Carrick-y-Rede, Antrim 1839
Watercolour and bodycolour with scraping-out and stopping-out, 62.5 x 82
Inscr. lower left: *H Gastineau delᵗ / 1839*
Exh. OWCS 1839 (no. 101)
Birmingham Museums and Art Gallery
(47'23)
plate 301

WILLIAM GILPIN 1724–1804
136 (section I)
Landscape with Ruined Castle c. 1790
Black chalk, with pen and black ink and grey and brown washes, 36.1 x 26.9
Lower right: artist's blind stamp WG (monogram)
Lent by the Syndics of the Fitzwilliam Museum, Cambridge (no. 1355)
plate 8

137 (section I)
A View into a Winding Valley c. 1790
Pencil and grey wash, 27.5 × 36.9
Lower right: blind stamp WG (monogram); inscr. on a piece of paper mounted with the drawing: *A view into a winding valley. / The high ground, on ye right, is a / part of one of ye sidescreens; & / ye inlightened ground, on ye left is / a part of ye other. The valley winds / round a knoll with a castle upon / it, just touched with light; & goes / off between ye mountains.*
Leeds City Art Galleries (5.111/52)
plate 6

THOMAS GIRTIN 1775–1802
138 (section IV)
EXHIBITED LONDON ONLY
Coast of Dorset near Lulworth Cove c. 1798
Pencil and watercolour on laid paper, 38 × 28
Leeds City Art Galleries (16/35)
plate 170

139 (section II)
Lindisfarne c. 1798
Pencil and watercolour on laid paper, 41 × 28.7
Lent by the Syndics of the Fitzwilliam Museum, Cambridge (1608)
plate 76

140 (section III)
EXHIBITED LONDON ONLY
Near Beddgelert, North Wales c. 1798
Watercolour on laid paper, 29 × 43.2
Stamped lower right Chambers Hall: CH (monogram)
Trustees of the British Museum, London (1855-2-14-52)
plate 114

141 (section I)
Hawes, Yorkshire 1800
Pencil and watercolour on laid paper, 36.1 × 31.9
Inscr. lower left on river-bank: *Girtin 1800*
Birmingham Museums and Art Gallery (1'10)
plate 36

142 (section IV)
EXHIBITED WASHINGTON ONLY
The Village of Jedburgh, Roxburghshire 1800
Watercolour on laid paper, 30.1 × 51.1
Inscr. lower left: *Girtin 1800*
National Galleries of Scotland, Edinburgh
plate 166

143 (section IV)
The White House at Chelsea 1800
Watercolour on laid paper, 29.8 × 51.4
Inscr. near base of windmill: *Girtin 1800*
The Tate Gallery, London, Bequeathed by Mrs Ada Montefiori 1933 (N 04728)
plate 168

144 (section I)
EXHIBITED WASHINGTON ONLY
A Village Street and Church with Spire 1800
Pencil and watercolour on laid paper, 31.6 × 12.5
Inscr. lower left: *Girtin 1800*
Whitworth Art Gallery, University of Manchester (D 1892–111)
plate 37

145 (section I)
EXHIBITED WASHINGTON ONLY
Richmond Castle, Yorkshire 1800
Watercolour, 32.2 × 47.2
Inscr. lower right: *Girtin 1800*
Leeds City Art Galleries (503/23)
plate 38

146 (section IV)
Jedburgh Abbey from the South-east c. 1800
Watercolour with some pen on laid paper, 42.4 × 55.5
Inscr. lower right: *Girtin*
Private Collection
plate 167

147 (section IV)
Kirkstall Abbey, Yorkshire: Evening c. 1800–1
Watercolour on laid paper, 31.7 × 52
The Board of Trustees of the Victoria and Albert Museum, London (405-1885)
plate 169

148 (section II)
EXHIBITED LONDON ONLY
London: The Albion Mills c. 1801
Pencil and watercolour on laid paper, 32.7 × 53.9
Stamped lower left by Chambers Hall: CH (monogram)
Trustees of the British Museum, London (1855-2-14-24)
plate 78

149 (section II)
EXHIBITED LONDON ONLY
London: The Thames from Westminster to Somerset House c. 1801
Watercolour on laid paper, 24 × 53.9
Stamped lower right by Chambers Hall: CH (monogram)
Trustees of the British Museum, London (1855-2-14-27)
plate 77

150 (section I)
Ilkley, Yorkshire, from the River Wharfe c. 1801
Pencil and watercolour on laid paper, 30.5 × 51.8
Inscr. verso: *Mr Lascelles*
Leeds City Art Galleries (5.113/52)
plate 39

151 (section II)
Paris: Rue St Denis 1801–2
Pencil and watercolour, 39.4 × 48.9
Etched in soft-ground by Girtin in 1802 as a more distant view entitled *View of the Gate of St. Denis, taken from the Suburbs*, for *Twenty of the Most Picturesque Views of Paris*, and later aquatinted by F.C. Lewis
Private Collection
plate 79

152 (section I)
EXHIBITED LONDON ONLY
Bridgnorth, Shropshire 1802
Watercolour, 62.3 × 94.6
Inscr. below, centre: *Girtin 1802*
Trustees of the British Museum, London (1840-6-9-75)
plate 41

153 (section IV)
Storiths Heights, Wharfedale, Yorkshire c. 1802
Watercolour on laid paper, 28.3 × 41.8
Private Collection
plate 165

154 (section I)
Morpeth Bridge c. 1802
Pencil and watercolour with some pen, 31.4 × 52.7
Laing Art Gallery, Newcastle upon Tyne (Tyne and Wear Museums)
plate 40

JOHN GLOVER 1767–1849
155 (section IV)
A Scene in Italy c. 1820
Watercolour, 29 × 41.5
Private Collection
plate 211

ALBERT GOODWIN 1845–1932
156 (section VI)
Near Winchester 1864
Pencil and watercolour with bodycolour, 14.9 × 12.1
Inscr. lower left: AG (monogram) / 64
Private Collection, Courtesy Peter Nahum, London
plate 319

157 (section VI)
Old Mill, near Winchester 1875
Watercolour and pen and ink with bodycolour, 22.2 × 31.7
Inscr. lower right: AG (monogram) 1[8]75
Chris Beetles
plate 320

JAMES DUFFIELD HARDING 1797–1863
158 (section VI)
Modern Greece 1828
Watercolour with some bodycolour and scraping-out, 74.9 × 100
Exh. RA 1828 (no. 159, as Modern Greece, 'And many a summer flower is there…', Childe Harold)
The Sudeley Castle Collection
plate 293

WILLIAM HAVELL 1782–1857
159 (section IV)
Classical Figures in a Mountainous Landscape (Moel Siabod) 1805
Pencil and watercolour with scraping-out, 60.3 × 51.1
Inscr. lower left: W HAVELL 1805
Exh. OWCS 1805 (no. 252, as Moel Siabod, North Wales; or no. 23 or 145, both titled A Composition)
Reading Museum and Art Gallery (358.72)
plate 210

160 (section IV)
EXHIBITED LONDON ONLY
Windermere 1811
Watercolour with scraping-out and stopping-out, 24.8 × 34
Inscr. below centre: W HAVELL / 1811
Exh. OWCS 1811 (no. 12)
Trustees of the British Museum, London (1859-5-28-140)
plate 201

161 (section IV)
View on the Brathay near Ambleside, Westmorland 1828
Bodycolour on card, 35.5 × 50.9
Inscr. lower right on rock: W. Havell / 1828
Although engr. by F.J. Havell under the present title, this subject has recently been identified as Wetherlam from Little Langdale
Reading Museum and Art Gallery (279.73)
plate 203

THOMAS HEAPHY 1775–1835
162 (section VI)
Fish Market, Hastings 1809
Watercolour, with some bodycolour and scraping-out, 69.8 × 90.2
Exh. OWCS 1809 (no. 22)
Private Collection
plate 283

THOMAS HEARNE 1744–1817
163 (section II)
Edinburgh Castle from Arthur's Seat c. 1778
Pencil and watercolour, 35.6 × 50.8 cm
Inscr. lower left: *Hearne*
The Tate Gallery London; Presented by Frederick John Nettlefold 1947 (N 05792)
plate 64

ROBERT HILLS 1769–1844
164 (section III)
Two Studies of Skies, at Windsor c. 1810
Pencil and watercolour, 23.5 × 19
Inscr. lower right: *July 28th Windsor Forest. 8 Evening A…* [shorthand notes]… C…; and A, A, C in drawing
Lent by the Syndics of the Fitzwilliam Museum, Cambridge (1377)
plate 123

165 (section III)
Sheet of Studies of Country Children c. 1815
Pencil and watercolour, 30.2 × 22.2
Lent by the Syndics of the Fitzwilliam Museum, Cambridge (1564d)
plate 128

166 (section IV)
A Village Snow-scene 1819
Pencil and watercolour with bodycolour and scraping-out, 32.4 × 42.5
Inscr. lower right: R. Hills 1819

Yale Center for British Art, New Haven, Paul Mellon
Collection (B 1977.14.4907)
plate 184

167 (section IV)
EXHIBITED LONDON ONLY
The Turnip Field 1819
Watercolour and bodycolour, 29.2 x 41.3
Inscr. lower right: R. Hills 1819
Oldham Art Gallery (9.88/11)
plate 183

168 (section III)
Farm Buildings (?) c. 1815
Pencil and watercolour, 33 x 18.4
Inscr. in shorthand above cottage
Lent by the Syndics of the Fitzwilliam
Museum, Cambridge (1369)
plate 154

HENRY GEORGE HINE 1811–1895
169 (section VI)
Amberley Castle, Sussex, Seen from the Marshes 1867
Watercolour and bodycolour with scraping-out, 26 x 57.2
Inscr. lower right: HG HINE 1867
Exh. NWCS 1867 (no. 141)
Christopher and Jenny Newall
plate 323

170 (section VI)
Nine Barrow Down near Swanage, Dorset c. 1875
Pencil, watercolour and scraping-out, 50 x 89
Inscr. lower left: HG HINE
Abbott and Holder, London
plate 325

JAMES HOLLAND 1799–1870
171 (section II)
Villa do Conde, near Oporto, Portugal
1837
Pencil and watercolour with bodycolour,
29.9 x 43.2
Inscr. lower right: JH (monogram) Villa de Conde / Sept 2ᵈ
Exh. (?) OWCS 1838 (no. 141, as Convent of Santa Clara, at
Ville de Conde, near Oporto)
The Board of Trustees of the Victoria and Albert Museum,
London (FA 30)
plate 95

172 (section V)
View in North Wales: Arenig, with Snowdon Beyond 1852
Pencil, watercolour and bodycolour,
37.3 x 53.6
Inscr. lower right: JH [monogram] NW Octʳ 19ᵗʰ 52
Bill Thomson, Albany Gallery, London
plate 247

ALFRED WILLIAM HUNT 1830–1896
173 (section V)
EXHIBITED LONDON ONLY
The Tarn of Watendlath between Derwentwater and Thirlmere
1858
Watercolour with bodycolour and scraping-out,
32.2 x 49.2
Inscr. lower left: A. W. Hunt / 1858
Trustees of the British Museum, London (1969-9-20-1)
plate 254

174 (section V)
Near Abergele, Wales (?) c. 1860
Watercolour with scraping-out, 23 x 32
Chart Analysis Ltd
plate 253

175 (section VI)
*Travelling Cranes, Diving Bells, etc. on the Extremity of
Tynemouth Pier* c. 1867
Watercolour with scraping-out, 31.8 x 26.7
Exh. OWCS 1867 (no. 274)
Christopher and Jenny Newall
plate 318

176 (section VI)
Naples, or Land of Smouldering Fire 1871
Watercolour with bodycolour, sponging and scraping-out,
49 x 75
Inscr. lower right: A W Hunt 1871
Exh. OWCS 1871 (no. 70)
Chart Analysis Ltd
plate 326

177 (section VI)
Whitby (?) c. 1878
Watercolour with scraping-out, 38.5 x 56
Chart Analysis Ltd
plate 324

WILLIAM HENRY HUNT 1790–1864
178 (section II)
Old Bell Yard, Bushey c. 1815
Pencil and watercolour with pen and brown ink,
50.8 x 68.4
The Trustees of the Cecil Higgins Art Gallery, Bedford
(P 109)
plate 81

179 (section III)
Still-life with Earthenware Pitcher, Coffee Pot and Basket
c. 1825
Pencil and watercolour with bodycolour,
17 x 25
Inscr. lower right: W. HUNT
The Visitors of the Ashmolean Museum, Oxford (RUD 59)
plate 153

180 (section VI)
Preparing for Sunday c. 1832
Watercolour and bodycolour with scraping-out, 33.7 x 43.6
Inscr. lower right: W. HUNT
Harris Museum and Art Gallery, Preston (P 1273)
plate 306

181 (section VI)
The Kitchen Maid c. 1833
Pencil, watercolour and bodycolour with scraping-out,
47.9 x 58.5
Inscr. lower right: W. HUNT, and again on sack
City of Nottingham Museums: Castle Museum and Art
Gallery (1957.38)
plate 304

182 (section VI)
Jug with Plums and Rosehips c. 1840
Watercolour and bodycolour, 39.1 x 28.3
Inscr. lower right: W. HUNT
The Board of Trustees of the Victoria and Albert Museum,
London (1926-1900)
plate 305

183 (section VI)
Primroses with Bird's Nest c. 1850
Watercolour and bodycolour, 28 x 22.9
Inscr. lower right: W. HUNT
The Robertson Collection, Orkney, Courtesy
Peter Nahum, London
plate 307

184 (section III)
An Oyster Shell and an Onion c. 1859
Watercolour and bodycolour, 12.2 x 16.5
Inscr. lower right: W. HUNT
Exh. OWCS 1859 (no. 226, as 'Painted for J. Ruskin, Esq.')
Private Collection
plate 150

WILLIAM HOLMAN HUNT 1827–1910
185 (section V)
Fishing-boats by Moonlight c. 1869
Pencil, watercolour and some bodycolour,
40.5 x 55.8
Inscr. lower left: WHH (monogram)
The Trustees of the Cecil Higgins Art Gallery, Bedford (P 351)
plate 271

SAMUEL JACKSON 1794–1869
186 (section IV)
*Mother Pugsley's Well, looking towards Somerset Street,
Kingsdown* 1823
Pencil and watercolour, 22.3 x 19.7
Bristol City Museums and Art Gallery (M 964)
plate 193

187 (section IV)
View of the Hotwells and Part of Clifton near Bristol (?) 1823
Pencil and watercolour with some bodycolour and
scraping-out, 39.3 x 90.1
Exh. (?) OWCS 1823 (no. 223)
Bristol City Museums and Art Gallery (K 2238)
plate 191

188 (section II)
Bristol: St Augustine's Parade c. 1825
Pencil and watercolour, 27.8 x 45.2
Engr. by Fenner Sears & Co as the frontispiece for
J. Chilcott's New Guide to Bristol, 2nd edn, c. 1831
Bristol City Museums and Art Gallery (Mb 700)
plate 71

189 (section II)
Composition: Hunters Resting after the Chase 1827
Watercolour and bodycolour with scraping-out, 57.7 x 85
Inscr. verso: Sir Humphrey de Trafford
Exh. OWCS 1827 (no. 121)
Bristol City Museums and Art Gallery (K 4363)
plate 302

190 (section VI)
Composition: A Land of Dreams 1830
Watercolour with gum arabic, 56.8 x 86.7
Inscr. on label on reverse: No. 1 Composition 'A Land of
dreams where the spirit strays in the silent time [of night] /
And friends meet friends – long lost – in the glow of the
evening l[ight]' / 940 Guineas, S Jackson. Cotham /.
Exh. OWCS 1830 (no. 180; the quotation on the label gives
the approximate title under which the work was
exhibited)
Bristol City Museums and Art Gallery (K 4083)
plate 294

JAMES JOHNSON 1803–1834
191 (section II)
*Bristol: Interior of St Mary Redcliffe; the North Aisle looking
East* 1828
Pencil and watercolour, 25.9 x 19.4
Inscr. lower right: JJ – 1828 –
Bristol City Museums and Art Gallery (M 1950)
plate 83

EDWARD LEAR 1812–1888
192 (section II)
The Monastery of Esphigmenou, Mount Athos, Greece 1856
Watercolour with pen and brown ink, 30.5 x 22.8
Inscr. lower left: Esphyménu / 19. Sepr 1856, and elsewhere
with colour notes
Private Collection
plate 105

193 (section II)
The Pyramids with Sphinx and Palms 1858
Pencil and watercolour, 16.5 x 51.4
Inscr. lower right: Cairo / 21 March 1858 and elsewhere with
colour notes
The Tate Gallery, London, Presented by the Earl of
Northbrook 1910 (N 02796)
plate 104

194 (section II)
Mount Parnassus, with a Group of Travellers in the Foreground
1879
Watercolour, 25.7 x 51.8
Inscr. lower right: EL (monogram) 1879
Private Collection, Courtesy of the Leger Galleries,
London

plate 106

GEORGE ROBERT LEWIS 1782–1871

195 (section III)
Clearing a Site in Paddington for Development c. 1820
Pencil and watercolour, 26.7 x 49.5
Inscr. lower right: *G. R. Lewis Paddington*
The Tate Gallery, London, Purchased 1975 (T 02009)
plate 120

JOHN FREDERICK LEWIS 1805–1876

196 (section VI)
Highland Hospitality 1832
Pencil, watercolour and bodycolour with gum arabic and
scraping-out, 56 x 78
Exh. OWCS 1832 (no. 192)
Yale Center for British Art, New Haven, Paul Mellon
Collection (B 1978.43.167)
plate 308

197 (section II)
EXHIBITED LONDON ONLY
*Torre de las Infantas: One of the Towers in the Grounds of the
Alhambra, Granada*
1833
Pencil and watercolour with bodycolour on grey paper,
36.2 x 25.4
Inscr. lower left: *Torre de las Infantas / Sept. 19, 1833*
Lithographed by J.D. Harding, *Lewis's Sketches and
Drawings of the Alhambra*, plate 24, Sir Brinsley Ford, plate
103

198 (section VI)
*The Suburbs of a Spanish City (Granada) on the Day of a Bull-
fight* 1836
Pencil and watercolour with bodycolour, 64.7 x 85
Inscr. lower right: *J. F. Lewis / 1836*
Exh. OWCS 1836 (no. 302)
Whitworth Art Gallery, University of Manchester
(D 1887–44)
plate 309

199 (section VI)
EXHIBITED LONDON ONLY
The Noonday Halt 1853
Pencil and watercolour with bodycolour,
40.5 x 56.5
Inscr. lower right (in strap): *JFL. 1853*
Exh. RA 1854 (no. 248)
Lent by the Syndics of the Fitzwilliam Museum,
Cambridge (716)
plate 310

200 (section VI)
Life in the Hhareem, Cairo 1858
Watercolour and bodycolour, 60.6 x 47.7
Inscr. lower right: *JFL (monogram) / 1858*
The Board of Trustees of the Victoria and Albert Museum,
London (679-1893)
plate 311

201 (section VI)
The Pipe-bearer 1859
Pencil, watercolour and bodycolour, 55.9 x 40.6
Inscr. lower right: *JFL ARA / 1859*
Exh. (?)RA 1862 (no.812, as *Egyptian Servant*)
The Trustees of the Cecil Higgins Art Gallery, Bedford (P 305)
plate 313

202 (section VI)
Girl with Two Caged Doves 1864
Pencil, watercolour and bodycolour,
32.4 x 22.5
Inscr. lower left: *J F Lewis / 1864*
Exh. RA 1864 (no. 577, as *Caged Doves, Cairo*)
Lent by the Syndics of the Fitzwilliam Museum,
Cambridge (PD 6-1959)
plate 312

JOHN LINNELL 1792–1882

203 (section III)
EXHIBITED LONDON ONLY
Primrose Hill 1811
Watercolour with pen and brown ink and white chalk,
39.5 x 67.8
Inscr. below, centre: *Primrose Hill. J. Linnell. 1811*; and lower
right: *part of primrose hill*

Lent by the Syndics of the Fitzwilliam Museum,
Cambridge (PD 16–1970)
plate 119

204 (section III)
Bayswater and Kensington Gardens 1811
Pencil and watercolour on laid paper, 24 x 37.7
Inscr. below, centre: *Bayswater & Kensington
Garden. 1811. Linnell*
Martyn Gregory Gallery
plate 122

205 (section III)
Regent's Park 1812
Watercolour, 10.6 x 14.9
Inscr. lower left: *J.L.* and *1812*; and lower right: *Regents Park*
Martyn Gregory Gallery
plate 126

206 (section III)
Dovedale 1814
Pencil and watercolour, 32.3 x 52.8
Inscr. below, centre: *J. Linnell. 1814 – Dovedale Derbyshire*
Martyn Gregory Gallery
plate 117

207 (section III)
Tree Study at Tythrop 1817
Pencil and watercolour with black and white chalks on
grey paper, 44.3 x 28.7
Inscr. lower right: *J Linnell Tythrop 1817*
Lent by the Syndics of the Fitzwilliam Museum,
Cambridge (PD 4-1957)
plate 132

208 (section V)
Sailing-boats on Southampton Water 1819
Watercolour, 15.6 x 22.3
Inscr. below: *Southampton River Isle of Wight in distance 1819
J Linnell*
National Gallery of Art, Washington DC, Paul Mellon
Collection (1986.72.10)
plate 268

THOMAS MALTON JNR 1748–1804

209 (section II)
St Paul's Church, Covent Garden, London, from the Piazza
c.1787
Pencil and watercolour with pen and black ink on laid
paper, 31.7 x 47.2
Engr. for the *Picturesque Tour through the Cities of London
and Westminster*, 1792, plate 32
Exh. RA 1787 (no. 587)
Whitworth Art Gallery, University of Manchester (D 1951-14)
plate 67

JOHN MARTIN 1789–1854

210 (section IV)
Sunset over a Rocky Bay 1830
Watercolour with scraping-out, 24 x 36.8
Inscr. lower left: *J. Martin 1830*
Private Collection, through Hazlitt, Gooden & Fox
plate 221

211 (section V)
EXHIBITED LONDON ONLY
Landscape 1835 (? 1839)
Watercolour and scraping-out, 23.5 x 31.8
Inscr. lower right: *J. Martin 1835 (?1839)*
Oldham Art Gallery (9.88/56)
plate 246

212 (section VI)
The Destruction of the Pharaoh's Host 1836
Watercolour and bodycolour with gum arabic and
scraping-out, 57.5 x 85
Inscr. lower right: *1836 /J. Martin*
Private Collection
plate 303

JOHN MIDDLETON 1827–1856

213 (section V)
A Shady Lane, Tunbridge Wells, Kent 1847
Pencil and watercolour, 31 x 47
Inscr. lower left: *Tonbridge Wells / JM (monogram) 1847*

Private Collection, USA
plate 248

JOHN EVERETT MILLAIS 1829–1896

214 (section III)
A Mountainous Scene, Scotland – possibly Ben Nevis (?) 1854
Watercolour and bodycolour with scraping-out, 12.1 x 19.5
Inscr. lower right: *Ben Nevis 4 Sept*, and by the artist
(?later) JEM (monogram) 1853
Whitworth Art Gallery, University of Manchester
(D 1928–38)
plate 162

ALBERT JOSEPH MOORE 1841–1893

215 (section III)
Study of an Ash Trunk 1857
Watercolour and bodycolour with gum arabic, 30.3 x 22.9
Inscr. lower left: AM (monogram) 1857
Exh. RA 1858 (no. 633)
The Visitors of the Ashmolean Museum, Oxford (1959.59)
plate 141

WILLIAM JAMES MÜLLER 1812–1845

216 (section II)
Cairo: A Street with a Minaret c. 1838
Pencil and watercolour, 34.9 x 24.7
Private Collection
plate 98

217 (section V)
Distant View of Xanthus 1843
Watercolour, 35.2 x 53.1
Private Collection
plate 250

218 (section V)
EXHIBITED LONDON ONLY
Rock Tombs at Pinara 1843
Pencil, watercolour and bodycolour, 35.6 x 53.3
Inscr. lower left: *Pinara. Lycia. / Novr 18 1843 / WM*
Trustees of the British Museum, London
(1878-12-28-123)
plate 252

FREDERICK NASH 1782–1856

219 (section III)
Showery Day, Glastonbury Tor (?) c. 1820
Watercolour, 21.9 x 36.2
Inscr. lower right: F. NASH
The Board of Trustees of the Victoria and Albert Museum,
London (P. 135-1931)
plate 159

PATRICK NASMYTH 1787–1831

220 (section III)
Broad Dock (Rumex obtusifolius) (?) c. 1810
Watercolour, 29.2 x 20.9
Lent by the Syndics of the Fitzwilliam Museum,
Cambridge (1404)
plate 136

221 (section III)
*Burdock (Arctium) (?)*c. 1810
Watercolour, 29.2 x 20.9
Lent by the Syndics of the Fitzwilliam Museum,
Cambridge (1405)
plate 135

JOHN WILLIAM NORTH 1842–1924

222 (section VI)
Gypsy Encampment 1873
Watercolour and bodycolour with scraping-out, 64.1 x 92.7
Inscr. lower left: *J. W. North 1873 March*
The Board of Trustees of the Victoria and Albert Museum,
London (68-1895)
plate 317

SAMUEL PALMER 1805–1881

223 (section IV)
Moonlit Scene with a Winding River c. 1827
Pen and black ink and brown wash with bodycolour on
buff paper, 28.6 x 18.4
Yale Center for British Art, New Haven, Paul Mellon
Collection (1977.14.4643)
plate 219

224 (section IV)
Harvesters by Firelight c. 1830
Pencil, watercolour and bodycolour with pen and black ink, 28.7 x 36.7
National Gallery of Art, Washington DC, Paul Mellon Collection (1986.72.12)
plate 220

225 (section IV)
The Bright Cloud c.1833–4
Pen and black ink and wash with white body-colour, 22.9 x 30.5
The Tate Gallery, London, Presented by Hugh Blaker through the National Art Collections Fund 1917 (N 03312)
plate 222

226 (section III)
EXHIBITED WASHINGTON ONLY
A Cascade in Shadow c. 1835–6
Watercolour and bodycolour, 47.3 x 37.5
Inscr. lower left: *No 7 / Samuel Palmer*; and (party obscured): *Cascade ...at the junction of the rivers... Machno, Wales*
Exh. OWCS 1871 (no. 317)
Private Collection, New York
plate 158

227 (section V)
EXHIBITED LONDON ONLY
The Herdsman c. 1850
Black chalk and watercolour with bodycolour, gum arabic and scraping-out, 52 x 73.7
Oldham Art Gallery (9.88/69)
plate 255

228 (section VI)
EXHIBITED WASHINGTON ONLY
The Lonely Tower (Illustration to Milton's 'Il Penseroso') 1868
Pencil, watercolour, bodycolour and gum arabic with scraping-out on board, 51.7 x 70.8
Inscr. on label on reverse: *No: 1 / The Lonely Tower / 'Or let my lamp, at midnight hour, / Be seen in some high lonely tower, / Where I may oft outmatch the Bear, / With thrice great Hermes.' / Samuel Palmer*
Exh. OWCS 1868 (no. 16)
Yale Center for British Art, New Haven, Paul Mellon Collection (B 1977.14.147)
plate 299

229 (section VI)
A Towered City (Illustration to Milton's 'L'Allegro') 1868
Watercolour and bodycolour with gum arabic and scraping-out, 51.1 x 70.8
Inscr. lower left: S. PALMER
This subject is also known as *The Haunted Stream*
Rijksprentenkabinet, Rijksmuseum, Amsterdam (1978–39)
plate 300

230 (section VI)
Morning (Illustration to Milton's 'Il Penseroso') 1869
Watercolour and bodycolour with gum arabic and scraping-out, 51 x 78
Inscr. lower left: S. PALMER; and on label on reverse: *No. 2, Samuel Palmer / Morn, / Not trickt and frounct, as she was wont / With the Attic Boy to hunt; / But kercheift in a comely cloud, / While rocking winds are piping loud, / Or usher'd with a shower still / When the gust hath blown his fill, /Ending on the rustling leaves, / With minute drops from off the eaves.*
This subject is also known as *The Dripping Eaves*
The Duke of Devonshire and the Chatsworth Settlement Trustees
plate 298

WILLIAM PARS 1742–1782
231 (section II)
EXHIBITED LONDON ONLY
A Ruin near the Port of Aegina c. 1766
Pencil and watercolour with gum arabic, 28.7 x 49
Engr. William Byme, *Ionian Antiquities*, II, 1797, plate 1; and as an aquatint by Paul Sandby, 1777
Trustees of the British Museum, London (Mm 11-10)
plate 58

232 (section II)
A Picnic Party in Ireland 1771
Pencil and watercolour, with pen and black ink on laid paper, 33.6 x 48.2
Birmingham Museums and Art Gallery (P. 296'53)
plate 56

SAMUEL PROUT 1783–1852
233 (section II)
A View in Strasbourg (?) 1822
Watercolour with reed pen and brown ink, 61.9 x 47.6
Inscr. lower left: HANDLUN[G] *von* S. PROU[T]
Exh. (?) OWCS 1822 (no.85)
The Visitors of the Ashmolean Museum, Oxford
plate 99

234 (section VI)
The Ducal Palace, Venice 1830
Watercolour, 74.9 x 104.1
Exh. OWCS (no. 58)
The Sudeley Castle Collection
plate 292

ALLAN RAMSAY 1713–1784
235 (section II)
EXHIBITED WASHINGTON ONLY
Study of Part of the Ruins of the Colosseum 1755
Watercolour, 37.6 x 26.6
National Galleries of Scotland, Edinburgh (D 3774)
plate 61

GEORGE RICHMOND 1809–1896
236 (section III)
A View of Norbury Woods 1860
Black chalk, watercolour and bodycolour on blue paper, 27.2 x 38.7
Inscr. lower left: *Norbury Woods – from the Garden of Cowslip Cottage / Mickleham, Surrey, /by Geo. Richmond, 1860*
Lent by the Syndics of the Fitzwilliam Museum, Cambridge (PD 43-1971)
plate 157

DAVID ROBERTS 1796–1864
237 (section II)
Madrid: Palacio Real 1833–5
Pencil and watercolour, 27.3 x 35.5
University of Liverpool Art Gallery and Collections, Sir Sydney Jones Collection (FA 236)
plate 96

GEORGE FENNEL ROBSON 1788–1833
238 (section VI)
EXHIBITED LONDON ONLY
Loch Coruisk and the Cuchullin Mountains, Isle of Skye 1826
Watercolour with scraping-out, 64.2 x 111.8
Exh. OWCS 1826 (no. 136, with a quotation from Scott's *Lord of the Isles*)
The Board of Trustees of the Victoria and Albert Museum, London (1426-1869)
see fig. 54

239 (section IV)
Tryfan, Caernarvonshire (?) 1827
Watercolour and bodycolour with gum arabic and scraping-out, 46.4 x 76
Exh. (?)OWCS 1827 (no. 152)
Yale Center for British Art, New Haven, Paul Mellon Collection (B 1981.25.2048)
plate 205

MICHAEL 'ANGELO' ROOKER 1746–1801
240 (section I)
EXHIBITED LONDON ONLY
Entrance to a Park (?) c. 1790
Watercolour with pen and ink on laid paper, 45.7 x 35.1
Inscr. lower left (?in a later hand): M. A. Rooker
Trustees of the British Museum, London (1889-6-3-261)
plate 16

241 (section II)
The Gatehouse at Battle Abbey, Sussex 1792
Pencil and watercolour, 41.9 x 59.6
Inscr. lower right: MA Rooker/ MAR in monogram / 1792; and on artist's washline mount: *Battle Abbey and MA Rooker/ MAR in monogram / Delin*[t]
Exh. (?) RA 1792 (no. 438)
Royal Academy of Arts, London
plate 65

242 (section II)
Interior of the Abbot's Kitchen, Glastonbury c. 1795
Pencil and watercolour, 35.6 x 45.1
Inscr. lower left: MA Rooker (MAR in monogram)
The Tate Gallery, London, Presented by the Art Collections Fund (Herbert Powell Bequest) 1967 (T 01013)
plate 74

THOMAS ROWLANDSON 1756–1827
243 (section II)
EXHIBITED LONDON ONLY
London: Skaters on the Serpentine 1784
Pencil and watercolour with pen and black ink, 42.4 x 73.9
Exh. RA 1784 (no. 511, as *The Serpentine River*)
National Museum of Wales, Cardiff (748)
plate 69

JOHN RUSKIN 1819–1900
244 (section II)
Milan: The Pulpit in the Church of S. Ambrogio (?) 1845
Pencil and watercolour on buff paper, 43.8 x 33
The Board of Trustees of the Victoria and Albert Museum, London (226-1887)
plate 102

245 (section III)
The Garden of S. Miniato, Florence 1845
Pencil and watercolour and bodycolour with pen and black ink, 33.3 x 47.3
National Gallery of Art, Washington DC, Patrons' Permanent Fund (1991.88.1[GD])
plate 156

246 (section III)
Head of Lake Geneva (?) 1846
Pencil and watercolour with pen and brown ink, 23.8 x 39.9
Inscr. lower right: *Head of Lake Geneva*
Rijksprentenkabinet, Rijksmuseum, Amsterdam (1987–19)
plate 164

247 (section III)
EXHIBITED LONDON ONLY
Study of Ivy (Hedera Helix) c.1872
Black chalk, watercolour and bodycolour with gum arabic, 42 x 28
Inscr. verso: *Study of ivy, Coniston*
Trustees of the British Museum, London (1979-1-27-11)
plate 142

248 (section III)
Study of Two Shells c. 1881
Watercolour and bodycolour on blue paper, 14.4 x 24.2
Whitelands College Archive, London
plate 149

PAUL SANDBY 1731–1809
249 (section II)
EXHIBITED LONDON ONLY
Horsefair on Bruntsfield Links, Edinburgh in the Background 1750
Watercolour, bodycolour and pen and black ink on laid paper, 24.4 x 37.3
Inscr. lower right: *P. Sandby Delin 1750*
National Galleries of Scotland, Edinburgh (D 5184)
plate 48

250 (section III)
EXHIBITED LONDON ONLY
Figure Studies at Edinburgh and in the Vicinity c. 1750
(a) *Street Groups*

Pencil and watercolour with pen and ink on laid paper,
7.6 x 18.7
(b) Pedlars etc.
Pencil and watercolour with pen and ink on laid paper,
8.6 x 22.6
(c) A Meat Market
Pencil and watercolour with pen and ink on laid paper,
12.1 x 23.5
Trustees of the British Museum, London (Nn 6–19, 65, 38)
plate 127

251 (section II)
Windsor: The Lodge Kitchen at Sandpit Gate c. 1751
Pencil, watercolour and some bodycolour with pen and
black ink and scraping-out on laid paper, 25 x 32.5
Inscr. lower left: The Kitchen at Sandpit Gate W' Park 1754
PS.
This inscription appears to have been added by Sandby at
a later date, and may be inaccurate by two or three years
Royal Library, Windsor Castle (RL 14331)
plate 54

252 (section II)
Windsor: The Curfew Tower from the Horseshoe Cloister,
Windsor Castle c. 1765
Pencil and watercolour with pen and black ink on laid
paper, 34.5 x 50.7
Royal Library, Windsor Castle (RL 14555)
plate 52

253 (section II)
Windsor: View of the Ascent to the Round Tower, Windsor
Castle c. 1770
Pencil and watercolour with pen and black ink on laid
paper, 36.3 x 43.6
Inscr. on label attached to artist's washline mount:
Windsor / View of the Ascent to the Round Tower
Royal Library, Windsor Castle (RL 17876)
plate 53

254 (section III)
The Tide Rising at Briton Ferry 1773
Pencil and watercolour on laid paper, 29.7 x 53.3
Inscr. verso: This view pointed out by Sir Joseph Banks, Bart,
in the year 1773. He stood by while I made the Sketch, his ser-
vant holding an umbrella to keep the glare of the sun from my
paper. I was so attentive in making this Drawing correct as not
to perceive the Tide approach, it flowing very fast and follow us
upward of a mile before we was in Safety, when looking back
to sand hillocks on which I had sat to sketch, they was under
water, the Tide generally rising 8 feet. P. Sandby, R.A. N.B. On
the left hand of the Ferry House rises smoke from the Copper
Works at Neath over Lord Vernon's Wood, on the Right hand
Mr. Morriss's Plantations.
National Gallery of Art, Washington DC, Gift of the Circle
of the National Gallery of Art (1988.19.1)
plate 112

255 (section I)
A Rocky Coast by Moonlight (?) c. 1790
Bodycolour, 31.8 x 47
City of Nottingham Museums: Castle Museum and Art
Gallery (1971–86)
plate 24

256 (section II)
EXHIBITED LONDON ONLY
View of Eton College from the River c. 1790
Bodycolour, 54.7 x 76.5
The Nivison Loan to the Laing Art Gallery, Newcastle
upon Tyne
plate 51

257 (section III)
EXHIBITED LONDON ONLY
Bayswater 1793
Pencil and watercolour on laid paper, 18.4 x 40.6
Inscr. lower right: Bayswater 1793 P.S.
Trustees of the British Museum, London (1904-8-19-67)
plate 111

258 (section II)
Tea at Englefield Green, near Windsor c. 1800
Pencil and bodycolour with pen and black ink on laid
paper, 28.6 x 43.2

Inscr. lower right on back of artist's seat: P Sandby /R.A.
pinxt
City of Nottingham Museums: Castle Museum and Art
Gallery (1945–146)
plate 55

THOMAS SANDBY 1721–1798
259 (section II)
Windsor, from the Lodge Grounds in the Great Park early
1750s
Pencil and watercolour with pen and black ink on laid
paper, 26.6 x 49.5
Inscr. verso: Windsor, from the Lodge grounds in / the Great
Park N°1
Royal Library, Windsor Castle (RL 17751)
plate 50

260 (section II)
EXHIBITED LONDON ONLY
The Camp on Cox Heath (?) 1754
Pencil and watercolour with pen and black ink on laid
paper, 49.1 x 147.3
Traditionally dated to 1778, when an encampment took
place on Cox Heath, but more likely a view of the one
there in 1754
Royal Library, Windsor Castle (RL 14729)
plate 49

WILLIAM BELL SCOTT 1811–1890
261 (section III)
Penwhapple Stream 1860
Pencil, watercolour and bodycolour, 22.6 x 31.6
National Galleries of Scotland, Edinburgh (D 4715A)
plate 161

WILLIAM SIMPSON 1823–1899
262 (section II)
Valley of Vardan, Caucasus 1855–8
Watercolour and bodycolour, 30.7 x 46.8
Inscr. lower left: Valley of Vardan, Circassia / 19th Oct' 1855;
and lower right: Wm Simpson 1858
Bill Thomson, Albany Gallery, London
plate 107

JONATHAN SKELTON c. 1735–1759
263 (section I)
In Greenwich Park 1757
Pencil and watercolour with pen and black ink on laid
paper, 24.9 x 53.7
Inscr. verso of artist's washline mount: In Greenwich Park /
J. Skelton. 1757
Lent by the Syndics of the Fitzwilliam Museum,
Cambridge (1710)
plate 14

264 (section III)
EXHIBITED LONDON ONLY
A Study at Tivoli 1758
Pencil and watercolour with pen and black ink on laid
paper, 26.4 x 37.5
Inscr. lower right: a View of one side of Tivoli / up the River J
Skelton 1758
Lent by the Syndics of the Fitzwilliam Museum,
Cambridge (1163 verso)
plate 108

JOHN 'WARWICK' SMITH 1749–1831
265 (section I)
EXHIBITED LONDON ONLY
Study of Part of the Interior of the Colosseum 1776
Pencil and watercolour with pen and brown ink, 39 x 53.3
Inscr. on artist's washline mount: in the Colleseo; and
verso: In the Collesseum Rome 17[7]6
Trustees of the British Museum, London (1936-7-4-13)
plate 62

JAMES 'ATHENIAN' STUART 1713–1788
266 (section II)
Athens: The Monument of Philopappos c. 1755
Pencil and bodycolour on laid paper, 31.5 x 45.5
Engr. for The Antiquities of Athens, III, 1795, ch. V, plate I
British Architectural Library Drawings Collection / Royal
Institute of British Architects, London (Y30[12])
plate 59

267 (section II)
Salonica: The Incantada or Propylaea of the Hippodrome
c. 1755
Pencil and bodycolour on laid paper, 33 x 47
Engr. for The Antiquities of Athens, III, 1795, ch. IX, plate I
British Architectural Library Drawings Collection / Royal
Institute of British Architects, London (Y30[15])
plate 60

FRANCIS TOWNE 1740–1816
268 (section II)
EXHIBITED LONDON ONLY
Rome: A Gateway of the Villa Ludovisi 1780
Watercolour with pen and black ink on laid paper,
46.4 x 32.1
Inscr. lower right: F Towne del / No 19 Dec' 9 178[0], and on
backing sheet: N° 19 Going into the Villa Ludovisi Dec 9 1780
Rome Francis Towne del'
Trustees of the British Museum, London (1972 u 731)
plate 63

269 (section I)
EXHIBITED LONDON ONLY
Lake Albano with Castel Gandolfo 1781
Watercolour with pen and brown ink on laid paper,
32.1 x 70.2
Inscr. lower left: No 7 Francis Towne / del' July 12 1781; and on
backing sheet: Italy / No. 7 Lake of Albano taken July 12th 1781
/Francis Towne / Morning light from the left hand
Trustees of the British Museum, London (1972 u 646)
plate 22

270 (section I)
Naples: A Group of Buildings Seen from an Adjacent Hillside
1781
Pen and black ink and wash on laid paper, 32.6 x 47
Inscr. verso: Naples / March 19th 1781 / from 10 till 12 o'clock /
sun from the left in the morning out / of the picture and the
right in the after / – noon // N.°6
Private Collection, Courtesy of the Leger Galleries,
London
plate 17

271 (section I)
The Source of the Arveiron: Mont Blanc in the Background 1781
Watercolour with pen and brown ink, 42.5 x 31.1
Inscr. lower right: F. Towne. Delt / 1781 /N°.53
The Board of Trustees of the Victoria and Albert Museum,
London (P 20-1921)
plate 21

272 (section I)
The Source of the Arveiron 1781
Watercolour with pen and brown ink on laid paper, 31 x 21
Inscr. lower right: F. Towne / N.°52 1781; and verso: N°. 52. A
view of the Source of the Arviron drawn by Francis Towne,
Sept... 1781
Private Collection
plate 20

273 (section I)
Head of Lake Geneva from Vevay 1781
Pen and brown ink with blue and grey washes on laid
paper, 26.4 x 37.9
Inscr. verso: Head of the Lake of Geneva Taken at Vevay N°2
Septr. 11n, 1787 Francis Towne
Leeds City Art Galleries (13.211/53)
plate 18

274 (section I)
Pantenbruck 1781
Pen and black ink and wash on laid paper, 46.5 x 28.5
Inscr. verso: Pantenbruck Morning light from the right Hand /
No. 29 Septr 3d. 1781 / Francis Towne
Leeds City Art Galleries (13.209/53)
plate 19

275 (section I)
A View at the Head of Lake Windermere 1786
Pencil and watercolour with pen and brown ink on laid
paper, 15.6 x 47.4
Inscr. lower right: F. Towne del' / No. 14 1786; and verso: No.
14. A view taken near the Turnpike coming from Low Wood to
Ambleside, at the head of the Lake of Windermere, in
Westmorland. Drawn on the spot by Francis Towne, August

12th 1786. Also inscribed verso with a list of hills indicated by letters: A, Rydal Peak; B, Rydal Cragg; C, Rydal head; B. Lower Greaves and A, Higher Greaves in Rydal Park; C, Rydal Lower peak or cragg; D, Rydal higher peak; E, Great Ridge; F, Red Crease. Leicester Square, 1791.
Birmingham Museums and Art Gallery (91'21)
plate 23

276 (section III)
Trees Overhanging Water 1800
Watercolour with pen and brown ink, 36.7 x 22.2
Inscr. lower left: F. Towne /del.ᵗ 1800
Leeds City Art Galleries (13.204/53)
plate 134

JOSEPH MALLORD WILLIAM TURNER 1775–1851

277 (section II)
The Pantheon, Oxford Street, London 1792
Pencil and watercolour, 51.6 x 64
Inscr. lower left: W Turner Del
Exh. RA 1792 (no. 472)
The Tate Gallery, London, Bequeathed by the artist, 1856
TB IX-A (D 00121)
plate 68

278 (section II)
Wolverhampton, Staffordshire 1796
Pencil and watercolour, 31.8 x 41.9
Exh. RA 1796 (no. 651)
Wolverhampton Art Gallery and Museums
plate 70

279 (section II)
Transept of Ewenny Priory, Glamorganshire 1797
Pencil and watercolour with scraping-out and stopping-out, 40 x 55.9
Exh. RA 1797 (no. 427)
National Museum of Wales, Cardiff (497a)
plate 75

280 (section I)
View across Llanberis Lake towards Snowdon c. 1799
Watercolour, 43.5 x 56.4
One of a series of preparatory colour studies
The Tate Gallery, London, Bequeathed by the artist, 1856
TB LXX-C (D 04180)
plate 35

281 (section VI)
Conway Castle 1800
Watercolour with scraping-out and stopping-out, 52.5 x 77
The Leger Galleries, London
plate 279

282 (section VI)
EXHIBITED WASHINGTON ONLY
Glacier and Source of the Arveiron, Going up the Mer de Glace, Chamonix 1802–3
Pencil and watercolour with scraping-out and stopping-out, 68.5 x 101.5
Exh. RA 1803 (no. 396)
Yale Center for British Art, New Haven, Paul Mellon Collection (B 1977.14.4650)
plate 278

283 (section VI)
A View of Lincoln from the Brayford c. 1802–3
Pencil, watercolour and some bodycolour with scraping-out and stopping-out, 66 x 102
Lincolnshire County Council: Usher Art Gallery, Lincoln (U.G. 2379)
plate 276

284 (section)
The Great Falls of the Reichenbach 1804
Watercolour with scraping-out and stopping-out, 103 x 70.4
Inscr. lower right: IMW TURNER RA1804
Exh. RA 1805 (no. 292)
The Trustees of the Cecil Higgins Art Gallery, Bedford (P98)
plate 275

285 (section III)
Benson (or Besington), near Wallingford c.1805
Pencil and watercolour, 25.9 x 37.1
A sheet from the *Thames from Reading to Walton* sketch-book
The Tate Gallery, London, Bequeathed by the artist, 1856
TB XCV–13 (D 05917)
plate 118

286 (section III)
Head of a Heron c. 1815
Pencil and watercolour with scraping-out, 24.9 x 28.9
A detached sheet from the *Ornithological Collection*, III; frontispiece to 'Of the Heron'
Leeds City Art Galleries (I/85)
plate 145

287 (section VI)
Landscape: Composition of Tivoli 1817
Pencil, watercolour and bodycolour with scraping-out and stopping-out, 67.6 x 102
Inscr. lower right: IMW TURNER 1817
Exh. RA 1818 (no.474) and OWCS 1823 (no. 88)
Private Collection
plate 277

288 (section II)
Caley Hall, Yorkshire c. 1818
Bodycolour, 29.9 x 41.4
National Galleries of Scotland, Edinburgh (D 502 3/41)
plate 87

289 (section II)
Rome: The Church of SS Giovanni e Paolo 1819
Watercolour and bodycolour on white paper prepared with a grey wash, 23 x 36.9
A sheet from the *Rome: C. Studies* sketchbook
The Tate Gallery, London, Bequeathed by the artist, 1856
TB CLXXXIX-39 (D 16366)
plate 90

290 (section III)
Study of Fish: Two Tench, a Trout and a Perch c. 1822
Pencil and watercolour, 27.5 x 47
The Tate Gallery, London, Bequeathed by the artist, 1856
TB CLXXXIX–339 (D 25462)
plate 146

291 (section VI)
The Sun Setting over the Sea in Orange Mist c. 1825
Watercolour, 24.5 x 34.6
The Tate Gallery, London, Bequeathed by the artist, 1856
TB CCLXIII–210 (D 25332)
plate 257

292 (section II)
Dartmouth Cove c. 1826
Watercolour and scraping-out, 27.5 x 39.5
Engr. By W. R. Smith, 1827, for *Picturesque Views in England and Wales*
Exh.: Moon, Boys and Graves Gallery, 1833
The Leger Galleries, London
plate 278

293 (section II)
Stamford, Lincolnshire c.1828
Watercolour and some bodycolour with scraping-out, 29.3 x 42
Engr. by W. Miller, 1830, for *Picturesque Views in England and Wales*
Exh.: Moon, Boys and Graves Gallery, 1833
Lincolnshire County Council: Usher Art Gallery, Lincoln
plate 86

294 (section II)
Paris: Pont Neuf and Ile de la Cité c. 1832
Watercolour and bodycolour on blue paper, 14.3 x 18.8
Engr. by W Miller for *Turner's Annual Tour – the Seine*, 1835
The Tate Gallery, London, Bequeathed by the artist, 1856
TB CCLIX–118 (D 24683)
plate 91

295 (section II)
Kidwelly Castle, Carmarthenshire 1832–3
Watercolour, 29 x 44.8
Engr. by T.Jeavons, 1837, for *Picturesque Views in England and Wales*
Exh. Moon, Boys and Graves Gallery, 1833
Harris Museum and Art Gallery, Preston (P1280)
plate 89

296 (section V)
Storm off the East Coast (?) c. 1835
Watercolour, chalk and bodycolour on buff paper, 20.9 x 27.3
Sheffield City Art Galleries (2205)
plate 258

297 (section V)
Oberwesel 1840
Watercolour and bodycolour with scraping-out, 34.6 x 53.3
Inscr. lower right: IMWT.1840
Private Collection, Courtesy the Leger Galleries, London
plate 261

298 (section V)
A Raft and Rowing-boat on a Lake by Moonlight c. 1840
Watercolour, 19.2 x 28
Inscr. Verso: Now from a... [illegible] / [?] thrills... / as the Moon [?] descends yet Venice gleams of many winking lights / and like the... sails when she [?] wanes
The Tate Gallery, London, Bequeathed by the artist, 1856
TB CCCLXIV-334 (D 36192)
plate 256

299 (section V)
Venice: S. Maria della Salute and the Dogana c. 1840
Watercolour, 22.1 x 32.1
The Tate Gallery, London, Bequeathed by the artist, 1856
TB CCCXV–14 (D 32130)
plate 264

300 (section V)
Venice: The Riva degli Schiavoni from the Channel to the Lido c. 1840
Watercolour and bodycolour with pen and brown and red ink, 24.5 x 30.6
The Tate Gallery, London, Bequeathed by the artist, 1856
TB CCCXVI–18 (D 32155)
plate 265

301 (section V)
The Lake of Brientz 1841
Watercolour and bodycolour with pen and brown ink, 23.1 x 28.8
Private Collection
plate 262

302 (section V)
The Rhine at Reichenau (?) 1841
Watercolour, 24.4 x 31.1
The Tate Gallery, London, Bequeathed by the artist, 1856
TB CCCLXIV-217 (D 36063)
plate 267

303 (section V)
The Rigi at Sunset c. 1841
Watercolour with some pen, 24.5 x 36
Private Collection, England
plate 259

304 (section V)
EXHIBITED LONDON ONLY
Lake Lucerne: The Bay of Uri from above Brunnen 1842
Pencil and watercolour with scraping-out, 29.2 x 45.7
Private Collection, New York
plate 260

305 (section V)
EXHIBITED LONDON ONLY
The Dark Rigi 1842
Watercolour with scraping-out, 30.5 x 45.5
The Nivison Loan to the Laing Art Gallery,

Newcastle upon Tyne
 plate 263

306 (section V)
The Cathedral at Eu 1845
Pencil and watercolour, 23.2 x 32.8
The Tate Gallery, London, Bequeathed by the artist, 1856
TB CCCLIX-16 (D 35451)
 plate 266

WILLIAM TURNER OF OXFORD 1789–1862
307 (section IV)
Wychwood Forest, Oxfordshire 1809
Watercolour and bodycolour with gum arabic, sponging
and scraping-out, 60.7 x 79.3
Inscr. lower left: *W. Turner Shipton on Cher. Oxon*; and
verso: *Scene near where a pleasure fair was formerly held in
Whichwood Forest, Oxfordshire, William Turner, Shipton on
Cherwell, Oxon, 1809*
Exh. OWCS 1809 (no. 243)
The Board of Trustees of the Victoria and Albert Museum,
London (P 136-1929)
 plate 202

308 (section III)
EXHIBITED WASHINGTON ONLY
A Pollarded Willow 1835
Watercolour and bodycolour with some gum arabic,
37.3 x 27.1
Inscr. verso: *Godstow Oct* 13 1835
National Galleries of Scotland, Edinburgh
(D 5023/44)
 plate 140

309 (section VI)
EXHIBITED LONDON ONLY
Halnaker Mill, near Chichester, Sussex c. 1837
Watercolour, 52.2 x 75
Inscr. lower left: *W. Turn[er]*
Exh. (?)OWCS 1837 (no. 35, as *Shepherds returning with their
Flocks – Evening Scene, Halnacker Down, near Goodwood,
Sussex*)
National Galleries of Scotland, Edinburgh (DNG 1520)
 plate 290

310 (section IV)
Portsmouth Harbour from Portsdown Hill c. 1840
Pencil and watercolour with bodycolour and scraping-out,
59 x 99
Inscr. lower right: *W. Turner Oxford*
Private Collection
 plate 206

CORNELIUS VARLEY 1781–1873
311 (section III)
EXHIBITED LONDON ONLY
Lord Rous's Park, Henham, Suffolk 1801
Pencil and watercolour with touches of white bodycolour,
26.4 x 37.3
Inscr. lower left: *Lord Rouses Park / 1801 / C.V.*
Trustees of the British Museum, London (1973-4-14-15)
 plate 121

312 (section III)
Near Pont Aberglaslyn, North Wales 1805
Pencil and watercolour, 21.3 x 30.7
Inscr. below, centre: *NearPont Aber Glas Lyn C. Varley 1805*
Michael C. Jaye
 plate 113

313 (section III)
Evening at Llanberis, North Wales 1805
Watercolour, 20 x 23.8
Inscr. below: *Evening at Llanberis
C. Varley 1805*
The Tate Gallery, London, Purchased 1973
(T 01710)
 plate 115

314 (section III)
Mountainous Landscape, Ireland 1808
Watercolour, 19 x 25.6
Inscr. lower left: *Ireland 1808 C Varley*
Whitworth Art Gallery, University of Manchester (D 1973.4)
 plate 116

315 (section IV)
Pastoral, with Cattle and Figures in a Glade c. 1810
Pencil and watercolour, 54.2 x 37.4
Birmingham Museums and Art Gallery (P420'53)
 plate 212

JOHN VARLEY 1778–1842
316 (section II)
Market Place at Leominster, Hereford 1801
Pencil and watercolour, 28.3 x 40
Inscr. lower left on mount: *J.VARLEY / 1801*
Exh. (?)RA 1802 (no. 965, as *View of the town hall, Leominster*)
Hereford City Museum and Art Gallery (N3229)
 plate 72

317 (section IV)
Harlech Castle and Tygwyn Ferry 1804
Pencil and watercolour, 39.2 x 51.5
Inscr. lower left: *J.VARLEY 1804*
Exh. OWCS 1805 (no. 5)
Yale Center for British Art, New Haven, Paul Mellon
Collection (B 1986.29.578)
 plate 198

318 (section VI)
Snowdon from Moel Hebog 1805
Watercolour, 54 x 79.4
Inscr. lower right: *J VARLEY*
Exh. OWCS 1805 (no. iii)
Private Collection
 plate 280

319 (section VI)
Suburbs of an Ancient City 1808
Pencil and watercolour with stopping-out and sponging-
out, 72.2 x 96.5
Inscr. lower right: *J VARLEY / 1808*
Exh. OWCS 1808 (no. 163) and, lent by Thomas Hope, OWCS
1823 (no. 196)
The Tate Gallery, London, Presented by the Patrons of
British Art through the Friends of the Tate Gallery 1990
(T 05764)
 plate 287

JAMES WARD 1769–1859
320 (section III)
Study of a Weasel c. 1805
Pencil and watercolour on card, varnished, 14.9 x 22.5
Inscr. lower right: *JWD (monogram) RA*
Lent by the Syndics of the Fitzwilliam Museum,
Cambridge (3395)
 plate 148

321 (section III)
Two Studies of an Eagle c. 1815
Watercolour with pen and brown ink, 25.8 x 50.4
Inscr. lower left: *An Eagle two [?versions]
J. Ward R.A*; lower right: *JWD (monogram) RA*
Lent by the Syndics of the Fitzwilliam Museum,
Cambridge (3390)
 plate 147

JAMES ABBOTT MCNEILL WHISTLER 1834–1903
322 (section V)
Seascape with Schooner (?)c. 1880
Watercolour, 14.4 x 24
With artist's butterfly symbol lower left
Birmingham Museums and Aft Gallery (335'30)
 plate 274

323 (section V)
Seascape, A Grey Note (?) c.1880
Watercolour, 16.5 x 26.8
With artist's butterfly symbol lower right
Lent by the Syndics of the Fitzwilliam Museum,
Cambridge (PD 74–1959)
 plate 273

324 (section V)
St Ives c. 1883
Watercolour, 19.7 x 13.5
Lent by the Syndics of the Fitzwilliam Museum,
Cambridge (PD 16–1960)
 plate 269

325 (section V)
Beach Scene c. 1883
Watercolour and bodycolour on board, 12.5 x 21.2
With artist's butterfly symbol lower right
National Gallery of Art, Washington DC, Gift of Mr and Mrs
Paul Mellon, in Honor of the fifteenth Anniversary of the
National Gallery of Art (1991.7.3)
 plate 270

HUGH WILLIAM 'GRECIAN' WILLIAMS 1773–1829
326 (section VI)
View of the Forum in Rome 1828
Pencil and watercolour with stopping-out and scraping-
out, 40.5 x 65.3
Inscr. lower right: *H. W. Williams / 1828*
Yale Center for British Art, New Haven, Paul Mellon
Collection (B 1978.16.2)
 plate 291

SELECT BIBLIOGRAPHY

D. G. C. Allan, *William Shipley: Founder of the Royal Society of Arts*, London 1968

M. Andrews, *The Search for the Picturesque: Landscape Aesthetics and Tourism in Britain, 1760–1800*, Aldershot 1989

The Arrogant Connoisseur: Richard Payne Knight, 1751–1824, exh. cat. by M.Clarke & N.Penny; Manchester, Whitworth Art Gallery, 1982

Art for Newcastle: Thomas Miles Richardson and the Newcastle Exhibitions, 1822–1843, exh. cat. by P. Usherwood; Newcastle upon Tyne, Laing Art Gallery, 1984

J. Barrell, *The Dark Side of the Landscape: The Rural Poor in English Painting, 1730–1840*, Cambridge 1981

Beauty, Horror and Immensity: Picturesque Landscape in Britain, 1750–1850, exh. cat. by P. Bicknell; Cambridge, Fitzwilliam Museum, 1981

A. Bermingham, *Landscape and Ideology: The English Rustic Tradition, 1740–1860*, London 1987

P. Bicknell, *The Picturesque Scenery of the Lake District, 1752–1855: A Bibliographical Study*, Winchester 1990

D. Bindman, ed., *The Thames and Hudson Encyclopaedia of British Art*, London 1985

L. Binyon, *Catalogue of Drawings by British Artists and Artists of Foreign Origin working in Great Britain preserved in the Department of Prints and Drawings in the British Museum*, 4 vols, London 1898–1907

—, *English Watercolours*, London 1933, revd 1944, reprd New York 1969

T. S. R. Boase, *English Art, 1800–1870*, Oxford History of English Art x, Oxford 1959

The Bristol School of Artists: Francis Danby and Painting in Bristol, 1810–1840, exh. cat. by F.Greenacre; Bristol, City Art Gallery, 1973

British Artists in Rome, 1700–1800, exh. cat. by L. Stainton; London, The Iveagh Bequest, Kenwood, 1974

British Landscape Watercolours, 1600–1860, exh. cat. by L. Stainton; London, British Museum, 1985; revd as *Nature in to Art: British Landscape Watercolors*; Cleveland, OH, Museum of Art; Raleigh, NC, Museum of Art; 1991

British Watercolours: A Golden Age, 1750–1850, exh. cat. by S. Somerville; Louisville, KY, J. B. Speed Art Museum, 1977

British Watercolors, 1750–1850: A Loan Exhibition from the Victoria & Albert Museum, exh. cat. by G. Reynolds and J. Mayne; USA touring exhibition organised by the International Exhibitions Foundation; Washington, D.C. 1966

British Watercolours, 17 60–1930, from the Birmingham Museum and Art Gallery, exh. cat. by R. Lockett; Arts Council touring exhibition [1980]

British Watercolours and Drawings from Rowlandson to Riley, exh. cat. organised by the British Council and the Edinburgh International Festival; Edinburgh, Royal Scottish Academy, 1982

British Watercolors: Drawings of the 18th and 19th Centuries from the Yale Center of British Art, exh. cat. by S. Wilcox; New Haven, Yale Center for British Art, 1985

British Watercolours from Birmingham, exh. cat. by S. Wildman; London, Bankside Gallery; Birmingham, City Art Gallery; 1992

D.B. Brown, *Catalogue of the Collection of Drawings in the Ashmolean Musem, Oxford, iv: The Earlier British Drawings, British Artists and Foreigners working in Britain born before c. 1775*, Oxford 1982

—, & F. Owen, *Collector of Genius: A Life of Sir George Beaumont*, London 1988

Brush to Paper: Three Centuries of British Watercolours from Aberdeen Art Gallery, exh. cat. by F. Irwin; Aberdeen, Art Gallery, 1991

J. Burke, *English Art, 1714–1800*, Oxford History of English Art ix, Oxford 1976

P. Butler, *Three Hundred Years of Irish Watercolours and Drawings*, London 1990

C. Chard, 'Rising and Sinking in the Alps and Mt. Etna: The Topography of the Sublime in 18th-century England', *Journal of Philosophy and the Visual Arts*, 1, 1989, pp. 60–69

M. Clarke, *The Tempting Prospect: A Social History of English Watercolours*, London 1981

Clarkson Stanfield, 1793–1867, exh. cat. by P. van der Merwe; Gateshead, Tyne & Wear Museums, 1979

Classic Ground: British Artists in Italy, 1740–1830, exh. cat. ed. D. Bull; New Haven, Yale Center for British Art, 1981

D. Clifford, *Watercolours of the Norwich School*, London 1965

—, *Collecting English Watercolours*, London 1970

R. Cohen, ed., *Studies in Eighteenth-century British Art and Aesthetics*, London 1985

Color Printing in England, 1486–1870, exh. cat. by J.M. Friedman; New Haven, Yale Center for British Art, 1978

H. M. Colvin, *A Biographical Dictionary of English Architects, 1660–1840*, London 1954, revd as *A Biographical Dictionary of British Architects, 1600–1840*, 1978

Concise Catalogue of British Watercolours and Drawings, Manchester City Art Gallery, 2 vols, 1985, 1986

P. Conisbee, 'Pre-Romantic "Plein-air" Painting', *Art History*, 11, 1979, pp.413–28

D. Cosgrove & S. Daniels, eds, *The Iconography of Landscape*, Cambridge 1988

M. C. Cowling, 'The Artist as Anthropologist in Mid Victorian Britain', *Art History*, vi, 1983, pp. 461–77

H.M. Cundall, *of History of British Watercolour Painting*, London 1908, revd 1929

L. Cust & S. Colvin, *The History of the Society of Dilettanti*, London 1898

H. A. E. Day, *East Anglian Painters*, 3 vols, Eastbourne 1968–9

A Decade of English Naturalism, 1810–1820, exh. cat. by J. Gage; Norwich, Castle Museum; London, Victoria & Albert Museum; 1969–70

The Discovery of the Lake District: A Northern Arcadia and its Uses, exh. cat., prefaced by John Murdoch; London, Victoria & Albert Museum, 1984

The Discovery of Scotland: The Appreciation of Scottish Scenery through Two Centuries of Painting, exh. cat. by J. Holloway 8c L. Errington; Edinburgh, National Gallery of Scotland, 1978

Dr Thomas Monro (1759 –1833) and the Monro Academy, exh. brochure by J. Mayne; London, Victoria & Albert Museum, 1976

Drawing: Technique and Purpose, exh. cat. by S. Lambert; London, Victoria & Albert Museum, 1981, revd London 1984

J. Egerton, *British Watercolours*, London 1986

—, *English Watercolour Painting*, Oxford 1979

R. K. Engen, *Dictionary of Victorian Engravers, Print Publishers and fheir Works*, Cambridge 1979

English Artists Paper: Renaissance to Regency, exh. cat. by J. Krill; London, Victoria & Albert Museum, 1987

English Drawings and Watercolours, 1550–1850, in the Collection of Mr and Mrs Paul Mellon, exh. cat. by J. Baskett and D. Snelgrove, with a foreword by C. Ryskamp & introdn by G. Reynolds; New York, Pierpont Morgan Library; London, Royal Academy of Arts; 1972

English Landscape, 1630–1850: Drawings, Prints and Books from the Paul Mellon Collection, exh. cat. by C.White; New Haven, Yale Center for British Art, 1977

English Watercolours and other Drawings: The Helen Barlow Bequest, exh. cat.; Edinburgh, National Gallery of Scotland, 1979

J. Farington, *The Diary*, 16 vols, ed. K. Garlick, A.Macintyre & K.Cave, London 1978–84

T. W. Fawcett, *The Rise of English Provincial Art*, Oxford 1974

S. Fisher, *A Dictionary of Watercolour Painters, 1750–1900*, London 1972

The Fitch Collection: A Record of the Major English

Watercolours and Drawings Collected by Dr Marc Fitch, exh. cat., introd by A. Wilton; London, Leger Galleries, 1988

Forty-two British Watercolours from the Victoria and Albert Museum, exh. cat. by J. Murdoch; USA & Canada touring exhibition; London, 1977

D. Foskett, *A Dictionary of British Miniature Painters*, 2 vols, London 1972

R. Gard, ed., *The Observant Traveller: Diaries of Travel in England, Wales and Scotland in the County Record Offices of England and Wales*, London 1989

Gilpin to Ruskin: Drawing Masters and their Manuals, 1800–1860, exh. cat. by P.Bicknell & J.Munro; Cambridge, Fitzwilliam Museum; Grasmere, Dove Cottage and Wordsworth Museum; 1987–8

P. Goldman, *Looking at Prints, Drawings and Watercolours: A Guide to Technical Terms*, London 1988

R. T. Godfrey, *Printmaking in Britain: A General History from its Beginnings to the Present Day*, Oxford 1978

M. H. Grant, *A Dictionary of British Landscape Painters*, Leigh-on-Sea 1952

—, *A Chronological History of the Old English Landscape Painters*, 8 vols, 2nd edn, Leigh-on-Sea 1957–61

A. Graves, *The British Institution, 1806–1867: A Complete Dictionary of Contributors and their Work from the Foundation of the Institution*, London 1908, reprd 1969

—, *The Royal Academy of Arts: A Complete Dictionary of Contributors and their Work from its Foundation in 1769 to 1904*, 8 vols, London 1905–6

—, *The Society of Artists of Great Britain, 1760–1791; The Free Society of Artists, 1761–1783: A Complete Dictionary of Contributors and their Work from the Foundation of the Societies to 1791*, London 1907, reprd 1969

A. Griffiths, *Prints and Printmaking: An Introduction to the History and Techniques*, London 1980

G. Grigson, *Britain Observed: The Landscape through Artists' Eyes*, Oxford 1975

J.Halsby, *Scottish Watercolours, 1740–1940*, London 1986

M. Hardie, *English Coloured Books*, London 1906, reprd 1990

—, *Watercolour Painting in Britain*, 3 vols, ed. D. Snelgrove with J.Mayne and B.Taylor: I: *The Eighteenth Century*, London 1966, revd 1967; II: *The Romantic Period*, 1967; III: *The Victorian Period*, 1968

R. D. Harley, *Artists' Pigments, c. 1600–1835: A Study of English Documentary Sources*, London 1970

J. Harris, *The Artist and the Country House: A History of Country House and Garden View Painting in Britain, 1540–1870*, London 1979, revd 1985

A. Hemingway,'Cultural Anthropology and the Invention of the Norwich School', *Oxford Art Journal*, 11/2, 1988, pp. 17–39

—, *The Norwich School of Painters, 1803–1833*, Oxford 1979

—, 'The "Sociology" of Taste in the Scottish Enlightenment', *Oxford Art Journal*, XII, 1989, pp.3–35

—, *Landscape Images and Urban Culture in Early Nineteenth–century Britain*, Cambridge 1992

C. Hemming, *British Landscape Painters: A History and Gazetteer*, London 1989

—, *British Painters of the Coast and Sea: A History and*

Gazetteer, London 1988

L. Herrmann, *British Landscape Painting of the Eighteenth Century*, London 1973

W Hipple, *The Beautiful, the Sublime and the Picturesque in Eighteenth-century British Aesthetic Theory*, Carbondale, IL, 1957

S. Houfe, *The Dictionary of British Book Illustrators and Caricaturists, 1800 –1914*, Woodbridge 1978

C. E. Hughes, *Early English Watercolours*, London 1913, revd (by J. Mayne) 1950

J. D. Hunt, *The Figure in the Landscape: Poetry, Painting and Gardening in the Eighteenth Century*, London 1976

—, 'Picturesque Mirrors and the Ruins of the Past', *Art History*, IV, 1981, pp. 254–70

C. Hussey, *The Picturesque: Studies in a Point of View*, London 1927

S. C. Hutchison, *The History of the Royal Academy, 1768–1968*, London 1968, revd 1986

In the Shadow of Vesuvius: Views of Naples from Baroque to Romanticism, 1631–1830, exh. cat., with essays by G. Briganti, N. Spinosa & L. Stainton; London, Accademia Italiana delle Arti e delle Arti Applicate, 1990

D. Irwin & F. Irwin, *Scottish Painters at Home and Abroad, 1700–1900*, London 1975

R. Joppien & B. Smith, *The Art of Captain Cook's Voyages*, 3 vols, London 1985–8

F. D. Klingender, *Art and the Industrial Revolution*, London 1947, revd edn by A. Elton, 1968

R. P. Knight, *Expedition into Sicily*, ed. & introd by C. Stumpf, London 1986

R. Kuhns, 'The Beautiful and the Sublime', *New Literary History*, XIII, 1982, pp. 287–307

L. Lambourne & J.Hamilton, *British Watercolours in the Victoria & Albert Museum: An Illustrated Summary Catalogue of the National Collection*, London 1980

Landscape in Britain, c. 1750–1850, exh. cat. by L. Parris; London, Tate Gallery, 1974

Landscape in Britain, 1850–1950, exh. cat. ed. J. Collins & N. Bennett; London, Hayward Gallery; Bristol, City Art Gallery; Stoke-on-Trent, City Museum & Art Gallery; Sheffield, Mappin Art Gallery; 1983

H. Lemaitre, *Le paysage anglais a l'aquarelle, 1760 – 1851*, Paris 1955

R. Lister, *British Romantic Art*, London 1973

London – World City, 1800–1840, exh. cat. ed. C. Fox; Essen, Villa Hugel, 1992

Louis Francia, 1772–1839, exh. cat. by P. le Nouëne & A. Haudiquet; Calais, Musee des Beaux-Arts et de la Dentelle de Calais, 1988

S. T. Lucas, *Bibliography of Water Colour Painting and Painters*, London 1976

H. L. Mallalieu, *The Norwich School: Crome, Cotman and their Followers*, London 1974

—, *Understanding Watercolours*, Woodbridge 1985

—, *British Watercolour Artists up to 1920*, 2 vols, Woodbridge 1976, revd 1986; vol. 3, Woodbridge 1990
Masters of the Sea: British Marine Watercolours, exh. cat. by

R. Quarm & S. Wilcox; New Haven, Yale Center for British Art; London, National Maritime Museum; 1987

E. Moir, *The Discovery of Britain: The English Tourists, 1540 to 1840*, London 1964

S. H. Monk, *The Sublime: A Study of Critical Theories in Eighteenth-century England*, New York 1935, reprd 1960

W. C. Monkhouse, *The Earlier English Watercolour Painters*, London 1890, revd 1897

A. W. Moore, *The Norwich School of Artists*, Norwich 1985

The Most Beautiful Art of England: Fifty Watercolours, 1750–1850, exh. cat. by F. W Hawcroft; Manchester, Whitworth Art Gallery, 1983

C. Newall, *Victorian Watercolours*, Oxford 1987

The Northern Landscape: Flemish, Dutch and British Drawings from the Courtauld Collection, exh. cat. by D. Farr & W Bradford; New York, The Drawing Center, 1986

The Old Water-Colour Society and its Founder-Members, exh. cat. by B.Taylor; London, Spink & Son, 1973

A. P. Oppe, *English Drawings: Stuart and Georgian Periods in the Collection of H. M. the King at Windsor Castle*, London 1950

The Orient Observed: Images of the Middle East from the Searight Collection, exh. cat. by B. Llewellyn; London, Victoria & Albert Museum, 1989

The Orientalists, Delacroix to Matisse: European Painters in North Africa and the Near East, exh. cat. ed. M. A. Stevens; London, Royal Academy of Arts, 1984

Original Eyes: Progressive Vision in British Watercolour, 1750–1850, exh. cat. by D.B. Brown; Liverpool, Tate Gallery, 1991

I. Ousby, *The Englishman's England: Taste, Travel and the Rise of Tourism*, Cambridge 1990

F. Owen, 'Sir George Beaumont and the Old Watercolour Society', *The Old Water-Colour Society's Club*, LXII, 1991, pp. 23–9

Painters and Engraving: The Reproductive Print from Hogarth to Wilkie, exh. cat. by D.Alexander & R.T. Godfrey; New Haven, Yale Center for British Art, 1980

Painting from Nature, exh. cat. by P. Conisbee & L. Gowing; Cambridge, Fitzwilliam Museum; London, Royal Academy of Arts; 1980–1

Painting in Scotland: The Golden Age, exh. cat. by D. Macmillan; Edinburgh, Talbot Rice Art Centre; London, Tate Gallery; 1986–7

M. Paley, *The Apocalyptic Sublime*, London 1986

A. Payne, *Views of the Past: Topographical Drawings in the British Library*, London 1987

I. Pears, *The Discovery of Painting: The Growth of Interest in the Arts in England, 1680–1768*, London 1988

The Picturesque Tour in Northumberland and Durham, c. 1720–1830, exh. cat. by G.Hedley; Newcastle uponTyne, Laing Art Gallery, 1982

M. Pointon, *The Bonington Circle: English Watercolour and Anglo–French Landscape, 1790–1855*, Brighton 1985

Preferred Places: A Selection of British Landscape Water colours from the Collection of the Art Gallery of Ontario, exh. cat. by K. Sloan; Toronto, Glendon Gallery; Kitchener–Waterloo Art Gallery; Sarnia, Public Library & Art Gallery; 1987, *The Pre-Raphaelites*, exh. cat., introd by A. Bowness; London, Tate Gallery, 1984

Presences of Nature: British Landscape 1780–1830, exh. cat. by L. Hawes; New Haven, Yale Center for British Art, 1982–3

M. Rajnai, The Norwich Society of Artists, 1803 –1833: A Dictionary of Contributors and their Work, Norwich 1976

R. Redgrave & S. Redgrave, A Century of Painters of the English School, 2 vols, London 1866, revd 1890, reprd 1947

S. Redgrave, A Dictionary of Artists of the English School, 1874, revd 1878, reprd Bath 1970

R. Reilly, British Watercolours, London 1974, revd 1982

G. Reynolds, A Concise History of Watercolours, London 1971

—, English Watercolours: An Introduction, 1950, revd London 1988

Richard Wilson: The Landscape of Reaction, exh. cat. by D. H. Solkin; London, Tate Gallery; Cardiff, National Museum of Wales; New Haven, Yale Center for British Art; 1982–3

S. K. Robinson, Inquiry into the Picturesque, Chicago 1991

J. L. Roget, A History of the 'Old Water-Colour Society', now the Royal Society of Painters in Watercolours, 2 vols, London, 1891, reprd Woodbridge 1972

Romantic Art in Britain: Paintings and Drawings, 1760–1860, exh. cat.; Detroit, Institute of Art; Philadelphia, Museum of Art; 1968

M. Rosenthal, British Landscape Painting, Oxford 1982

S. Ross, 'The Picturesque: An Eighteenth–century Debate', Journal of Aesthetics and Art Criticism, XLVI, 1987, pp. 271–9

The Royal Watercolour Society: The First Fifty Years, 1805–1855, Antique Collectors' Club Research Project, Woodbridge 1992

Ruins in British Romantic Art from Wilson to Turner, exh. cat., introd by L. Hawes; Nottingham, Castle Museum, 1988

Scenery of Great Britain and Ireland in Aquatint and Lithography, 1770–18 50, from the Library of J. R. Abbey: A Bibliographical Catalogue, Folkestone and London 1972

Sketching at Home and Abroad: British Landscape Drawings, 1750–1850, exh. cat. by E.J. Phimister, S. Wiles & C. Denison; New York, Pierpont Morgan Library, 1992

The Sketching Society, 1799–1851, exh. cat. by J. Hamilton; London, Victoria & Albert Museum, 1971

K. Sloan, 'Drawing – A "Polite Recreation" in Eighteenth-century England', Studies in Eighteenth-century Culture, II, 1982, pp. 217–39

M. Spender, The Glory of Watercolour: The Royal Watercolour Society's Diploma Collection, London 1987

A. Staley, The Pre–Raphaelite Landscape, Oxford 1973

Town, Country, Shore and Sea: British Drawings and Watercolours from Antony van Dyck to Paul Nash, exh. cat. by D. Robinson; Cambridge, Fitzwilliam Museum, 1982

Travels in Italy, 1776–1783: Based on the Memoirs' of Thomas Jones, exh. cat. by F.Hawcroft; Manchester, Whitworth Art Gallery, 1988

M. L. Twyman, Lithography, 1800–1850: The Techniques of Drawing on Stone in England and France and their Application in Works of Topography, London 1970

Victorian Landscape Watercolours, exh. cat. by S. Wilcox & C. Newall; New Haven, Yale Center for British Art; Cleveland, OH, Museum of Art; Birmingham, Museum & Art Gallery; 1992

Visions of Venice: Watercolours and Drawings from Turner to Ruskin, exh. cat. by T. Wilcox; London, Bankside Gallery, 1990

Wash and Gouache: A Study of the Developments of the Materials of Watercolor, exh. cat. by M. B. Cohn & R. Rosenfeld; Cambridge, MA, Fogg Art Museum, 1977

E. K. Waterhouse, The Dictionary of British Eighteenth-century Painters in Oils and Crayons, Dictionary of British Art II, Woodbridge 1981

—, Painting in Britain, 1530 to 1790, Pelican History of Art, Harmondsworth 1953, 4th revd edn 1978

D. Watkin, The English Vision: The Picturesque in Architecture, Landscape and Garden Design, London 1982

W. T. Whitley, Artists and their Friends in England, 1700–1799, 2 vols, London 1928

L. A. Williams, Early English Watercolours, and Some Cognate Drawings by Artists born not later than 1785, London 1952

A. Wilton, British Watercolours, 1750–1850, Oxford 1977

C. Wood, Victorian Painters, Dictionary of British Art IV, Woodbridge 1971, revd 1978

H. T. Wood, The History of the Royal Society of Arts, London 1913

N. Wood, 'The Aesthetic Dimension of Burke's Political Thought', Journal of British Studies, IV, 1964, pp. 41–64

William Wordsworth and the Age of English Romanticism, exh. cat. by J. Wordsworth, M. C. Jaye & R. Woof; New York, Public Library; Bloomington, Indiana University Art Museum; Chicago, Historical Society; 1987

Works of Splendor and Imagination: The Exhibition Watercolor, 1770–1870, exh. cat. by J. Bayard; New Haven, Yale Center for British Art, 1981

Lenders to the Exhibition

Amsterdam, Rijsprentenkabinet, Rijksmuseum, cat. 229, 246
Bedford, The Cecil Higgins Art Gallery, cat. 110, 178, 185, 201, 284
Chris Beetles, cat. 157
Birmingham, City Museums and Art Gallery, cat. 7, 54, 57, 63, 66, 67, 68, 76, 135, 141, 232, 275, 315, 322
Bristol, City Museums and Art Gallery, cat. 101, 102, 103, 104, 186, 187, 188, 189, 190, 191
Cambridge, The Syndics of the Fitzwilliam Museum, cat. 1, 17, 20, 23, 24, 74, 112, 113, 119, 136, 139, 164, 165, 168, 199, 202, 203, 207, 220, 221, 236, 263, 264, 320, 321, 323, 324
Cardiff, National Museum of Wales, cat. 75, 105, 243, 279
Chart Analysis Ltd, cat. 174, 176, 177
Chicago, Art Institute of Chicago, cat. 73
The Duke of Devonshire and the Chatsworth Settlement Trustees, cat. 230
Edinburgh, National Galleries of Scotland, cat. 50, 97, 98, 111, 142, 235, 249, 261, 288, 308, 309
Sir Brinsley Ford, CBE, Hon. FRA, FSA, cat. 197
H.M. The Queen, cat. 5, 251, 252, 253, 259, 260
Hereford, City Museum and Art Gallery, cat. 96, 99, 100, 316
Michael C. Jaye, cat. 312
Leeds, City Art Galleries, cat. 8, 36, 42, 51, 53, 87, 92, 137, 138, 145, 150, 273, 274, 276, 286
Lincoln, Lincolnshire County Council, Usher Gallery, cat. 115, 117, 118, 283, 293
Liverpool, University of Liverpool Art Gallery and Collections, cat. 71, 77, 116, 237
Liverpool, Trustees of the National Museums and Galleries on Merseyside, Walker Art Gallery, cat. 59
London, Abbot and Holder, cat. 64, 170
London, Agnew's, cat. 81
London, Albany Gallery, cat. 172, 262
London, British Architectural Library Drawings Collection, Royal Institute of British Architects, cat. 266, 267
London, Trustees of the British Museum, cat. 13, 28, 29, 31, 32, 38, 40, 43, 44, 48, 82, 85, 95, 114, 140, 148, 149, 152, 160, 173, 218, 231, 240, 247, 250, 257, 265, 268, 269, 311
London, Courtauld Institute Galleries, cat. 55
London, Martyn Gregory Gallery, cat. 204, 205, 206
London, Hazlitt, Gooden & Fox, cat. 79
London, The Leger Galleries, cat. 281, 292
London, Royal Academy of Arts, cat. 241
London, Tate Gallery, cat. 11, 18, 52, 69, 70, 143, 163, 193, 195, 225, 242, 277, 280, 285, 289, 290, 291, 294, 298, 299, 300, 302, 306, 313, 319
London, The Board of Trustees of the Victoria and Albert Museum, cat. 26, 27, 30, 33, 34, 35, 47, 56, 60, 78, 86, 147, 171, 182, 200, 219, 222, 238, 244, 271, 307
London, Whitelands College Archives, cat. 248
Manchester, City Art Galleries, cat. 58
Manchester, Whitworth Art Gallery, University of Manchester, cat. 41, 83, 144, 198, 209, 214, 314
The National Trust, Arlington Court, cat. 10
Christopher and Jenny Newall, cat. 19, 169, 175
Newcastle upon Tyne, Laing Art Gallery (Tyne and Wear Museums), cat. 22, 154
Newcastle upon Tyne, The Nivison Loan to the Laing Art Gallery, cat. 256, 305
New Haven, Yale Center for British Art, Paul Mellon Collection, cat. 45, 106, 108, 127, 129, 130, 166, 196, 223, 228, 239, 282, 317, 326
New York, The Pierpont Morgan Library, cat. 9
Nottingham, Castle Museum and Art Gallery, cat. 16, 21, 181, 255, 258
Oldham, Art Gallery, cat. 4, 88, 89, 167, 211, 227
Orkney, The Robertson Collection, Courtesy Peter Nahum, London, cat. 183
Oxford, The Visitors of the Ashmolean Museum, cat. 90, 125, 131, 179, 215, 233
Pittsburgh, PA, Mellon Bank Corporation, cat. 46
Preston, Harris Museum and Art Gallery, cat. 180, 295
Reading, Museum and Art Gallery, cat. 159, 161
Sheffield, City Art Galleries, cat. 14, 296
The Sudeley Castle Collection, cat. 158, 234
James Swartz Esq., cat. 6
John Swire and Sons Ltd, cat. 3
Washington, DC, National Gallery of Art, cat. 2, 84, 94, 208, 224, 245, 254, 325
Wolverhampton, Art Gallery and Museums, cat. 278

and other owners who wish to remain anonymous

Photographic Acknowledgements

Amsterdam, Rijksmuseum, cat. 229, 246
Birmingham Museums and Art Gallery, cat. 7, 54, 57, 63, 66, 67, 68, 76, 135, 141, 232, 275, 315, 322
Bristol, Andy Cotton, cat. 101, 102, 103, 104, 186, 187, 188, 189, 190, 191
Cambridge, Fitzwilliam Museum, cat. 1, 17, 20, 23, 24, 74, 112, 113, 119, 136, 164, 165, 199, 202, 203, 207, 220, 221, 236, 263, 264, 320, 321, 323, 324
Cambridge, Neville Taylor, cat. 133, 146
Cardiff, National Museum of Wales, cat. 75, 105, 243, 279
Chicago, Art Institute of Chicago, cat. 73
Edinburgh, National Galleries of Scotland (Antonia Reeve Photography), cat. 50, 97, 98, 111, 142, 235, 249, 261, 288, 308, 309;
H. M The Queen, cat. 5, 251, 252, 254, 259, 260
Hereford, Hammonds Photography, cat. 96, 99, 100, 316
Leeds, City Art Galleries, cat. 8, 36, 42, 51, 53, 87, 92, 137, 138, 45, 150, 273, 274, 276, 286
Liverpool, John Mills (Photography), cat. 59; fig. 7
Liverpool, University Art Gallery and Collections, cat. 71, 77, 116, 237
London, Agnew's, cat. 65, 81, 310
London, Albany Gallery, cat. 172, 262
London, Chris Beetles, cat. 157

London, © British Museum, cat. 13, 28, 29, 31, 32, 38, 40, 43, 44, 48, 82, 85, 95, 114, 140, 148, 149, 152, 160, 173, 218, 231, 240, 247, 250, 257, 265, 268, 269, 311; fig. 1, 2, 4
London, Christie's, fig. 5
London, Courtauld Institute Galleries, cat. 55; fig. 3
London, Prudence Cuming Associates Ltd., cat. 3, 6, 12, 15, 19, 25, 37, 39, 61, 62, 64, 72, 91, 107, 109, 115, 117, 118, 120, 121, 122, 123, 124, 126, 151, 155, 156, 162, 169, 170, 174, 175, 176, 177, 184, 197, 216, 217, 230, 248, 270, 272, 281, 283, 287, 292, 293, 297, 301, 312
London, Martyn Gregory Gallery, cat. 49, 128, 204, 205, 206
London, Hazlitt, Gooden & Fox, cat. 79, 80, 210
London, Leger Galleries cat. 134, 194
London, Peter Nahum, cat. 132, 183
London, Trustees of the National Gallery, fig. 10
London, P−inc Photography, cat. 158, 234
London, Royal Academy of Arts, cat. 241
London, Royal Institute of British Architects, cat. 266, 267
London, Sotheby's, cat. 153, 212
London, © Tate Gallery, cat. 11, 18, 52, 69, 70, 143, 163, 193, 195, 225, 242, 277, 280, 285, 289, 290, 291, 294, 298, 299, 300, 302, 306, 313, 319; fig. 8, 12
London, © The Board of Trustees of the Victoria and Albert Museum, cat. 26, 27, 30, 33, 34, 35, 47, 56, 60, 78, 86, 147, 171, 182, 200, 219, 222, 238, 244, 271, 307

Manchester, City Art Galleries, cat. 58
Manchester, Whitworth Art Gallery, cat. 41, 83, 144, 198, 209, 214, 314
National Trust Photographic Library/Derrick E. Witty, cat. 10
Newcastle upon Tyne, Laing Art Gallery, cat. 22, 154, 256, 305; fig. 11
New Haven, Richard Caspole, Yale Centre for British Art, cat. 45, 106, 108, 127, 129, 130, 166, 196, 223, 228, 239, 282, 317, 326
New York, © The Pierpont Morgan Library, 1992, cat. 9
Northumberland, Fiona Lees−Millais, cat. 318
Nottingham, Layland Ross Ltd., cat. 16, 21, 181, 255, 258
Oxford, © Ashmolean Museum, cat. 90, 125, 131, 179, 215, 233; fig. 6
Pittsburgh, PA, Mellon Bank Corporation, cat. 46
Preston, Norwyn Photographics, cat. 180, 295
Reading, Jonathan Farmer, cat. 159, 161
Sheffield, City Art Galleries, cat. 14, 296
Southport, Alan R. Jones Photography, cat. 4, 88, 89, 167, 211, 227
Surrey, Nick Nicholson, cat. 110, 178, 185, 201, 284
Washington, DC, © National Gallery of Art, cat. 2, 84, 94, 208, 224, 245, 253, 266, 304, 325
Wolverhampton, Eardley Lewis Photographers, cat. 278

INDEX

Abbott, John White 26

Beaumont, Sir George 26
Blake, Robert 20
Blake, William 20, 28n, fig. 8
Bonington, Richard Parkes 21
Boydell, Josiah 13
Bristol School of Artists 26
Buck, Samuel 23
Byron, George Gordon, Lord 18

Claude Lorrain 16, 22, fig. 6
Coleridge, Samuel Taylor 17, 20
Constable, John 25
Cotman, John Sell 21–22, 26
Cox, David 18, 24, 25
Cozens, Alexander 16
Cozens, John Robert 15–16, 18, 24, 25
Cristall, Joshua 22–23, 29n
Crome, John 6

DeWint, Peter 24
Ducros, Louis 11, 14, fig. 3
Dürer, Albrecht 14

Farington, Joseph 18

Girtin, Thomas 18–19, 20–21, 22, 23, 24, 28n
Glover, John 27

Goodwin, Albert 25
Gore, Charles 11
Goupy, Joseph 14
Goupy, Louis 14

Hackert, Philipp 10, 11
Haydon, Benjamin Robert 23
Heaphy, Thomas 23
Hearne, Thomas 11
Hogarth, William 12, 18
Hope, Thomas 23
Hunt, Alfred William 25

Kaisermann, Franz 11
Kant, Immanuel 17
Knight, Richard Payne 10
Koninck, Philips fig. 2

Lear, Edward 18
Lens III, Bernard 14

Monro, Dr Thomas 18

Palmer, Samuel 18, 25
Pars, William 14
Poussin, Nicolas 22, 29n, fig. 10
Pre-Raphaelite Brotherhood 24, 25
Pyne, William Henry 9

Reynolds, Sir Joshua 13, 18, 19
Ricci, Marco 14, fig. 5
Rota, Martino after Titian fig. 9
Rousseau, Jean-Jacques 17
Rowlandson, Thomas 20
Royal Academy of Arts 13, 15, 18; founding of (1768) 12
Royal Academy Schools 15
Ruskin John 24, 27, 29n

Sandby, Paul 14–15, 18, 19
Smith, John 'Warwick' fig. 1
Society of Painters in Water-Colours (OWCS) 9, 13, 22, 27; founding of (1804) 22
Stuart, James 'Athenian' 14
Swinburne, Algernon Charles 26

Thomson, James 16, 18
Titian 22, fig. 9
Towne, Francis 26
Turner, J.M.W. 18, 19, 20, 21–22, 23–24, 25, 26, 28n, 29n

Uwins, Thomas 26

Vaughan Williams, Ralph 25

Wilkie, David 23, fig 11
Wilson Richard 13, 16, 19, 22, fig. 7
Woollett, William fig. 4
Wordsworth, William 17, 18

First published on the occasion of the exhibition *The Great Age of British Watercolours, 1750–1880*, held at the Royal Academy of Arts, London, 15 January–12 April 1993, and at the National Gallery of Art, Washington D.C., 9 May–25 July 1993.

Front cover: J. M. W. Turner, *The Dark Rigi* , 1842 (detail), see pl. 263
Back cover: William Blake, *The Arlington Court Picture*, 1821 (detail), see pl. 218
Frontispiece: Francis Towne, *Trees Overhanging Water*, 1800, see pl. 134
Page 8: James Duffield Hardling, *Modern Greece*, 1828 (detail), see pl. 293

Prestel, a member of Verlagsgruppe Random House GmbH

Prestel Verlag
Neumarkterstrasse 28
81673 Munich
Tel. +49 (0) 89 4136-0
Fax +49 (0) 89 4136-2335

Prestel Publishing Ltd.
4 Bloomsbury Place
London WC1A 2QA
Tel. +44 (0) 20 7323-5004
Fax +44 (0) 20 7636-8004

Prestel Publishing
900 Broadway, Suite 603
New York, NY 10003
Tel. +1 (212) 995-2720
Fax +1 (212) 995-2733

www.prestel.de

www.prestel.com

www.prestel.com

Library of Congress Control Number: 2010941111; British Library Cataloguing-in-Publication Data: a catalogue record for this book is available from the British Library; Deutsche Nationalbibliothek holds a record of this publication in the Deutsche Nationalbibliografie; detailed bibliographical data can be found under: http://dnb.d-nb.de

Prestel books are available worldwide. Please contact your nearest bookseller or one of the above addresses for information concerning your local distributor.

Catalogue edited by Robert Williams
Catalogue coordinators: MaryAnne Stevens & Jane Martineau
Production: Friederike Schirge
Origination and typesetting: ludwig media, Zell am See
Printed and bound by C&C Printing

Verlagsgruppe Random House FSC-DEU-0100
The FSC®-certified paper Chinese Golden Sun matt art is produced by mill Yanzhou Tianzhang Paper Industry Co., Ltd., Shandong, PRC.
Printed in China

ISBN 978-3-7913-4539-0 (flexi edition)